Guide to TV /
Film Shooting
in Nanjing

南京
影视拍摄
指南

中共南京市委宣传部　指导
南京影视文化公共服务中心　编

东南大学出版社
SOUTHEAST UNIVERSITY PRESS

内容提要

本书通过对南京的著名景点进行中英双语介绍,为影视拍摄提供了一份直观形象、生动具体的高品质实用指南。同时,走进本书,也可以更深入地了解南京这座城市的发展变迁,感受时代的进步。

图书在版编目(CIP)数据

南京影视拍摄指南:汉英对照 / 南京影视文化公共服务中心编 -- 南京:东南大学出版社,2022.6
 ISBN 978-7-5641-9979-1

Ⅰ.①南… Ⅱ.①中… ②南… Ⅲ.①电影摄影艺术 – 南京 – 指南 – 汉、英 Ⅳ.① J931-62

中国版本图书馆 CIP 数据核字(2021)第 275903 号

责任编辑:徐 潇 装帧设计:有品堂 责任印制:周荣虎

南京影视拍摄指南 NanJing YingShi PaiShe ZhiNan

指 导	中共南京市委宣传部
编 者	南京影视文化公共服务中心
文 字	周化光
出版发行	东南大学出版社
社 址	南京四牌楼 2 号 邮编:210096 电话:025-83793330
网 址	http://www.seupress.com
电子邮件	press@seupress.com
经 销	全国各地新华书店
印 刷	南京迅驰彩色印刷有限公司
开 本	889 mm × 1194 mm 1/24
印 张	8.75
字 数	360 千
版 次	2022 年 6 月第 1 版
印 次	2022 年 6 月第 1 次印刷
书 号	ISBN 978-7-5641-9979-1
定 价	128.00 元

(本社图书若有印装质量问题,请直接与营销部调换。电话(传真):025-83791830)

前　言

　　南京，虎踞龙盘、六朝形胜，古寺城墙承载了悠悠千年深邃厚重的历史。南京，博爱之城、天下文枢，江河湖水孕育了温婉包容的人文品质。南京，人文绿都、科教之城，创业创新铸就了时尚现代的国际化宜居之城。作为闻名世界的旅游重点城市，南京的美在于山水城林的交相辉映。挺拔苍翠的紫金山，碧波荡漾的玄武湖，璀璨迷人的秦淮河和蔚为壮观的明城墙都在低调中展示着这座城市独特的魅力。南京的美还在于历史与现代、古典与时尚的完美融合。这里既有被列为世界文化遗产名录的明孝陵，也有新兴的网红景区大塘金薰衣草园等。近年来，随着社会、经济、文化等各项事业的快速发展，南京这座"世界文学之都"的文化艺术事业迈入了快速发展的轨道，影视产业的发展更是高歌猛进，涌现出一大批影视产业基地。南京深厚的历史底蕴、多元化的城市建筑和周边优美的生态环境等都为不同题材影视剧的拍摄提供了理想的取景地。本书以图文并茂的形式介绍了南京的主要景区、热门景点和重要的文化地标、时尚商圈、生活设施等，既便于人们对南京有更好的了解，也致力于为影视文化产业提供便利的服务，相信无论什么题材的影视剧都可以在这里找到理想的拍摄场景。

<div style="text-align:right">

编　者

2021 年 12 月

</div>

南京影视文化公共服务中心

南京影视文化公共服务中心,为各类主体来宁拍摄影视剧提供免费的咨询、协调服务116项。

首批推出的咨询服务包括政策、资讯咨询;服务协调包括取景地、拍摄器材租赁、后期制作、特殊拍摄、道具、服装、化妆、置景、车辆、保险、法务、推介等。

政策咨询
相关影视产业各种政策咨询

服务协调
- 取景地
- 拍摄器材租赁
- 道具/服装/化妆
- 保险/法务
- 专业人员
- 后期制作
- 宣传
- 特殊拍摄(大片)

- 六合区
- 雨花9424电影公园
- 秦淮网络文学谷
- 耳东电影产业园
- 溧水石湫
- 南京影视文化公共服务中心

目 录

Jiangbei New Area
Pukou District
Luhe District

江北新区（浦口区、六合区）

南京长江大桥	002
珍珠泉风景区	003
金牛湖风景区	004
金牛湖野生动物王国	005
四方当代美术馆	006
冶山国家矿山公园	007
池杉湖国家湿地公园	008
老山国家森林公园	009
平山森林公园	010
滨江生态公园	012
灵岩山风景区	013
浦口火车站	014
太子山公园	015
桃湖公园	016
佛手湖郊野公园	017
河岸花海公园	018
水墨大埝旅游景区	019
蜂巢酒店	020
弘阳未来世界	021
华昌龙之谷	022
江北龙湖天街	023
六合老街	024
六合文庙	025
西埂莲乡	026
不老村	027
张圩油菜花海	028
T81文化科技产业园	029

南京云幽谷旅游区	030
泰山寺	031
六合国家地质公园	032
大泉湖	033
止马岭森林公园	034
枫彩漫城	035

紫金山景区	038
中山陵景区	039
明孝陵景区	040
美龄宫	041
中山陵音乐台	042
南京中山植物园	043
陵园路	044
石象路	045
南京海底世界	046
总统府景区（中国近代史遗址博物馆）	047
民国邮政博物馆	048
南京博物院	049
南京十朝历史文化园	050
南京图书馆	051
玄武湖公园	052
前湖公园	053
九华山公园	054
梅花山	055

Xuanwu District

玄武区

古鸡鸣寺景区	056
南京火车站	057
红山森林动物园	058
德基广场	059
1912 街区	060
国展中心	061

秦淮区 Qinhuai District

夫子庙秦淮风光带	064
夫子庙	065
愚园	066
南京中国科举博物馆	067
老门东	068
明城墙	069
乌衣巷	070
江苏网络文学谷	071
中华门	072
中华门火车站	073
朝天宫	074
大报恩寺遗址公园	075
白鹭洲公园	076
瞻园	077
南京国家领军人才创业园	078
晨光 1865 科技创意产业园	079

建邺区 Jianye District

侵华日军南京大屠杀遇难同胞纪念馆	082
莫愁湖公园	083
江苏大剧院	084
南京奥林匹克体育中心	085
南京国际青年文化中心	086
南京眼步行桥	087
南京绿博园	088
南京金融城	089
河西大街	090
江心洲	091
南京江心洲长江大桥	092
南京云锦博物馆	093

鼓楼区 Gulou District

阅江楼	096
新街口商贸区	098
江苏广播电视塔	100
紫峰大厦	101
鼓楼	102
绣球公园	103
乌龙潭公园	104
清凉山公园	105
龙江船厂遗址	106
石头城	107
拉贝故居	108
苏宁睿城	109

Qixia District 栖霞区

龙潭港	112
八卦洲假日山庄	113
栖霞山	114
南京欢乐谷	116
桃花湖	117
燕子矶	118
羊山公园	120
江南水泥厂	121
南京栖霞山长江大桥	122
长江观音景区	123
仙林金鹰湖滨天地	124
陶行知纪念馆	125

Yuhuatai District 雨花台区

雨花台烈士陵园	128
南京科技馆	129
南京南站	130
9424 电影工园	131
南京证大喜玛拉雅中心	132
雨花客厅	133
莲花湖公园	134
三桥湿地公园	135
花神湖	136
天隆寺	137

Jiangning District 江宁区

南京禄口国际机场	140
牛首山	141
金陵小城	142
阳山碑材	143
汤山矿坑公园	144
汤山温泉	145
江苏园博园	146
百家湖	147
景枫中心	148
凤凰广场	149
银杏湖	150
谷里薰衣草庄园	151
黄龙岘	152
七仙大福村	153
佘村	154
石塘竹海	155
将军山	156
方山风景区	157
定林寺	158
龙湖南京龙湾天街	159
文鼎广场	160
小龙湾桥	161
华谊兄弟（南京）电影小镇	162

Lishui District	溧水区		
	石揪影视基地		166
	无想寺		167
	石臼湖		168
	天生桥		169
	大金山风景区		170
	东庐山观音寺景区		171
	状元坊文化公园		172
	周园		173
	溧水城隍庙文化街区		174
	江苏万驰国际赛车场		175

Gaochun District	高淳区		
	高淳国际慢城		178
	固城湖国家城市湿地公园		179
	高淳老街		180
	固城湖		182
	关王庙		183

Schools	学校类		
	南京大学		186
	南京理工大学		187
	南京师范大学		188
	南京航空航天大学		190
	南京艺术学院		191
	南京传媒学院		192

Jiangbei New Area

Pukou District

Luhe District

江北新区

（浦口区、六合区）

南京长江大桥

南京长江大桥是长江上第一座由中国自行设计和建造的双层式铁路、公路两用桥梁——上层公路桥长4 589米,下层双轨复线铁路桥宽14米、全长6 772米——是国家南北交通要道,在中国桥梁史和世界桥梁史上都具有重要意义。南京长江大桥不仅是新中国技术成就与现代化的象征,更承载了中国几代人的特殊情感与记忆,是江苏的文化符号,体现着新中国建设的辉煌成就,也是游客到南京的必游之地。夜间的长江大桥在莲花灯的照耀下,宛若闪亮的巨龙,飞架大江南北,成为南京的标志性建筑。

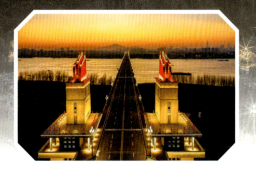

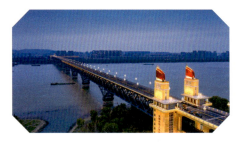

Spanning astride the north and south banks of the Yangtze River to the northwest of Nanjing, Nanjing Yangtze River Bridge is the first double-deck railroad bridge designed and built by China itself. The upper deck of Nanjing Yangtze River Bridge is a highway bridge with a length of 4,589 meters, the lower deck is a double-track complex-line railway bridge with a width of 14 meters and a length of 6,772 meters, making it the national north-south transport artery. The bridge is of great significance in the history of bridge-building in China and the world. It not only symbolizes the new China's technological achievements and modernization after 1949, but also carries the special feelings and memories of generations of Chinese people. It is a cultural symbol of Jiangsu and a glorious sight of China, also a must-see scenic spot for many travelers coming to Nanjing. At night, with hundreds of lotus-shaped lamps ablaze, it seems like a "fiery dragon" flying on the river, becoming a landmark of Nanjing.

珍珠泉风景区

珍珠泉风景区是著名的省级旅游度假区和国家级水利风景区，明清时期就被称为"江北第一游观之所"。珍珠泉四季泉涌，千年不绝，山青、水秀、泉奇、石美，被称为都市边的人间仙境、世外桃源。景区也是一个大型的综合休闲娱乐区域，人们可以在此露营、烧烤或乘坐竹筏。现在不仅有年轻人喜爱的过山车等大型游乐项目，还有儿童喜欢的野生动物园。景区核心景点珍珠泉的泉水自池底岩缝中涌起，如串串珍珠，因而得名"珍珠泉"。珍珠泉长城也是人们喜爱的景点。

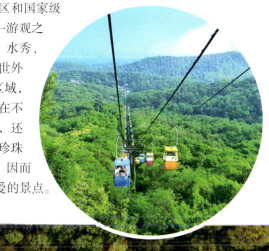

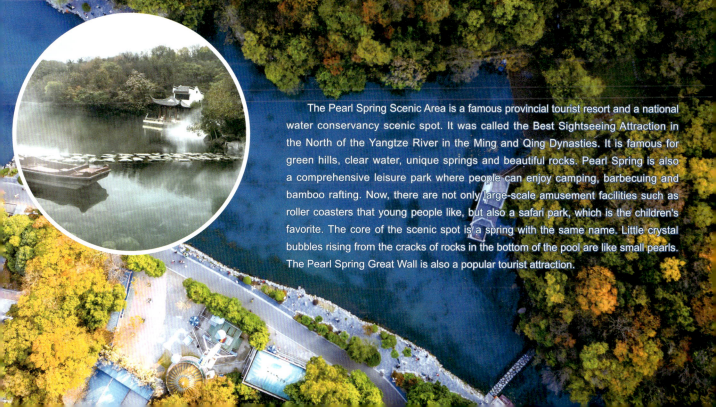

The Pearl Spring Scenic Area is a famous provincial tourist resort and a national water conservancy scenic spot. It was called the Best Sightseeing Attraction in the North of the Yangtze River in the Ming and Qing Dynasties. It is famous for green hills, clear water, unique springs and beautiful rocks. Pearl Spring is also a comprehensive leisure park where people can enjoy camping, barbecuing and bamboo rafting. Now, there are not only large-scale amusement facilities such as roller coasters that young people like, but also a safari park, which is the children's favorite. The core of the scenic spot is a spring with the same name. Little crystal bubbles rising from the cracks of rocks in the bottom of the pool are like small pearls. The Pearl Spring Great Wall is also a popular tourist attraction.

金牛湖风景区

金牛湖水面面积约17平方千米，因紧邻金牛山而得名，原名"金牛山水库"，是南京市最大的人工湖泊，也是国家水利风景区和省级森林公园。景区林木幽深、气候宜人、景色优美，是夏季避暑的好地方。主要景点有金牛山、金光禅寺、茉莉花茶园以及杉树林等。蜚声海内外的江苏民歌《茉莉花》就发源于金牛湖畔。这里还是水上运动的重要场地，2019年9月被国家帆船协会列为训练基地。人们在欣赏青山绿水优美风光的同时，也可以品尝当地特产和美食。

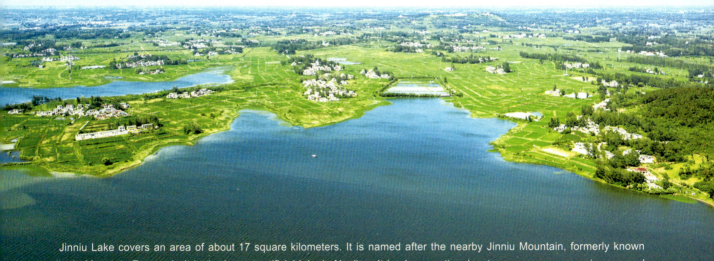

Jinniu Lake covers an area of about 17 square kilometers. It is named after the nearby Jinniu Mountain, formerly known as Jinniu Mountain Reservoir. It is the largest artificial lake in Nanjing. It is also a national water conservancy scenic area and provincial forest park. Famous attractions are Jinniu Mountain, Jinguang Temple, Jasmine Garden and Cedar Forests. Jinniu Lake also has a profound cultural heritage. The classic folk song *Jasmine Flower* originated here. Various international and domestic water competitions have been held, and it was listed as a training base by the National Sailing Association in September, 2019. People can enjoy the beautiful scenery of green mountains and clear water, as well as the local specialties and delicacies.

金牛湖野生动物王国

金牛湖野生动物王国面积约1 600亩,是长三角地区最具特色的以近距离体验为主题的野生动物园。园区特色鲜明,在原生态的基础上,利用山地、矿坑、宕口、林地等天然地形追求实景化设计,开发出草原部落、鸟语天堂、珍奇世界、海洋探险、动物嘉年华和大马戏城等主题区域。游客可以自驾或乘坐小火车在草原部落的丛林中体验与动物近距离接触,感受自然的魅力。在动物嘉年华区,游客还可以亲手逗喂呆萌羊驼和迷你矮马等温顺可爱的动物。大马戏城有马戏团、杂技团带来的精彩表演。

Jinniu Lake Wildlife Kingdom covers an area of about 1,600 mu and is known as the most distinctive wildlife park in the Yangtze River Delta where visitors can closely watch animals. The park has distinctive features, and on the basis of the original ecology, it utilizes the natural terrain such as mountains, mines, deserted quarries and woodland to pursue realistic design. The park has developed some thematic areas such as Grassland Tribes, Paradise of Birds, Exotic World, Marine Exploration, Animal Carnival and Grand Circus City. Visitors can drive by themselves or take small trains to get close contact with animals in the Grassland Tribes and feel the charm of nature. In the Animal Carnival, visitors can also feed cute and docile animals such as alpacas and miniature ponies. Some circus and acrobatic troupes often bring wonderful performances in the Grand Circus City.

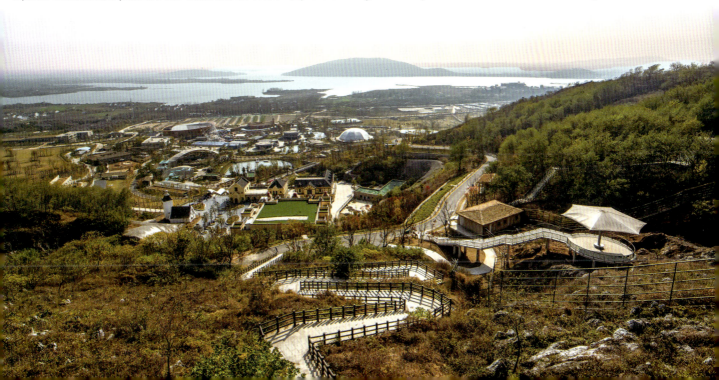

四方当代美术馆

四方当代美术馆是南京四方艺术湖区的代表性建筑，由美国著名建筑大师斯蒂文·霍尔（Steven Holl）设计，周围山清水秀，环境优美。美术馆以高雅的艺术和前卫时尚的建筑风格成为经典的艺术人文景观。设计充分体现了移动的视角和透视的空间。竹子制成的黑色混凝土花园墙极具特色，上方悬浮的半透明方体被称为"场域"，夜晚晶莹剔透，体现了建筑的独特性。展馆自成风格，由一条简洁的长廊组成，参观者不仅能够欣赏艺术和建筑之美，还能感受与周围自然环境融为一体，远离城市喧嚣，净化心灵。

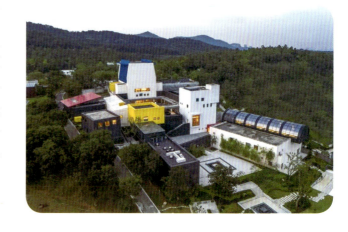

As the landmark of Nanjing Sifangcollec, Sifang Art Museum was designed by the famous American architect, Steven Holl. Surrounded by mountains and lakes, the museum enjoys spectacular scenery. With elegant art and avant-garde architectural style, the museum presents a unique artistic and cultural landscape. The design fully embodies the sense of motion and perspective, with unique gradation. The distinctive black concrete wall is made of bamboos like a garden, with a suspended translucent rectangular parallelepiped, known as "the domain", and shining brightly like crystal at night, embodying the uniqueness. The exhibition hall enjoys its own style with a simple rectangular corridor, where visitors can not only admire the beauty of fine arts and architecture, but also escape from the city's hustle and bustle to meditate and find spiritual satisfaction due to the harmonious co-existence of art, architecture and nature.

冶山国家矿山公园

南京冶山国家矿山公园紧临金牛湖风景区、桂子山石柱林风景区。冶山矿有着3000多年的历史，享有"华夏冶铸第一山"的美誉，"冶矿探幽"是新金陵四十八景之一。公园以矿业遗迹景观为主体，打造出吴王谷、大峡谷、仙人洞、F8断层、窄轨铁路、蒸汽小火车和井下巷道等具有典型特征的旅游景点项目，尤其是窄轨小火车，时速只有20千米，被称为"最慢的小火车"。这里不仅能作为普及地质知识的好教材，也是一部再现矿山开采的经典史料。

Nanjing Yeshan National Mine Park is close to Jinniu Lake Scenic Spot and Guizishan Stone Pillar Forest Scenic Spot. Known as the "No.1 mountain of smelting and casting in China", Yeshan mine has a history of over 3,000 years. Mining Exploration is one of the "48 new scenic spots of Jinling". The park takes the mining relic landscape as the main body, and has created typical tourist attractions such as Wuwang Valley, Grand Canyon, Fairy Cave, F8 Fault, narrow-gauge train, steam train and underground roadway. The most exciting experience is the narrow-gauge train, which only travels at the speed of 20 kilometers per hour, and is called the slowest train. The uniqueness makes it not only a good teaching material of geology, but also a classical record of mining history.

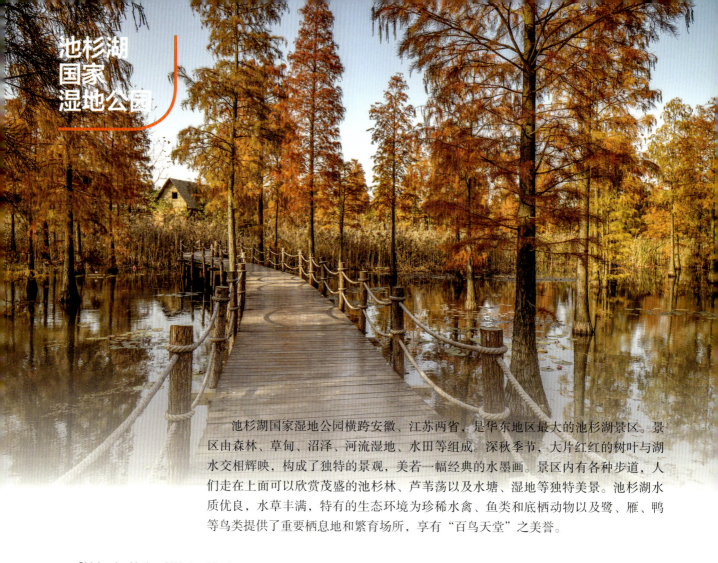

池杉湖
国家
湿地公园

池杉湖国家湿地公园横跨安徽、江苏两省，是华东地区最大的池杉湖景区。景区由森林、草甸、沼泽、河流湿地、水田等组成。深秋季节，大片红红的树叶与湖水交相辉映，构成了独特的景观，美若一幅经典的水墨画。景区内有各种步道，人们走在上面可以欣赏茂盛的池杉林、芦苇荡以及水塘、湿地等独特美景。池杉湖水质优良，水草丰满，特有的生态环境为珍稀水禽、鱼类和底栖动物以及鹭、雁、鸭等鸟类提供了重要栖息地和繁育场所，享有"百鸟天堂"之美誉。

Chishanhu National Wetland Park straddles Jiangsu and Anhui provinces. It is the largest taxodium ascendens pond in East China. The scenic area consists of forests, meadows, marshes, river wetlands, paddy fields, etc. In late autumn, trees are dressed in beautiful colors, and large patches of red leaves are ablaze and reflected in the lake, creating an impressive watercolor. Walking on the different kinds of plank trails and woodland paths, visitors can enjoy the lush taxodium ascendens forests, reed marshes, waterholes and wetlands. With excellent water quality and abundant water plants, the park is also home to rare waterfowls, fish and benthic animals, as well as birds such as herons, geese and wild ducks, making it known as the "paradise of birds".

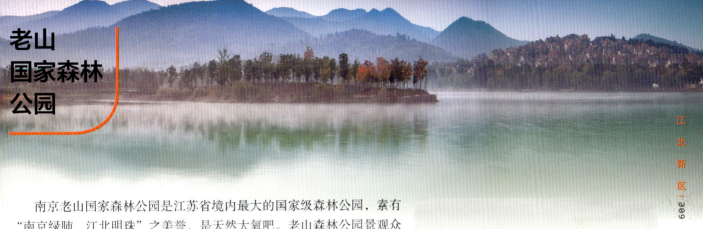

老山国家森林公园

　　南京老山国家森林公园是江苏省境内最大的国家级森林公园，素有"南京绿肺、江北明珠"之美誉，是天然大氧吧。老山森林公园景观众多：自然景观素以"林、泉、石、洞"四绝著称；人文景观也极为丰富，宋代王安石、苏轼、秦观，明太祖朱元璋以及清末李鸿章等历代名人都曾在老山驻足游览。老山野生动物种类丰富，更有穿山甲、河狸、中华虎凤蝶等国家级保护动物。老山还以温泉著名，连绵的温泉景点和山间幽静的步道，每年吸引众多游客到此休闲度假。

　　Laoshan National Forest Park of Nanjing is the largest national forest park in Jiangsu. Known as "Nanjing Green Lung, Jiangbei Pearl", it is also a natural oxygen bar. There are many landscapes in Laoshan Forest Park. The natural landscape is known for "forest, spring, stone and cave", and the culture landscape is extremely abundant. Many famous people in history travelled here, including Wang Anshi, Su Shi, Qin Guan in the Song Dynasty, Zhu Yuanzhang, the first emperor of the Ming Dynasty, and Li Hongzhang of the Qing Dynasty. Laoshan is rich in species of wild animals. Some rare animals like pangolins, beavers and Luehdorfia chinensis Leech are on the list of national protected animals. Laoshan National Forest Park is also famous for its widespread hot springs, together with quiet walkways, which attract tens of thousands of tourists to come for hiking and recreation.

平山森林公园

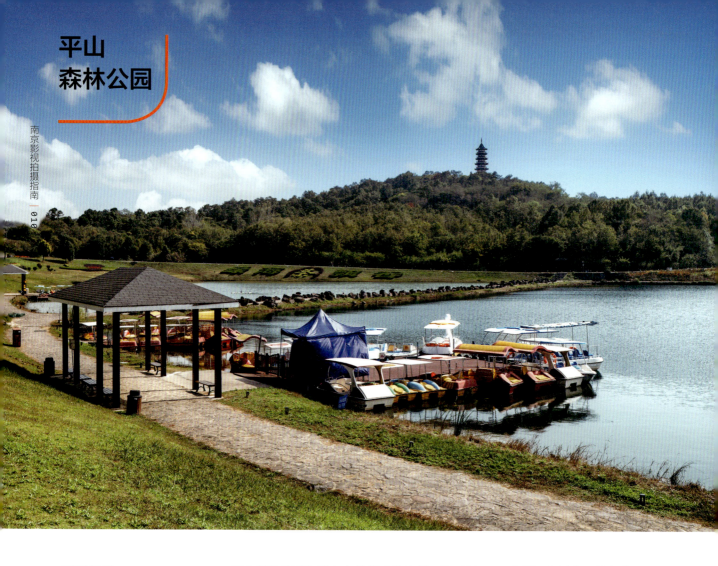

影视作品：
《战狼》

平山森林公园位于六合北部丘陵地带，总面积2 213公顷。公园内山林起伏，山水相连，生态环境良好。景区茶园、花园和松林一望无际，满眼翠绿，被誉为"天然氧吧"。公园还是江苏省首批生态示范教育基地和省级森林公园。园内的平安塔高58米，从塔上俯瞰，可以欣赏山下的水库和漫山的树林茶园。翠茗湖、茉莉花园、樱花谷、双叠湖、情侣园等景点都是度假游览的理想之地。

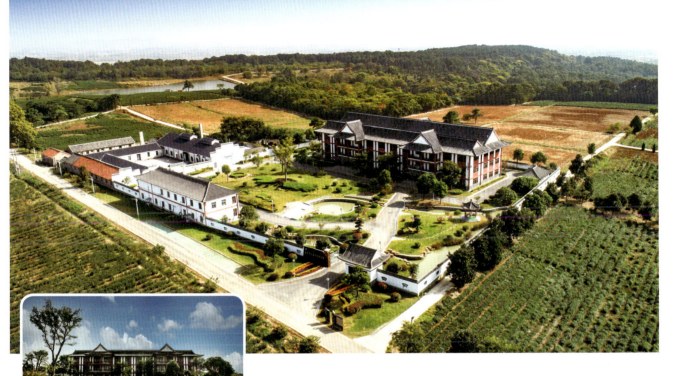

Pingshan Forest Park is located in the northern hilly area of Luhe, with a total area of 2,213 hectares. The park features sunken terrains and slopes, with luxuriant forests, mountains and rivers, enjoying a well-reserved ecological environment. Tea plantations, gardens and pine forests stretch endlessly, making the park a "natural oxygen bar". The park is also the first ecological education demonstration base of Jiangsu Province and provincial forest park. Ping'an Tower is 58 meters high, from where visitors can enjoy the reservoirs below and the tea plantations among the forests. The scenic spots such as Cuiming Lake, Jasmine Garden, Sakura Valley, Shuangdie Lake, Lovers' Garden and so on are all popular holiday attractions.

滨江生态公园

影视作品：
《张卫国的夏天》

　　桥北滨江生态公园位于长江北岸，紧临长江大桥。大片的杉树林、柳树林、芦苇塘和草坪等构成了良好的生态环境。公园内视野开阔，人们可近距离欣赏江景和南京长江大桥的雄姿，也可以远眺江对岸外滩城市风貌。民国时期的轮渡桥遗址似乎在对着滚滚江水默默讲述着昔日的辉煌。长江T台是公园重要的景观之一，由听风之台、港二仓影、T台水梦和杉林剪影等景观构成。这里可以临水感受江风拂面，欣赏花梯美景。晚上时尚动感的音乐喷泉灯光秀与对岸城市的绚丽灯光共同把江水染成流动的调色板。

　　Qiaobei Waterfront Ecological Park stretches along the north bank of the Yangtze River, adjacent to the Yangtze River Bridge. Patches of pine forests, willow trees, reed marshes and lawns, endow a good ecological enviroment. With a broad view, visitors can enjoy the unique waterfront landscape of the Yangtze River closely, admire the charm and glory of the Bridge and overlook the urban view. In the Ferry Bridge Beach Park, there are industrial relics of the Republic of China, peaceful and quiet, as if murmuring to the water about its past prosperity. The T-shaped Platform is comprised of the Platform of Listening to the Wind, Harbor II Warehouse Shadow, T-Stage Water Dream and Fir Forest Silhouette. It is a perfect place where people can enjoy the cool breeze and the beauty of flower terraces while appreciating the modern, dynamic and fashionable lightshow at night, which together with the shining lights of the urban buildings dyes the water into a flowing palette.

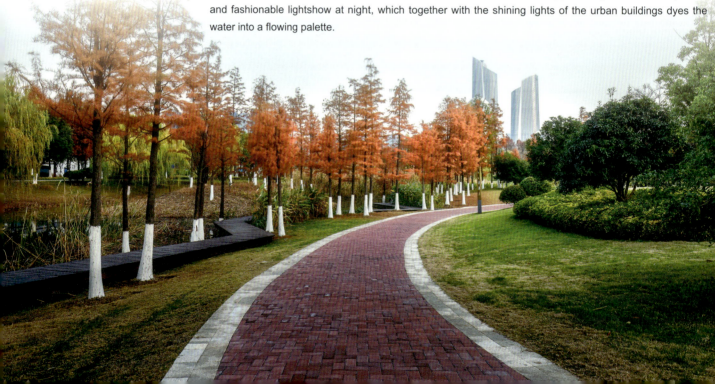

灵岩山风景区

灵岩山是江北地区著名的旅游景点，自古享有"六合第一名山"的美誉。山上有灵岩寺、偃月崖、仙人洞、鹿跑泉、白龙池等人文自然景观。"灵岩积雪"曾是六合八景之一。景区林木茂盛，风景秀丽，山下湖泊清澈明静，映照着竹林茶园。灵岩寺内的观音塑像是江北最大的一尊观音像，高度为11.38米。寺内著名的千年古银杏树枝繁叶茂，树上系着很多红色的许愿丝带，寄托着美好的祝福。景区内还有葡萄园、桃园、梨园等，游客可以在此采摘游览。

Lingyan Mountain is a famous tourist attraction in Jiangbei area and has enjoyed the reputation of "The No.1 Famous Mountain in Luhe" since ancient times. There are many cultural and natural landscapes such as Lingyan Temple, Yanyue Cliff, Xianren Cave, Lupao Spring and White Dragon Pool on the mountain. "Lingyan Snow" was once one of the eight scenic spots in Luhe. The scenic area boasts lush trees and beautiful scenery. The lake at the foot of the mountain is clear and quiet, reflecting the bamboo forests and tea gardens. The statue of Guanyin in Lingyan Temple is the largest one in Jiangbei area, with a height of 11.38 meters. The thousand-year-old ginkgo tree in the temple is still luxuriant with leaves. Countless red ribbons tied on the tree convey good blessings. There are also vineyards, peach gardens, and pear gardens, etc. in the scenic area, and tourists can pick and visit.

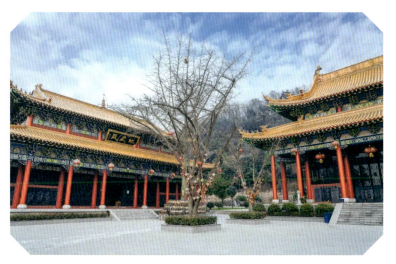

浦口火车站

浦口火车站始建于清光绪三十四年（1908年），被列为中国最文艺的九个火车站之一。火车站为三层砖木结构的老式英式建筑。1914年，浦口火车站正式开通运营；2004年10月，火车站停办客运。浦口火车站的候车大楼、月台、售票房、贵宾楼等主体及配套建筑都被系统性地保存下来。朱自清先生的著名散文《背影》中描述的送别场面就发生在这里。这里还是《情深深雨濛濛》等众多影视作品的取景地，现在已经成为著名的网红打卡地，吸引大批游客到此观光怀旧。

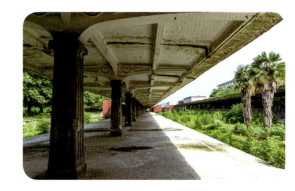

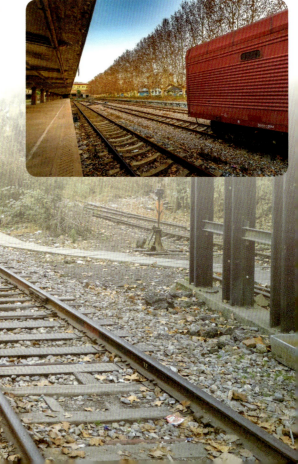

The former site of Pukou Railway Station, known as one of the nine most artistic stations in China, was built in the thirty-fourth year of the reign of Emperor Guangxu, Qing Dynasty (1908). It is an old-fashioned British-style building with a three-storied brick and wooden structure. In 1914, the station was officially put into operation, and was suspended the passenger service in October 2004.The main and supporting buildings of Pukou Railway Station, such as passenger halls, platforms, ticket rooms and VIP building, have been systematically preserved. The famous prose *The Sight of Father's Back* mentioned this old station in the scenario of farewell. This is also the shooting site of some film and television works like *Romance in the Rain*. Now it has become a gathering place of Internet celebrities, attracting a large number of tourists to come here for sightseeing and retrospective memory.

太子山公园

太子山公园总面积21.64公顷,是一个以植物为主的综合性公园,小巧精致却景点丰富。园内太子湖的南岸建有二层"湖南亭"。园中园位于太子湖西畔,内有各色花卉组建的"二龙戏珠"立体花坛和观赏性温室花房。太子阁位于太子山顶,高16.24米,造型美观典雅,周围有紫藤等花木围绕,站在上面可远眺江边美丽的景色。公园内重建的崇福寺历史上颇具规模,久负盛名。园内的梅花、荷花、茶花等在湖水的映照下,与假山、小桥构成宁静宜人的休闲场所。

Taizi Hill Park, with a total area of 21.64 hectares, is a comprehensive park dominated by plants. The park is small but delicate with abundant attractions. The two-storied Hunan Pavilion stands on the south bank of Taizi Lake. Inside the Yuanzhongyuan Garden, which lies on the west bank of Taizi Lake, there is a "two dragons playing with pearls" three-dimensional flower bed and an ornamental greenhouse. The Taizi Pavilion is located on the top of Taizi Hill, 16.24 meters high, beautiful and elegant in shape, surrounded by wisteria and other flowers and trees. Standing on it, you can overlook the beautiful scenery of the river. The reconstructed Chongfu Temple in the park was of great scale and enjoyed a high reputation in history. Under the reflection of the lake, the plum blossoms, lotus and camellias together with rockeries and small bridges, constitute a tranquil and pleasant leisure place.

桃湖公园

桃湖公园靠近丁解水库，是以桃花观赏为主的特色公园。园内桃林处处，中间点缀着各类乔木、灌木和草坪等。"花阶拾趣"可谓一步一景；"飞虹桥"像一条雨后彩虹挂在湖面上；"桃花溪涧"长约180米，溪水清澈见底，缓缓流淌在花丛下；还有"花径探幽""阳光花海"等众多景点点缀园内。公园内生态环境优良，有野鸭、白鹭等鸟类栖息。春季的公园桃红柳绿、鸟语花香。游客走在湖面栈道上，欣赏两侧丰富的水生植物和漫山的桃花，宛如畅游花海，怡然自得。

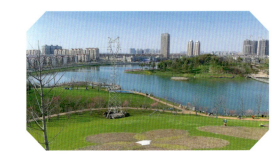

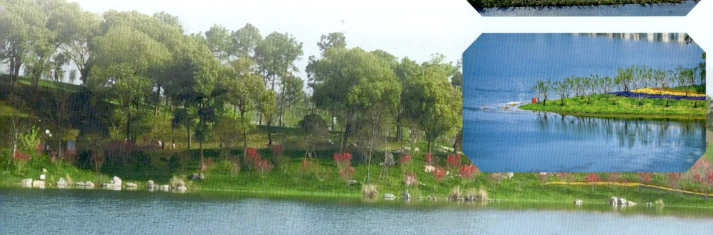

Taohua (Peach) Lake Park, adjacent to Dingjie Reservoir, is a thematic park of peach blossoms viewing. There are peach forests in the park, dotted with trees, shrubs and lawns. "Flower Terrace" changes its views from different angles. "Flying Rainbow Bridge" is like a rainbow hanging above the lake. "Peach Blossom Creek" is about 180 meters long with clear water running under the flowers. There are many other scenic spots, such as "Flower Path Exploration" and "Sunshine Flower Sea". The park owns a good ecological environment and becomes the habitat of wild ducks, egrets and other birds. In spring, with pink flowers and green trees, the park is fantastic and charming. Walking along the walkways on the river, tourists can watch the abundant aquatic plants and peach blossoms on both sides, enjoying the coziness of the beauty.

佛手湖郊野公园

佛手湖郊野公园是珍珠泉景区的一部分。湖边五个半岛像手指一样伸入近千亩湖面，形成奇特景观，因此被形象地称为"佛手湖"。公园充分发挥老山和定山寺的自然、历史文化等资源，以"佛手"和"菩提叶"为灵感，重点打造出翠玉花园、叠石水溪、五色花坡、湿地公园等景观，为游客提供了走进自然、亲近山水的自然环境。花间步道、湖中岛屿和冥想花园等与湖光山色构成了静谧、深邃、旷远的意境。

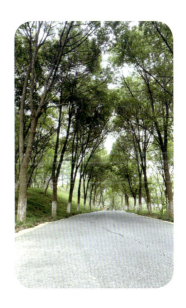

Foshou(Buddha's hand) Lake Country Park is part of the Pearl Spring Scenic Area. The five fingerlike peninsulas stretch into the lake, forming a unique landscape. The park combines natural, historical and cultural resources of Laoshan and Dingshan Temple, inspired by the connotations of "Buddha's hand" and "Bodhi leaves", creating attractions like Emerald Garden, Overlapping Streams, Five-color Flower Slope, Wetland Park and other spots, providing tourists with a natural environment where they can walk into nature and get close to the mountains and rivers. The splendid landscape of the lake and mountains, as well as flower paths and meditation gardens, constitute a tranquil, profound and distant artistic conception.

河岸花海公园

河岸花海公园是位于滁河风光带上的一个花卉主题公园。园内的樱花、薰衣草、马鞭草、月季花和大马士革玫瑰等在不同季节争奇斗艳、五彩缤纷,为美丽乡村增添了生机与活力。公园内河网密布,游客可以尽情泛舟花海。廊桥、彩虹步道、观光小火车等项目深受游客喜爱。"花海拱门"以及"玫瑰之神""玫瑰之约"两个主题雕塑更为公园增添了浪漫与温馨。

Riverbank Flower Park is a flower theme park located on the scenic belt of Chuhe River. The cherry blossoms, lavenders, verbenas, Chinese roses and Damascus roses in the park bloom in profusion in different seasons, adding life and vitality to the beautiful countryside. Many small rivers intersect in the park, providing visitors with a good opportunity to boat in the sea of flowers. Lounge bridges, rainbow footpaths, sightseeing trains and other projects are popular. Two thematic sculptures, "God of Roses" and "Appointment with Roses", together with the "Arch of Flowers" embellish the park, spicing up the romantic and sweet spirit in the park.

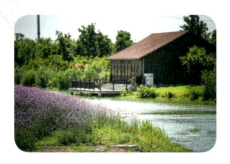

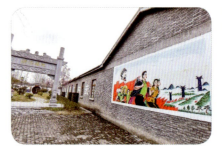

水墨大埝旅游景区

水墨大埝旅游景区位于老山现代文化旅游区的核心区域，山、水、泉、林点缀其间，环境优美。景区在充分发挥当地丰富的自然资源基础上，结合大埝的历史文化积淀以及众多的历史传说、文化典故，以黑白建筑为主色调勾勒出一幅山水画卷，打造出众多的特色文旅项目。九曲水街在整合原住民居基础上注入了简约、时尚的建筑风格，营造出小桥、流水、人家、古庵、古井的优美景观，成为人文气息浓郁、历史积淀深厚又充满文化古韵的特色商业休闲水街。水街中的黎营古井相传距今已有一千多年历史，与千年银杏树共同见证了当地发展的历史。自行车文化是景区一大特色，体验馆规模大、功能齐全、设施完善，还设有户外运动项目。景区现已打造成集亲子游乐、运动休闲旅游、乡村民俗旅游与森林文化体验十一体的山村旅游综合度假区，也成为乡村振兴的典范。

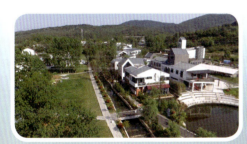

Ink Da Nian tourist area is located in the core area of Laoshan Modern Cultural Tourism Zone. The scenic area boasts its abundant natural tourist resources of green mountains, clear water, hot springs and forests. Giving full play to its numerous historical legends and cultural allusions, integrating natural resources, the scenic area endows a splendid landscape painting with black and white buildings as the main theme, decorated with numerous characteristic cultural and tourism projects. Based on the original local residences, Jiuqu Water Street is infused with simple and fashionable architectural styles, creating a beautiful landscape of bridges, streams, houses, nunnery and ancient well. It has become a characteristic commercial leisure water street with rich cultural atmosphere, profound historical connotation. The Liying ancient well in the water street, which is said to have a history of more than one thousand years, together with the even-aged ginkgo tree, witnesses the history of local development. Bicycle culture is a major feature of the scenic area. The experience hall is large in scale and equipped with perfect facilities. Visitors can also enjoy outdoor sports. So far, the scenic area has become a tourist complex with local features, integrating parent-child entertainment, leisure sports tourism, rural folk tourism and forest cultural experience. It is also regarded as a demonstration model of rural revitalization.

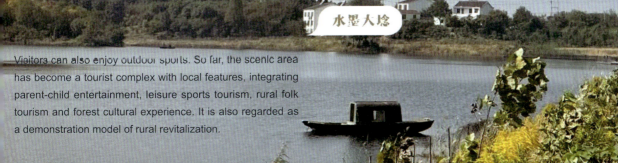

蜂巢酒店

蜂巢酒店位于老山东麓，占地81亩，周围环境优美。酒店主体建筑依照原有的悬崖矿坑等地形，在宕口修复的基础上精心打造出与山体相融相生的独特结构。作为老山生态旅游的重要部分，蜂巢酒店以老山地区知名特产蜂蜜为设计灵感，酒店主体设计成蜂巢状，夜间在灯光映照下宛若浪漫的水晶球点缀在翠墨的群山之中，充满科幻色彩，被称为"外星人基地"，是江北地区的新地标和著名的网红打卡地，众多游客到此体验浪漫、温馨与时尚。

Beehive Hotel is located at the eastern foot of Laoshan Mountain, covering an area of 81 mu. The main building of the hotel is based on the restoration of the cliff pit and other terrain, creating a unique structure that blends in with the mountain. As an important part of Laoshan ecotourism, the hotel draws its inspiration from the well-known specialty of Laoshan Mountain—honey. The main body of the hotel is designed in the shape of a beehive. Under the lights at night, it looks like a shining crystal ball embellished in the green mountains, fantastic and romantic. It is called "the base of aliens" by its fans, making it a new landmark in Jiangbei area and an Internet-famous site, attracting numerous visitors to pursue romance, warmth and fashion.

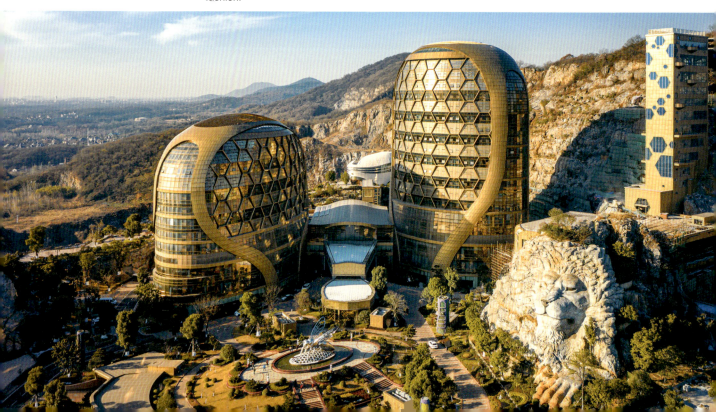

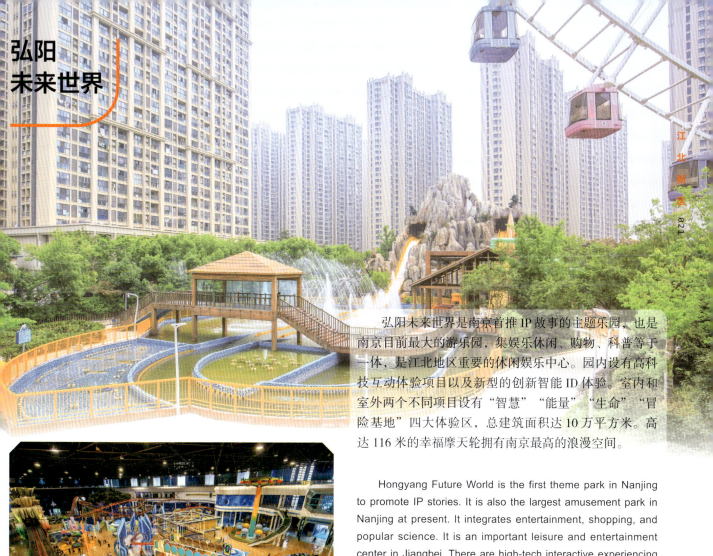

弘阳未来世界

弘阳未来世界是南京首推IP故事的主题乐园，也是南京目前最大的游乐园，集娱乐休闲、购物、科普等于一体，是江北地区重要的休闲娱乐中心。园内设有高科技互动体验项目以及新型的创新智能ID体验。室内和室外两个不同项目设有"智慧""能量""生命""冒险基地"四大体验区，总建筑面积达10万平方米。高达116米的幸福摩天轮拥有南京最高的浪漫空间。

Hongyang Future World is the first theme park in Nanjing to promote IP stories. It is also the largest amusement park in Nanjing at present. It integrates entertainment, shopping, and popular science. It is an important leisure and entertainment center in Jiangbei. There are high-tech interactive experiencing facilities and new innovative intelligent ID experiencing items in the park. There are indoor and outdoor areas, including four experiencing items, namely "Intelligence" "Energy" "Life" and "Adventurous Base", with a total construction area of 100,000 square meters. The park has the highest romantic scenic spot in Nanjing—the 116-meter-high Happiness Ferris Wheel.

华昌龙之谷

华昌龙之谷是一家以新科技体验和高端游乐设备为主的超大型综合类室内主题乐园。园内以热带雨林、沙滩、溶洞、温泉为特色，构建龙谷小镇、奇幻未来、雨林秘境、风暴水世界、龙藏山谷等板块，通过主题化场景，以高科技的手段为游客带来丰富精彩的文化体验。位于园区中心的龙藏山谷是以秦淮风光为主题的文化商业街，珍宝馆、瑶池蟠桃园、溶洞漂流、水幕演艺秀等游览项目引人入胜。

Huachang Dragon Valley is a super-large comprehensive indoor theme park focusing on new technology experience and high-end amusement equipment. The park features tropical rain forests, beaches, karst caves and hot springs, and builds Longgu Town, Fantasy Future, Rainforest Secret Realm, Stormwater World and Longcang Valley. Through themed scenes, it brings rich and wonderful cultural experience to tourists by high-tech means. Located in the center of the park, Longcang Valley is a cultural and commercial street with the theme of Qinhuai style. The tours such as Treasure Hall, Jade Pool Pantao Garden, Karst Cave Rafting and Water Curtain Performance Show are fascinating.

江北龙湖天街

江北龙湖天街是江北区域内单体最大的商业项目,以多元共享的新生活为主题。天街的设计以"海洋、天空、森林"自然景观为灵感,外部用阶梯或栈道从景观和功能上营造亲子互动氛围。室内景观以"漫忆岛""浮梦屿""拾光湾"为主题,以灯光水帘和巨幅屏幕精心打造梦幻般的IP活动场景,为消费者带来奇妙的视觉盛宴和感官体验。室内靓丽的流线造型宛若银河星空般梦幻。蓝精灵宇航员、星空千面蘑菇屋等场景具有高度的趣味性和互动性。

Jiangbei Longfor Paradise Walk is the largest single commercial project in Jiangbei New Area, with the theme of diversified and shared new life. Its design takes the natural inspiration of "sea, sky and forest" with exterior steps or boardwalks to create a parent-child interaction atmosphere. "Manyi Island" "Fumeng Island" and "Shiguang Bay" are the themes of interior design, together with lighted water curtains and huge screens, which meticulously create dreamlike IP activity scenes, bringing a wonderful visual feast and sensory experience to consumers. The beautiful streamline interior style creates an image of galaxy and starry sky. The Smurf Astronauts, Starry Sky Mushroom House and other scenes are highly attractive and interactive.

六合老街

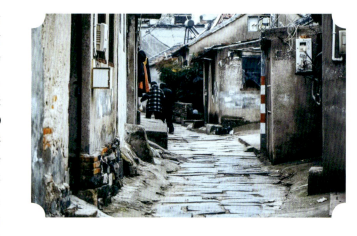

六合古称"棠邑",有着悠久的历史,也是雨花石的故乡。当地许多老街保护完整,具有鲜明的时代特色,其中以冶山老街最具代表性。这条号称"穿越回到40年前的高考"的街道上,供销社、小吃店、照相馆、杂货铺、新华书店、报刊亭等具有时代特征的景点高度还原了二十世纪七八十年代的生活场景。街区建筑具有浓厚的时代气息,《大江大河》等影视作品曾在这里取景。瓜埠老街的青石板路和两边青砖黛瓦的清式建筑以及别具风味的复古灯具无不体现着老街悠久的历史。

Luhe, also called "Tangyi" in ancient times, owns a long history and is also the hometown of Yuhuashi. Many local old streets are under well protection and have distinctive characteristics of the times, among which the Yeshan Old Street is the most representative. It is known as "a street that reflects the college entrance examination dating back to 40 years ago". Some scenic spots with the characteristics of the times such as supply and marketing cooperatives, snack shops, photo shops, groceries, Xinhua Bookstores and newsstands, as well as the old architecture in the blocks clearly reflect the life scenarios in the 1970s and 1980s. It is also the shooting site of many films or TV series, such as *Like a Flowing River*. Another old street, Guabu Old Street, is famous for its old stone pavement and the Qing style buildings with black bricks and tiles on both sides as well as the distinctive retro lamps and lanterns, which express a long history.

六合文庙

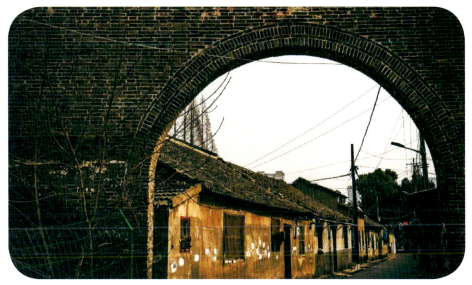

六合文庙始建于唐咸通元年（公元860年），清同治九年（公元1870年）重建，规模宏大，居全国第五。文庙的主体建筑为大成殿、魁星阁、照壁、泮池、灵棂门等，总面积为8 000平方米，是江北地区保存最完整的古代建筑群。庙内雕梁画栋，具有深厚的历史文化底蕴，尤其是魁星阁飞檐三层，斗拱四重，体现了精湛的建筑技艺。六合文庙是六合历史文化的重要体现。

The Luhe Confucius Temple was firstly built in the first year of Xiantong in the Tang Dynasty (860 AD) and rebuilt in the ninth year of Tongzhi in the Qing Dynasty (1870 AD), ranking the fifth largest in China. The main building of the temple is Dacheng Hall, which is a grand building. Other ancient buildings such as Kuixing Pavilion, Screen Wall, Panchi Pool, Lingling Gate are all typical. The temple covers a total area of 8,000 square meters and is the most intact ancient architecture in Jiangbei area. Those carved beams and painted rafters with profound historical and cultural heritage, especially Kuixing Pavilion with three eave rooftops and four bracket sets, express the superb architectural techniques. The Luhe Confucius Temple is an important embodiment of local history and culture.

西埂莲乡

"西埂莲乡"是以农业休闲为主,集莲文化展示、观光、科普等为一体的"美丽乡村"。荷博园是景区的核心,不同水域内种植着不同品种的莲花,成为华东地区规模最大的精品莲荷观赏及科研、科普基地。莲文化馆内介绍莲花的相关知识,游客可以感受莲文化的魅力。每到夏季,万亩荷花竞相绽放,呈现出"接天莲叶无穷碧,映日荷花别样红"的壮美景观。荷塘中间有航道,游客既可以泛舟河上,也可以漫步在木道栈桥上观赏十里荷花胜景。景区还有时光隧道、爱情灯光隧道和荷花仙子雕像等,更增添了浪漫色彩。

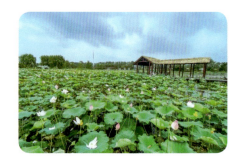

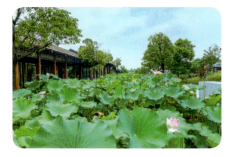

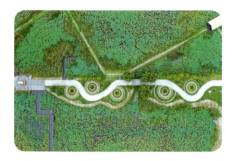

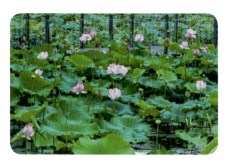

Xigeng Hometown of Lotus is a "beautiful village" featuring agricultural leisure, integrating lotus culture display, sightseeing and science popularization. The Lotus Expo Park is the core of the scenic spot, planting different varieties of lotus flowers in different waters, becoming the largest base of boutique lotus viewing and scientific research and popularization in East China. In the Lotus Cultural Center, visitors can learn the knowledge of lotus and enjoy the charm of lotus culture. In summer, tens of thousands of lotus flowers are in full bloom, presenting poetic scenery of "Green lotus leaves outspread as far as boundless sky. Pink lotus flowers take from sunshine a new dye". Visitors can either go boating in the lotus pond or stroll along the wooden trestles to enjoy the marvelous scenery of lotus. Time Tunnel, Love Light Tunnel and Lotus Fairy Statues decorate the field, presenting more romantic and colorful meanings to the park.

T81 文化科技产业园

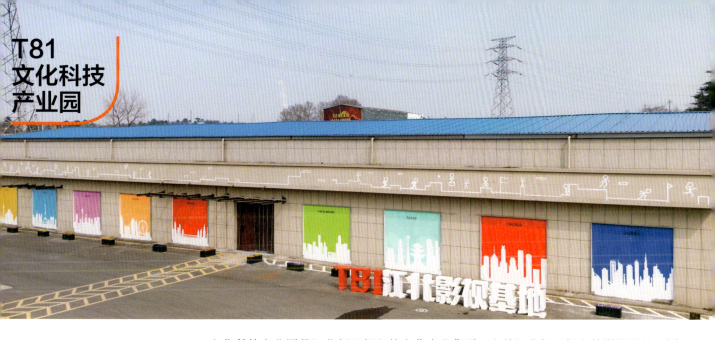

T81文化科技产业园是江北新区新兴的文化产业集群,也是江北新区新兴的影视基地。园区位于江北新区泰冯路81号,占地面积100多亩。园区依托高新技术文化企业优势,以文化创意科技产业为主要业态,搭建平台,引进创意展示、网络游戏、数字动漫、影视等文化企业,着力打造具有鲜明特色、配套完善的影视文化专业产业园。

T81 Cultural and Technological Industry Park, also the film and TV base of Jiangbei New Area, is an emerging cultural industry cluster. The park is located at No. 81 Taifeng Road, covering an area of over 100 mu. Endowed with the advantages of high-tec cultural enterprises, the park takes the creative culture industry as the dominant business format, setting up a platform to introduce quality projects of creative display, online games, digital animation, film and television, and strives to build a professional industrial park of film and television culture with distinctive characteristics and brilliant facilities.

南京云幽谷旅游区

　　南京云幽谷旅游区是国家AAAA级旅游景区、江苏省四星级乡村旅游区，北依老山，南临长江，距南京主城约18公里，占地面积4 000余亩，自然环境十分优美。园区以"科技、文化、生态、休闲"为主题，是一个集休闲度假、生态观光、主题游乐、特色演艺、农业科普、亲子活动、学农实践及拓展培训为一体的特大型生态旅游景区。景区旅游资源丰富多彩，生态景观独具特色，是南京农业特色旅游的新亮点。园内有四季花海、游乐园、农业博览园等景点，还有草莓园、葡萄园等供游客采摘，享受农趣。

Nanjing Yunyougu Tourist Attraction is a national 4A-level tourist attraction and a four-star rural tourism area in Jiangsu Province. It is adjacent to Laoshan in the north and the Yangtze River in the south. It is about 18 kilometers away from the main city of Nanjing and covers an area of more than 4,000 mu. The natural environment is very beautiful. Featuring the theme of "science and technology, culture, ecology and leisure", the park is a super-huge ecotourism attraction integrating leisure and holiday, ecological sightseeing, theme amusement, characteristic performances, agricultural science popularization, parent-child activities and agricultural practice and outreach training. It boasts rich and varied tourism resources and unique ecological landscape, which presents the new luminescent spots of Nanjing special agricultural tourism. There are flower gardens, amusement park and agricultural expo park and other attractions in the park, as well as strawberry fields, vineyards, etc. for tourists to pick and enjoy the fun of farming.

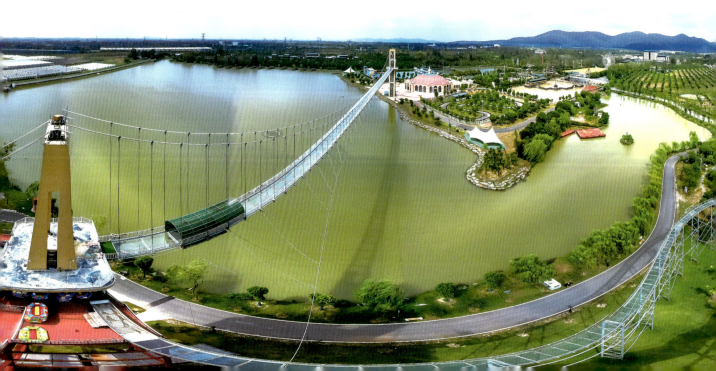

泰山寺

浦口泰山寺于清同治五年（公元1866年）重建，当时只有中殿和后殿，曾经是江北地区佛教圣地之一。寺庙附近有浦口明城墙遗址，民国时期这里曾经非常繁华。泰山庙会就源自此地，并成为当地重要的民间文艺活动，吸引了江北地区，也包括安徽省滁县、和县、来安等地的人们参与表演龙舞、狮子舞、高跷、旱船等民间文艺节目。寺内古木参天，闹中取静，规模较历史上辉煌时期小了很多，犹如隐在都市中的一颗明珠。

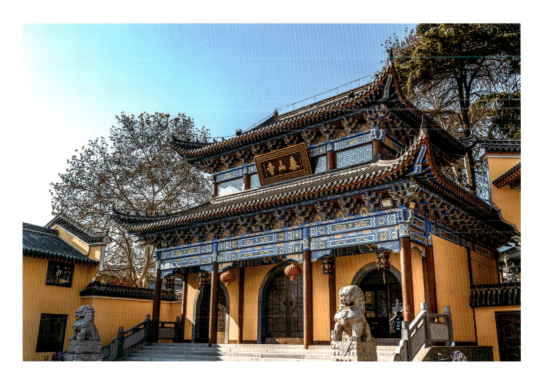

Taishan Temple was rebuilt in the fifth year of the reign of Emperor Tongzhi, Qing Dynasty (1866 A.D.) and there was only a nave and an apse, no front hall at that time. It was once one of the Buddhist resorts in Jiangbei region. Nearby there are relics of Ming City Wall. It used to be very prosperous during the period of the Republic of China. Taishan Temple Fair originated here and made itself an important folk-art activity in local area, attracting people from Jiangbei region, including Chu County, He County and Lai'an County of Anhui Province to participate in folk-art performances like dragon dance, lion dance, stilt walking and land boat dancing, etc. Though much smaller now than that at its peak period in history, Taishan Temple is a somewhat hidden gem, nestled among busy streets with towering old trees.

六合国家地质公园

六合国家地质公园地质地貌奇特，以奇山、秀水、生态和人文景观为代表，既有火山群、石柱林群、雨花石层群三大自然奇观，也有古冶炼场、采矿场遗迹等人文景观。公园内山林掩映，山势不高但十分秀美，以由玄武岩构成的盾火山为主，最高峰海拔 231 米，还有多处幽静的洞穴景观。石柱林是景区的典型景观，高达 40 多米，排列整齐，形状奇特，气势雄伟壮观，是南京新四十景之一。这里还是雨花石最重要的原产地。

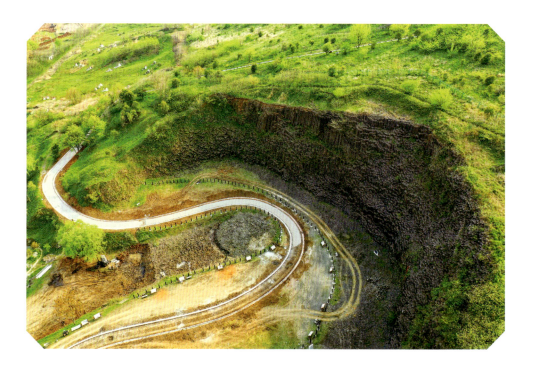

Luhe National Geopark has unique geological and geomorphological features, especially grotesque mountains, clean and bright water, ecological and cultural landscapes. It has three natural wonders, namely volcano groups, stone pillar forest groups and rain flower pebble stone layer groups, as well as cultural landscapes, such as ancient smelting and mining sites. With green lush forests, the mountains are not high but very beautiful, mainly composed of basalt shield volcanoes, with the highest peak of 231 meters above sea level and a number of sequestered caves. Stone pillar forests are typical landscapes with the height of more than 40 meters, orderly shaped, magnificent and marvelous, known as one of the new 40 scenes of Nanjing. The geopark is also the most important original place of rain flower pebbles.

大泉湖

大泉湖位于竹镇旅游区的东南,是六合区内的第三大水库。这里生态环境良好,也是重要的饮用水源地。景区有山岭、湖、小岛和原始生态林以及生态农业观光区等,融生态旅游、疗养度假、休闲运动、特色美食于一体,环境得天独厚,人文资源丰富,山水相映,风景十分秀丽。深秋季节,湖边的池杉树林色彩斑斓,在湖水映照下美不胜收,故被誉为"水上森林"。著名的乡村大舞台是人们举办各类文体活动尽情享受美好生活的地方。

Daquan Lake is located in the southeast of Zhuzhen Tourism Area and is the third largest reservoir in Luhe District. It has a good ecological environment, and it is also an important source of drinking water. The scenic area has mountains, lakes, islands, original ecological forest and ecological agricultural sightseeing area, which integrates ecological tourism, recuperation vacation, leisure sports and characteristic food. It has a unique environment, rich cultural resources and beautiful scenery. In the late autumn season, the pond cedar trees by the lake are colorful, and the red cedar forest is very beautiful under the reflection of the lake, known as the "water forest". There is a grand village stage. People often come here to hold various cultural and sports activities and enjoy a happy life.

止马岭森林公园

止马岭又名"芝麻岭",位于六合区城西北约35公里处,是苏皖两省的界山。其因丰富的野生动物、清新的空气和优美的风景,一直是南京的热门景点之一。这里空气清新、松风阵阵、绿树环绕,生态环境优良,是白鹭等鸟类的理想栖息地。"龙泉寺""广佛寺"遗址使其更具历史性和吸引力。水杉林是公园内的典型景观。秋季和初冬,森林呈现出最绚丽的色彩,宛如童话世界。公园以优质的空气和彭家港水库为依托,是以观光、休闲、保健、疗养、科普、商务活动为主的多功能旅游区。

Located in Luhe District, about 35 kilometers northwest of downtown Luhe, Zhima Ridge, also known as "Sesame Ridge", is the boundary mountain between Jiangsu and Anhui provinces. Because of its abundant wild life, fresh air and beautiful scenery, it has always been one of the popular scenic spots in Nanjing. The air here is fresh, the pine wind is blowing, surrounded by green trees, and the ecological environment is excellent. It is an ideal habitat of egrets and other birds. The ruins of Longquan Temple and Guangfo Temple make it more historic and attractive. Metasequoia forests are the typical scenery in the park. In autumn and early winter, the forests reveal their most brilliant colors, seemingly a world of fairy tales. Based on its high-quality air and Pengjiagang Reservoir, the park is a multi-functional tourism area for sightseeing, recreation, health care, recuperation, science popularization, conferences and business activities.

枫彩漫城

枫彩漫城景区浪漫多彩，宛如五彩调色板。景区功能多样，是观光、森林探秘、快乐休闲、亲近自然的理想之地。这里四季色彩变换，浪漫花海、伊甸园、观花长廊和湖边栈桥等都是热门景点。游客还可以乘坐观光小火车或者皇家马车沿红枫大道欣赏阳光草坪和红伞的奇景。景区秋天的景色更为迷人，红枫大道两边枫叶红艳。人们涌向这里拍照，尽享他们的快乐时光。

Nanjing Fullcolur Garden is like a color palette themed with romance and polychrome, an ideal destination for walking into nature. It consists of different areas with different purposes of sightseeing, forest experience, leisure and entertainment. The colors change in different seasons. The Romantic Sea of Flowers, the Garden of Eden, the long corridor and lakeside plank ways are all popular attractions. Visitors can also take tour trains or the royal carriages along the Red Maple Avenue to appreciate the Sunshine Lawn and the marvelous scene of red umbrellas. The autumn scenery in the scenic area is even more charming, with red maple leaves on both sides of the Red Maple Avenue. People flock here to take photos and enjoy their happy times.

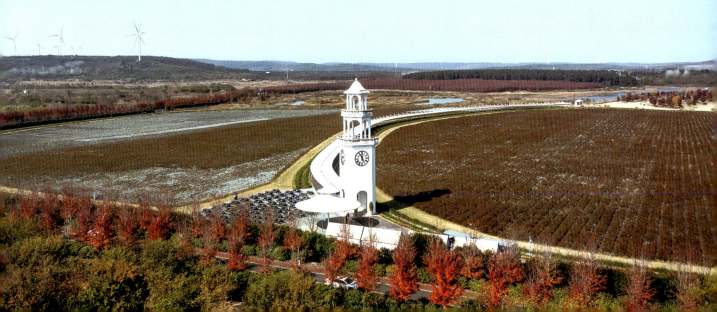

Xuanwu District

紫金山景区

影视作品：
《远方的家》

紫金山又名"钟山"，是江南四大名山之一，著名景点中山陵、明孝陵等都在这里。紫金山主峰海拔448.9米，森林茂密，风光旖旎，集六朝文化、明朝文化、民国文化、山水城林文化、生态休闲文化、佛教文化于一山。紫金山拥有森林面积3万余亩，保留了大量的古树名木，为城市提供了重要的风景资源和生态屏障。春梅花、夏林海、秋桂花及彩叶、冬蜡梅等景观引人入胜。紫金山天文台被誉为"中国现代天文学的摇篮"，依然保存着明清时期的天球仪、浑天仪、地平经纬仪、简仪、日晷等古代天文仪器。

Zijin Mountain, also known as Zhongshan Mountain, is one of the four famous mountains in Jiangnan area with some famous scenic spots and historical sites, such as Dr. Sun Yat-sen's Mausoleum, the Ming Tomb. Its main peak is 448.9 meters above sea level, with dense forests endowing splendid scenery. It is a complex of cultures of the Six Dynasties, the Ming Dynasty, the Republic of China, natural landscape, city and forests, eco-tourism and Buddhism. Zijin Mountain covers a forest area of over 30,000 mu, including many ancient valuable trees, providing an important scenic resource and natural ecological barrier for the city. Plum blossoms, osmanthus, colorful leaves and wintersweet flowers are the features of the four seasons. The Purple Mountain Observatory (PMO) is known as the "cradle of modern astronomy in China" with ancient astronomical facilities and instruments from the Ming and Qing Dynasties, which are still preserved here, including celestial globe, armillary sphere, theodolite horizon, abridged armilla and gnomon.

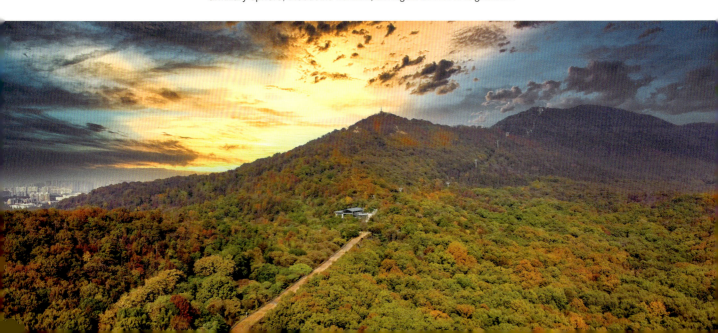

中山陵景区

影视作品：
《乔家的儿女》
《曾少年》

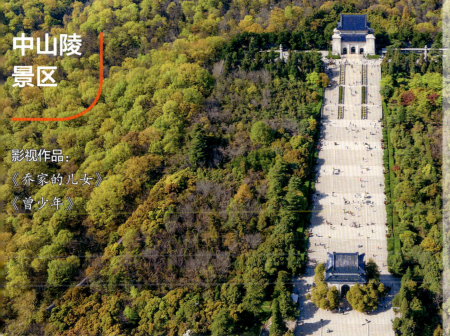

中山陵景区位于紫金山南麓，背靠巍峨山峰，周围林木葱郁，环境优美。陵墓主要由博爱坊、墓道、陵门、碑亭、祭堂和墓室等构成。392级石阶排列在中轴线上，两边对称体现了中国传统建筑的风格。陵门有三道拱门，屋顶覆盖着蓝色琉璃瓦。正门的上方，镶有一方石额，上刻"天下为公"四个大字，是孙中山先生的手书。碑亭建在陵门后面第二层平台上，以花岗岩建造，上覆蓝色琉璃瓦。祭堂外部用花岗岩砌成，门楣上刻着"民族""民生""民权"字样。祭堂中央供奉着孙中山坐像。墓室下面安葬着孙中山的遗体。从空中往下看，中山陵像一座平卧在绿绒毯上的"自由钟"，体现了孙中山先生英勇崇高的品质和做出的巨大贡献。陵墓整体建筑在结构设计、色彩搭配、材料选择和细节处理上都达到了较高的艺术效果，与周围环境高度协调。中西结合、和谐统一的色调更增添了庄严的气氛。中山陵有着极高的艺术价值，被誉为"中国近代建筑史上第一陵"。

Dr. Sun Yat-sen's Mausoleum was built on the south of Zijin Mountain with dense forests, resting against high mountains. From the entrance to the memorial hall there are 392 steps with the layout of symmetrical beauty of traditional Chinese architectural style. Along the way, there is a memorial archway, a tomb avenue, a triple-arch gateway with a roof of blue-glazed tile, on which there is a plaque inscribed with four Chinese characters, "The World Belongs to the Public" in Dr. Sun Yat-sen's own handwriting. Behind it is a pavilion, housing a stele inscribed with the burial date. The memorial hall is built of granite with two-tiered roofs of deep-blue tile. The transoms over the doors are inscribed with "Nationalism", "People's Livelihood" and "Democracy". There is a seated statue of Dr. Sun Yat-sen on a marble base. The coffin and the remains are laid in the coffin chamber. The whole Mausoleum Scenic Area represents an alarm bell as seen from the air, meaning freedom and symbolizing the noble spirit and heroic efforts of Dr. Sun Yat-sen's devotion to the Chinese people. The whole architecture is of great coordination in details of style and colors, in harmony with the surrounding natural landscapes, also with a mixture of Western architectural style and traditional Chinese mausoleum style, which gives a sense of solemn, reverence, firmness and loftiness. It is of great significance of art and is honored as the "No.1 mausoleum in the history of modern Chinese architecture".

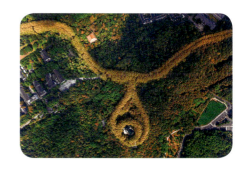

明孝陵景区

影视作品：
《消逝的皇城》

明孝陵位于紫金山南麓，是明太祖朱元璋与其皇后的合葬陵寝。因皇后马氏谥号"孝慈高皇后"，奉行"以孝治天下"，故名"孝陵"。陵墓占地面积170多万平方米，是中国规模最大的帝王陵寝之一。明孝陵始建于明洪武十四年（公元1381年），先后调用军工及劳力10万余人，历时达25年。陵墓建造将人文与自然和谐统一，充分发挥周围环境优势，成为中国传统建筑艺术与环境美学相结合的优秀典范。明孝陵作为中国明清皇陵之首，代表着明朝早期建筑和石雕艺术的最高成就，影响明清两代20多座帝王陵寝的形制，故而有"明清皇家第一陵"的美誉。尽管几经毁坏，"神功圣德碑"及碑亭（四方城）、神道等主要景点依然展示着陵寝当年的宏大规模。

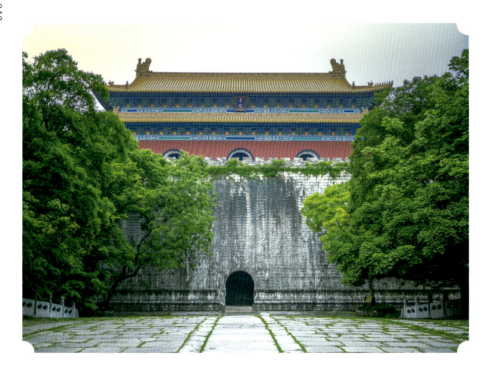

The Ming Tomb is the joint burial tomb of Zhu Yuanzhang, Emperor Taizu of the Ming Dynasty, and his empress. Because Empress Ma's posthumous name was Grand Filial Piety Queen, who pursued governing the world with filial piety, the tomb was also named Xiaoling. Covering an area of more than 1.7 million square meters, it is one of the largest imperial tombs in China. The construction of the tomb began in the 14th year of Hongwu of the Ming Dynasty (1381), and lasted for 25 years, with over 100,000 soldiers and civilians working on it. It took into consideration of the harmony of humanity and nature, and is an excellent model of the combination of traditional Chinese architectural art and environmental aesthetics. As the first imperial tomb of the Ming and Qing Dynasties in China, the Ming Tomb represents the highest achievement of architecture and stone carving art in the early Ming Dynasty. It had a great influence on the following 20 imperial tombs of the Ming and Qing Dynasties. So it has the reputation of the "No.1 imperial tomb of the Ming and Qing Dynasties". Though the tomb was destroyed many times, some remains like the Grand Stele of Merit, Stele Pavilion or Square City and Sacred Way can still express the grandeur in history.

美龄宫

美龄宫位于钟山风景名胜区内的小红山上,又称"小红山官邸",有"远东第一别墅"的美誉。美龄宫始建于1931年,原为国民政府主席的寓所,蒋介石与宋美龄常在此下榻,故称为"美龄宫"。美龄宫周边绿树环绕,环境优美,主体建筑是一座三层宫殿式建筑,外形为明清官式风格,飞檐绿瓦、雕梁画栋、高贵华美,内部设施齐全。从空中望去,美龄宫像一个大的项链,颜色四季变换,美不胜收。

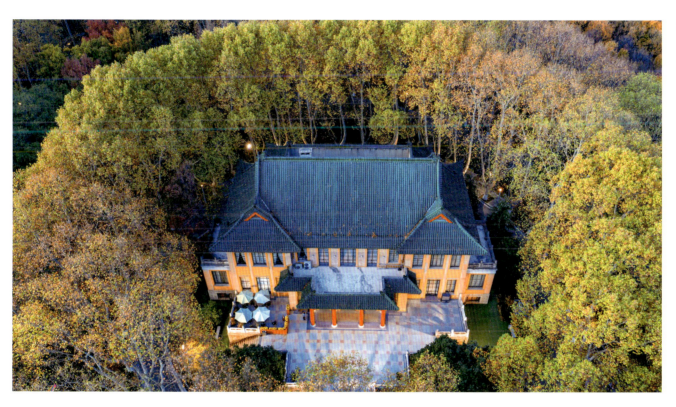

Meiling Palace is located at Xiaohongshan Mountain in Zhongshan Scenic Area, also known as "Xiaohongshan Mansion", and has the reputation of the "No.1 villa in the Far East". Meiling Palace was built in 1931 as the official residence of Chairman of the then Kumintang Government. Chiang Kai-shek and Song Meiling often lived here, so it was called Meiling Palace. Meiling Palace has a beautiful landscape with green trees and fresh air. The main building is a three-storied palatial building with well-equipped facilities. It is in the antique architectural style of Ming and Qing Dynasties, luxurious and glaring with glazed roof, upturned eaves, carved beams and painted rafters. From a bird's eye view, Meiling Palace is like an amazing necklace, changing its colors in different seasons.

中山陵音乐台

中山陵音乐台建于1932—1933年，占地面积约4 200平方米，由关颂声、杨廷宝设计，曾经是纪念孙中山先生的音乐表演及集会演讲的场所。音乐台建筑风格为中西合璧，也采用了中国江南古典园林的表现形式，有精湛雕饰的艺术风范，达到了自然与建筑的和谐统一，是中国20世纪建筑遗产之一。南京森林音乐会每年都在这里举行，成群的白鸽为舞台带来生机和活力，这是南京规模最大、知名度最高的音乐盛会。

Dr. Sun Yat-sen's Mausoleum Music Stage was built from 1932 to 1933, covering an area of about 4,200 square meters. It was designed by Guan Songsheng and Yang Tingbao, two famous architects. It used to be the venue for musical performances and speeches commemorating Dr. Sun Yat-sen. The Music Stage integrates Chinese and Western architectural styles, with the forms of traditional Jiangnan gardens and exquisite carving decoration, achieving a perfect harmony of nature and architecture. Now it is one of China's Architectural Heritage in the 20th Century. The Nanjing Forest Concert is held here every year. Flocks of white doves bring life and vitality to the stage. It is the largest and highest-profile music event in Nanjing.

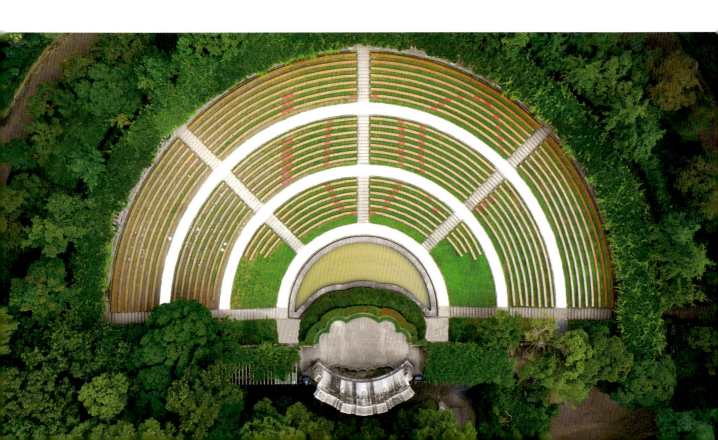

南京中山植物园

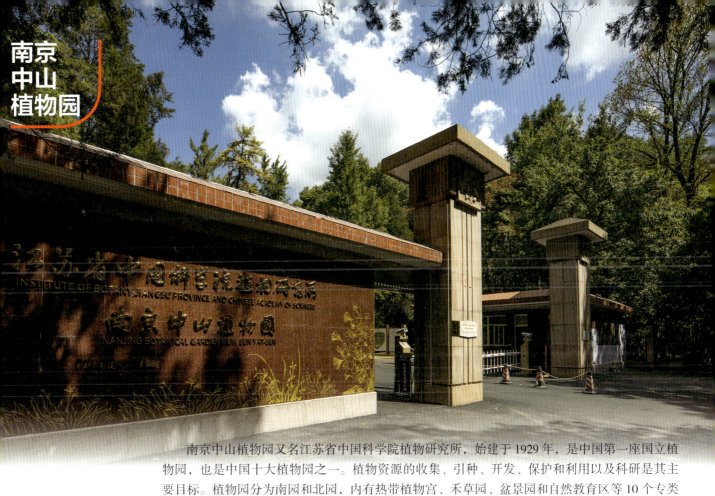

影视作品：
《功勋》

南京中山植物园又名江苏省中国科学院植物研究所，始建于1929年，是中国第一座国立植物园，也是中国十大植物园之一。植物资源的收集、引种、开发、保护和利用以及科研是其主要目标。植物园分为南园和北园，内有热带植物宫、禾草园、盆景园和自然教育区等10个专类园（区），共保存植物3 000多种以及70余万份珍贵的腊叶标本。植物园背靠紫金山，面朝前湖，气候温和，植被茂盛，城墙环绕，既是一个奥妙无穷的植物王国，又是一个独具魅力的旅游胜地。

Nanjing Botanical Garden Mem. Sun Yat-sen, also known as Institute of Botany, Jiangsu Province and Chinese Academy of Sciences, is the first national botanical garden and one of China's ten most important botanical gardens, established in 1929. Collection, introduction, development, utilization and protection of floristic resources are its major targets, as well as scientific research. With two parts, the northern and the southern gardens, the Botanical Garden has 10 specialized gardens such as Tropical Palace, Aquatic Plant Garden, Rock Garden and educational area, displaying over 3,000 species of plants, including more than 700, 000 sheets of herbarium specimens. The garden rests against Zijin Mountain and faces Qian Lake, with mild climate, luxuriant vegetation and city walls. It is both a fascinating scenic spot and a mysterious plant kingdom.

陵园路

陵园路位于紫金山南麓,是通往中山陵的一条园林道路。道路穿越中国著名的风景游览胜地——钟山风景名胜区,沿途植被茂盛,是一条"绿色隧道"。20世纪末,英国女王伊丽莎白二世曾盛赞南京有一条绿色长廊,就是指这条路。陵园路两侧矗立着许多法国梧桐,为民国时期栽种,树木参天蔚为壮观。陵园路颜色四季变换,春季郁郁葱葱,夏季阴凉繁茂,秋季一路金黄,冬季雪满枝头,沿途还串起了美龄宫、海底世界、明孝陵等著名景点,是一条美丽又充满历史故事的景观大道。

Lingyuan Road is a garden road leading to Dr. Sun Yat-sen's Mausoleum, located at the southern foot of Zijin Mountain. The road passes through Zhongshan Scenic Area, a famous scenic spot in China. Lingyuan Road is like a green tunnel. At the end of the 20th century, Queen Elizabeth II of the United Kingdom said with high praise that Nanjing has a Green Corridor, which refers to this road. On both sides of the road stand many tall Phoenix trees which are the characteristic of Nanjing. These trees were planted during the Republic of China, high and spectacular. Along the road, there is Meiling Palace, Underwater World and the Ming Tomb which make it impressive and rich in history. The colors change in the four seasons, lush and green in spring, cool and luxuriant in summer, golden and bright in autumn, white and pure in winter.

石象路

石象路是明孝陵神道的第一段,长615米,沿途依次排列着六种石兽——狮子、獬豸、骆驼、象、麒麟和马,每种两对。其中以象为最大,重达80吨。这些石兽是由整块巨石雕刻而成,线条流畅、造型圆润,展示了宏大的气魄和粗犷的风格。它们不仅仅是石刻,更是静止的生命,既代表着忠诚、圣洁、华美,也有保卫和礼仪的象征。石象路景色优美,尤其是秋天,红、橙、黄、绿,树丛中透出五彩斑斓的色彩,醉美秋色引人入胜。

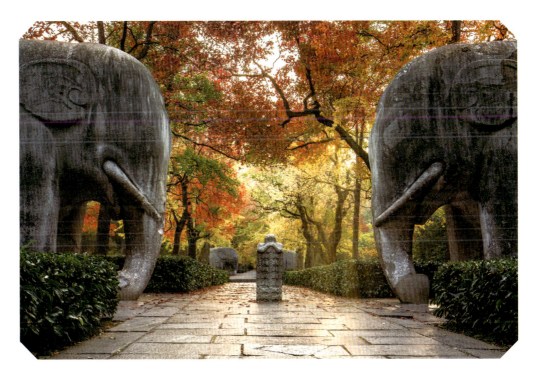

Stone Elephant Road is the first section of the Sacred Way in the Ming Tomb Scenic Area, with a length of 615 meters. The road is lined on both sides with two pairs each of stone lions, xiezhi(a mythical animal in ancient China), camels, elephants, unicorns and horses. The largest one is a stone elephant weighing 80 tons. These stone beasts were carved out of whole stones with exquisite carving techniques, vivid, vigorous in shape and posture. They are more than stone carvings, but still life, showing loyalty, beauty and purity, defense and etiquette. The road is impressive in scenery in autumn dotted with colorful leaves, like a beautiful painting.

南京海底世界

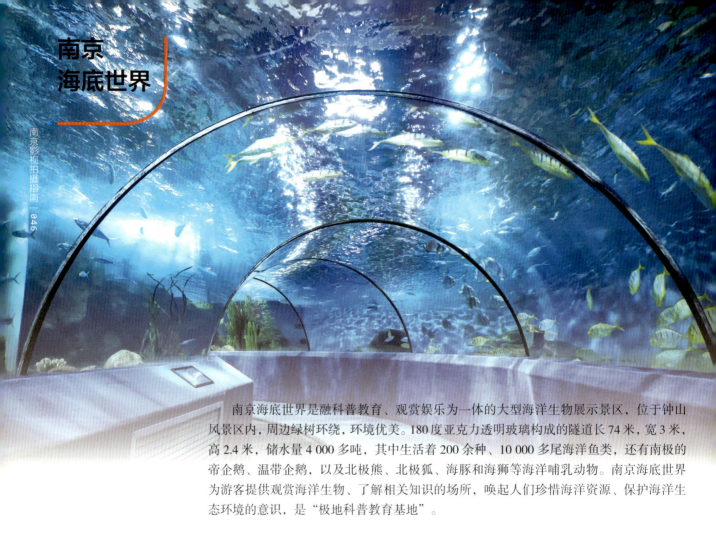

南京海底世界是融科普教育、观赏娱乐为一体的大型海洋生物展示景区,位于钟山风景区内,周边绿树环绕,环境优美。180度亚克力透明玻璃构成的隧道长74米,宽3米,高2.4米,储水量4 000多吨,其中生活着200余种、10 000多尾海洋鱼类,还有南极的帝企鹅、温带企鹅,以及北极熊、北极狐、海豚和海狮等海洋哺乳动物。南京海底世界为游客提供观赏海洋生物、了解相关知识的场所,唤起人们珍惜海洋资源、保护海洋生态环境的意识,是"极地科普教育基地"。

Located in Zhongshan Scenic Area, with lush trees around, Nanjing Underwater World is a large-scale marine life exhibition landscape that integrates science education and entertainment. The tunnel made of 180-degree acrylic transparent glass is 74 meters long, 3 meters wide and 2.4 meters high, with more than 4,000 tones of water storage, in which live more than 10,000 marine fish representing over 200 species, including emperor penguins from the Antarctic, temperate penguins, and marine mammals such as polar bears, Arctic foxes, dolphins and sea lions. Nanjing Underwater World provides visitors with a place to watch marine life and learn about marine-related knowledge, arousing people's awareness of cherishing marine resources and protecting the marine ecological system, thus it has been awarded the title of "Polar Science Education Base".

总统府景区
（中国近代史遗址博物馆）

总统府景区（中国近代史遗址博物馆）是中国近代建筑遗存中规模最大、保存最完整的建筑群，也是南京民国建筑的主要代表之一，至今已有600多年历史。明清时期，这里分别是汉王府和两江总督府。太平天国定都南京后，在此兴建规模宏大的天王府。1912年1月1日，孙中山在这里就任中华民国临时大总统。南京国民政府成立后把这里作为总统府。1949年4月23日，中国人民解放军解放南京攻占总统府。门楼是典型的西式建筑风格，也是总统府的标志性建筑。博物馆分三个区域，真实反映了近代不同时期南京的历史风貌，见证了政权的更替。景区内的"煦园"为江南传统风格，亭台假山倒映水中，里面的"不系舟"石舫也是著名景点。

玄武区

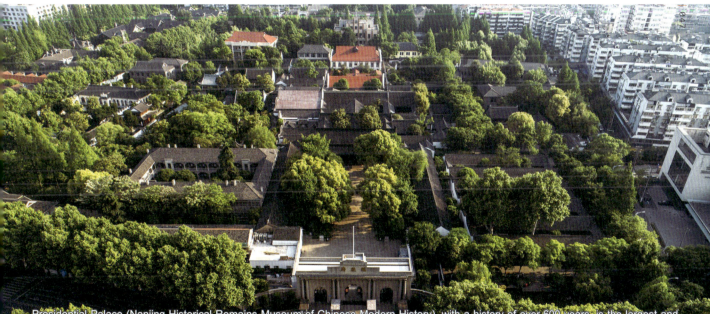

Presidential Palace (Nanjing Historical Remains Museum of Chinese Modern History), with a history of over 600 years, is the largest and best-preserved architectural complex of modern China, also one of the main representatives of the architecture of the Republic of China. In the Ming Dynasty, it was the residence of Prince Han. During the Qing Dynasty, it was the government office of the Liangjiang Governors. The Taiping Heavenly Kingdom later constructed a large-scale Heavenly King's Palace. On January 1, 1912, Dr. Sun Yat-sen swore as Provisional President here. Later, it was the Presidential Palace of the Nanjing National Government. On April 23, 1949, the People's Liberation Army occupied the Presidential Palace. The gate tower is the symbol of the Presidential Palace with a typical Western style. There are three main areas that clearly reflect the true history of Nanjing during different periods in modern times, witnessing the rise and fall of authorities. Xuyuan Garden is of traditional Jiangnan style with pavilions and rockeries reflected in the water. The symbolic building Buxizhou Stone Ship is another famous spot.

民国邮政博物馆

民国邮政博物馆位于中山陵风景区内,原是建于1934年的陵园邮局,1937年被日寇毁坏,1947年重建。博物馆因重檐八角,又被称为"八角亭",采取仿古的琉璃屋顶设计,有着典型的时代特色。它是我国目前唯一以历史时段命名的邮政博物馆,总建筑面积近1 000平方米。博物馆于2013年7月正式对外开放。馆内以历史发展时间为脉络,以典型的信函故事为线索,采取多样化的艺术表现手法,以五个发展阶段集中展现了民国时期的时代背景、邮政特点等。

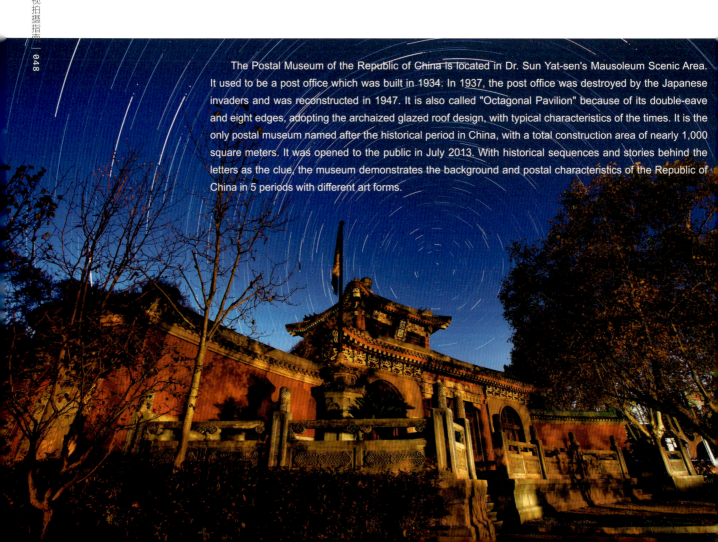

The Postal Museum of the Republic of China is located in Dr. Sun Yat-sen's Mausoleum Scenic Area. It used to be a post office which was built in 1934. In 1937, the post office was destroyed by the Japanese invaders and was reconstructed in 1947. It is also called "Octagonal Pavilion" because of its double-eave and eight edges, adopting the archaized glazed roof design, with typical characteristics of the times. It is the only postal museum named after the historical period in China, with a total construction area of nearly 1,000 square meters. It was opened to the public in July 2013. With historical sequences and stories behind the letters as the clue, the museum demonstrates the background and postal characteristics of the Republic of China in 5 periods with different art forms.

南京博物院

　　南京博物院是我国第一座由国家投资兴建的大型综合类博物馆,1936年动工兴建,由著名的建筑师徐敬直设计、梁思成等人修改而成,此后多次扩建,总建筑面积84 800平方米,展厅面积26 000平方米。南京博物院现拥有各类藏品43万余件(套),跨越历史时间长,从旧石器时代到当代的珍贵藏品都有展示,既有全国性的,又有江苏地域性的,成为数千年中华文明和江苏本地历史发展最为直接的见证。其中,新石器时代"玉串饰"、战国"错金银重络铜壶"、西汉"金兽"、东汉"广陵王玺"、西晋"青瓷神兽尊"、南朝"竹林七贤与荣启期模印砖画"、明代"釉里红岁寒三友纹梅瓶"等为国宝级文物。

Nanjing Museum is China's first large-scale comprehensive museum invested by the state. It was first built in 1936, designed by the famous architect Xu Jingzhi, modified by Liang Sicheng etc., and has been expanded for many times since then. Now it has a total construction area of 84,800 square meters and an exhibition area of 26,000 square meters. Nanjing Museum now has a collection of more than 430,000 historical relics, dating from the Paleolithic Age to the present, both national and regional in Jiangsu. These treasures are also the witnesses of the development of Chinese civilization and the history of Jiangsu for thousands of years. Among them, the Jade Necklace of the Neolithic Age, Gold and Silver Inlaid Copper Pot in the Warring States Period, Gold Beast in the Western Han Dynasty, Seal of Prince of Guangling in the Eastern Han Dynasty, Celadon Zun (Wine Vessel) with Mythological Creature Pattern in the Western Jin Dynasty, Brick Painting of Rong Qiqi and the Seven Sages of the Bamboo Grove in the Southern Dynasty, and Underglazed Red Plum Vase with Design of Pine, Bamboo and Prunus in the Ming Dynasty are national-treasure-level cultural relics.

南京十朝历史文化园

南京十朝历史文化园占地面积350亩,分为展馆区、文化经营区、商务办公区、户外景观区和演艺区等5个区域。展馆区包括南京十朝历史文化展览馆和明孝陵博物馆2个主题馆,以及5个专题馆。园区绿草如茵,风景秀丽,有十朝鼎立、天盛地灵和成语长廊等景点,体现了南京深厚的历史文化底蕴。文化园以十朝历史文化为主题,全面展示了十朝时期的政治、经济和文化发展,也为人们提供了文化休闲的理想场所。

Nanjing Historical and Cultural Park of Ten Dynasties covers an area of 350 mu. It has five areas with different functions, including exhibition area, cultural area, business area, outdoor landscape area and performance area. The exhibition area has two theme halls, namely Nanjing Ten Dynasties History and Culture Exhibition Hall and the Ming Tomb Museum. There are also five special halls. The park is lush with green grass and beautiful scenery. There are scenic spots such as Stone Columns of Ten Dynasties, Tianshengdiling Square and Idiom Corridor, reflecting the profound historical and cultural heritage of Nanjing. With the history of Ten Dynasties as the theme, the park comprehensively displays the political, economic and cultural development of Ten Dynasties, providing an ideal cultural place for leisure and entertainment.

南京图书馆

南京图书馆是南京文化的重要符号之一，前身可追溯到1907年由清朝两江总督端方创办的江南图书馆。截至2017年底，图书馆藏书总量超1 200万册，居全国第三位，其中尤以古籍著名，藏书达160万册。现在，它是江苏省省级公共图书馆，国家一级图书馆。南京图书馆天圆地方的造型简洁流畅又独具特色，寓意智慧与灵感，体现了现代性、城市地标性以及文化性，也体现着独特的文化历史传承。图书馆每层均设有安静且服务完善的阅览室，是市民读书学习的理想场所。

影视作品：
《乔家的儿女》

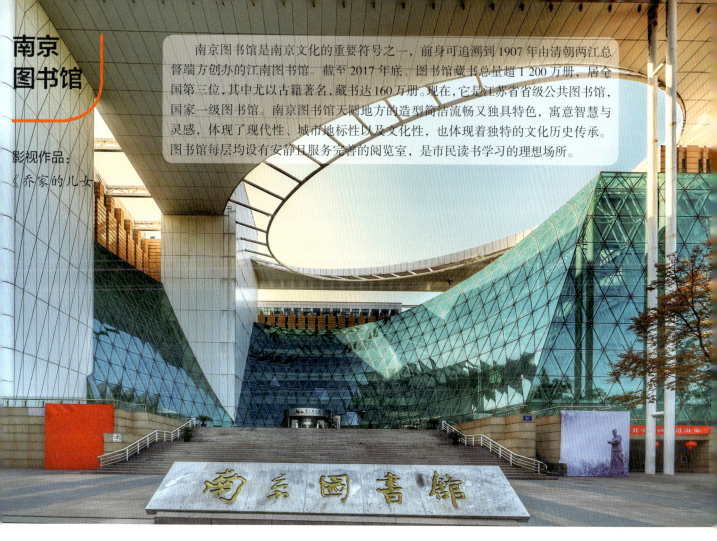

As an important cultural symbol of Nanjing, the history of Nanjing Library can be traced back to 1907, when Duan Fang, governor of Liangjiang in the Qing Dynasty built Jiangnan Library. By the end of 2017, the total amount of the collected books had reached over 12 million volumes, ranking the third in the whole country. Nanjing Library is famous for the historical document collection with 1.6 million volumes of ancient books together. Now, it is Jiangsu provincial public library, as well as one of the first-class libraries in China. The elegant and simple shape of Nanjing Library, with a circle on the top and a square beneath it, expresses the unique cultural and historical heritage, wise and creativity, which is now a landmark of the city. It provides an ideal place for reading and studying with quiet and well-served reading rooms on each floor.

玄武湖公园

影视作品：
《乔家的儿女》
《张卫国的夏天》

玄武湖又称"后湖""北湖"，是江南地区最大的城内公园，被誉为"金陵明珠"。玄武湖公园地理位置优越，人文古迹荟萃，山水城林相融，四季景色美不胜收。各具特色的五块绿洲点缀湖面，相互间有小桥步道连接。环洲因环抱樱洲而得名，素有"环洲烟柳"之称。春季里，樱洲遍布樱花，如烟如纱，有"樱洲花海"的盛景。梁洲有"梁洲秋菊"的美誉。菱洲盛产菱角，环境幽静，自古被誉为"菱洲山岚"。翠洲上杨柳依依，修竹亭亭，雪松如盖，风光幽静。环湖路总长10公里，沿途风光优美，是人们健身锻炼的好地方。

Xuanwu Lake also known as the "Back Lake" or "North Lake", is the largest city park in Jiangnan area, with its rich historical and cultural resources. The park enjoys favorable location and a perfect landscape of mountain, lake, city walls and forests, as well as abundant historical and cultural sites. Known as the "pearl of Jinling", Xuanwu Lake Park has five famous isles with their own characteristics decorating the lake, linked by bridges and walkways. Huan Isle is named for its ring-like shape, surrounding Ying Isle. It looks like a roll of mist or clouds. Therefore, it is reputed as "an isle covered with misty willows". In spring, Ying Isle is covered with cherry flowers, like fire and rosy-clouds, so, Ying Isle is also called "a sea of flowers". Liang Isle is famous for chrysanthemum. Ling Isle is teemed with water chestnuts in old days and is uniquely quiet and secluded. On Cui Isle, there is a dike with tender willows, henon bamboos, green pines and emerald cypresses, making it cool under exuberant foliage. The loop jogging road is 10 kilometers long with abundant scenic spots, offering a good place for exercise.

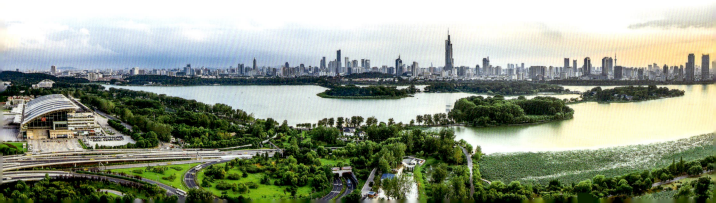

前湖公园

前湖曾是古代南京最大的两个湖泊之一,另一个是玄武湖(也称后湖)。这两个湖以紫金山为界。前湖在南朝时期被称为"燕雀湖"或"太子湖",为金陵名胜。湖的面积不大,幽静中透着灵秀之气。前湖湖畔有一条小堤,上有乌桕树,仿佛一弯月牙落在碧波之中,与周边的芦苇相映成趣。每到深秋时节,湖畔的水杉树林,色彩斑斓,棕色、黄色、红色与绿色绚烂夺目。湖水映照着紫金山,与地上厚厚的树叶一起组成多彩的调色板,展现出一派生机勃勃的秀丽景色。

Qian Lake used to be one of the two largest lakes in ancient Nanjing. The other one is Xuanwu Lake, or Hou Lake. The two lakes are bounded with Zijin Mountain. During the Southern Dynasty, it was called Yanque Lake or Prince Lake, which was a famous scenic spot in Jinling. The lake is small but very peaceful and quiet, with a lakeside dike, on which there are Chinese tallow trees and reeds, like a new moon shining in the lake. In late autumn, the metasequoia forests by the lake are colorful, dazzling in brown, yellow, red and green. The lake reflects the Zijin Mountain forming a colorful palette with the thick leaves on the ground, showing a vibrant and beautiful scenery.

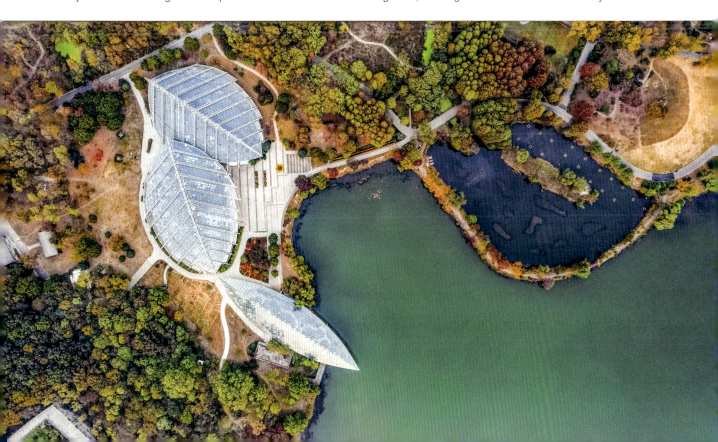

九华山公园

　　九华山公园位于南京太平门内西侧，占地面积12.9万平方米，毗邻玄武湖，遥望紫金山，人文荟萃，是集山、水、城、林为一体的综合性公园，曾是六朝皇家御园。九华山公园内建有玄奘寺，寺内的三藏塔是文物保护单位，为5层楼阁式青砖塔，因塔内葬有唐高僧玄奘顶骨舍利而得名。九华山公园环境幽静，林木参天，鸟语花香，是休闲散步的好去处。

　　Mount Jiuhua Park is located inside the west of Taiping Gate, covering an area of 129,000 square meters. It is adjacent to Xuanwu Lake and faces Zijin Mountain. It is a comprehensive park integrating mountains, rivers, city walls and forests. It was once the imperial garden in the Six Dynasties. Inside the park was built Xuanzang Temple in which there stands Sanzang Pagoda, a Cultural Relic Protection Unit of Nanjing. It is a five-storied black-brick pagoda. It got its name because the famous Monk Xuanzang's parietal relic of the Tang Dynasty is kept inside. Inside the park, there are tall trees and flowers, with birds singing, lending it an atmosphere of tranquil seclusion and making it a perfect place for leisure.

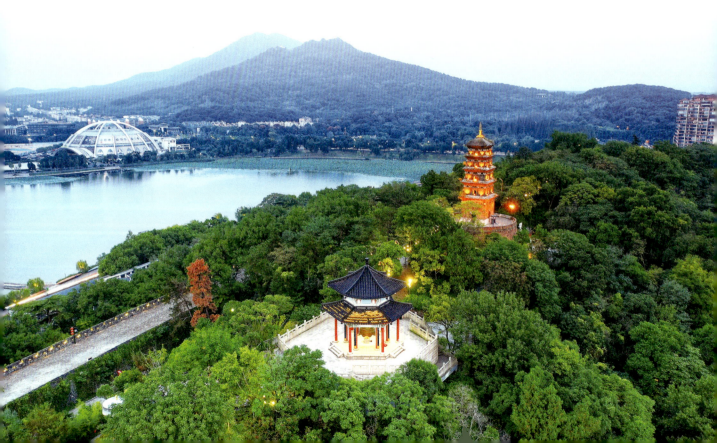

梅花山

梅花山位于紫金山南麓,是钟山风景名胜区的重要组成部分。南京梅花山有"天下第一梅山"之美誉,植梅面积1 533余亩,有近400个品种4万余株梅树。梅花也是南京的市花。梅花之所以吸引人,不仅是因为它的颜色,还有它的雅致和清香。每年二三月份来此赏梅的游人摩肩接踵。从山顶的博爱阁观赏梅花,能看到一片鲜艳的花海,粉红淡雅犹如一片片彩霞。山下有一个精致的小湖。湖水映照着多彩的颜色和湖边挺拔的松树。这里已经成为中国梅文化中心,是"南京国际梅花节"的主会场。

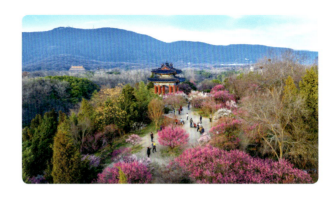

Plum Blossom Hill rests at the southern foot of Zijin Mountain. It is an important part of Zhongshan Scenic Area, known as the "No.1 plum mountain under heaven". The hill covers an area of more than 1,533 mu, with over 40,000 plum trees of nearly 400 species. Plum blossom is also the city flower of Nanjing. Plum blossoms appeal to people, not just for the color but also for their elegant appearance and faint aroma. Plum blossoms reach their peak from February to March each year, in full bloom, attracting millions of tourists to have an outing. There is a pavilion called Boai Pavilion, from where people can enjoy a grand view of flowers, white and rosy like snow and evening glow. The lake at the foot of the hill is small but elegant, with pine trees standing around, reflecting the amazing colors of the hill. Plum Blossom Hill is famous for its unique plum culture and is also the main venue of Nanjing International Plum Blossom Festival.

古鸡鸣寺景区

影视作品：
《新白娘子传奇》

古鸡鸣寺位于鸡笼山东麓，毗邻玄武湖和明城墙，始建于西晋永康元年（公元300年），是南京最古老的梵刹和皇家寺庙之一，自古有"南朝第一寺""南朝四百八十寺之首"的美誉。康熙皇帝南巡时曾到此游览并题写了"古鸡鸣寺"。鸡鸣寺环境幽雅，集山、水、林、寺于一体，有大雄宝殿、药师佛塔、香台等景点，香火旺盛。鸡鸣寺路以樱花著名，每年三、四月份，道路两旁无数樱花绽放，把鸡鸣寺路装扮得格外美丽，使其成为网红景点。

Jiming Temple is located at the eastern foot of Jilong Mountain, adjacent to Xuanwu Lake and Ming City Wall. It was built in the first year of Yongkang in the Western Jin Dynasty (300 AD). It is one of the oldest Buddhist temples and royal temples in Nanjing, reputed as the "No.1 temple in the Southern Dynasty" and ranked the first among the 480 temples in the Southern Dynasty. Emperor Kangxi inscribed the characters "Ancient Jiming Temple" during his southern inspection tour. Jiming Temple is an integration of mountain, water, forest and temple. There is Grand Buddha Hall, Yaoshi Pagoda and Incense Terrace with incense smoke curling up all day. Jimingsi Road is famous for cherry blossoms. In March and April every year, countless cherry blossoms bloom on both sides of the road, making it a popular spot on the Internet.

南京火车站

南京火车站前临玄武湖，后枕小红山，是中国唯一的临湖依山的火车站，"中国十大最美火车站"之一。车站像一艘竖起桅杆、拉满风帆的巨型帆船停泊在玄武湖畔，既具有江南文化特色，又融合现代化时尚建筑风格。站内广布绿植，有"绿色车站"之称。站前广场上有一个大型雕塑《梦舟》，出自著名美术家吴为山之手，抽象的造型像船和流动的水波，既动感又时尚。游客站在这里可以欣赏玄武湖的美景和湖对面林立的高楼大厦，缓解旅途的疲劳。

Nanjing Railway Station faces Xuanwu Lake and backs onto the Xiaohongshan. It is the only railway station in China that is close to the lake and mountain, and is also known as one of the ten most beautiful railway stations in China. Nanjing Railway Station looks like a giant sailing ship with its mast up and full sails moored beside Xuanwu Lake. It not only has the characteristics of Jiangnan culture, but also integrates modern and fashionable architectural style, with a large number of green plants around, becoming a "green station". In the square, there is a large modern sculpture named *Dream Boat*, created by the famous artist Wu Weishan, with an abstract shape of a boat and waves, embodying the dynamic effect of water. Standing at the square, travelers can admire the picturesque scenery of Xuanwu Lake and the marvelous view of the cluster of skyscrapers in the urban area.

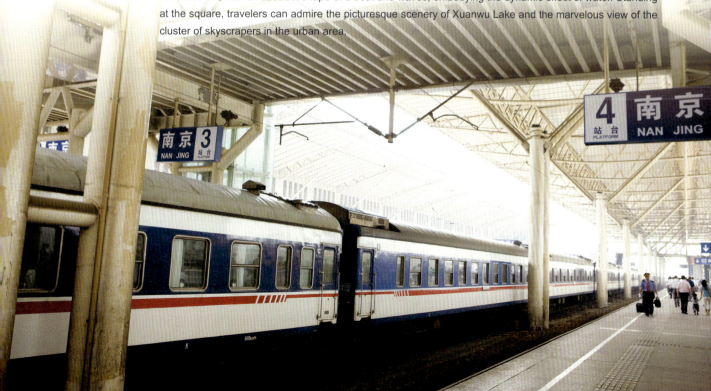

红山森林动物园

影视作品：
《你好，火焰蓝》

南京红山森林动物园总面积68公顷，园内山林幽静，湖泊点缀其间，树木葱郁，绿化覆盖率达85%，展示着世界各地珍稀动物260余种3 000余只。动物园以独特的森林景观、丰富的动物资源、多彩的主题活动成为国内最具特色的动物园之一。动物园集野生动物保护、动物科普教育、科学技术研究及文化娱乐休闲四大职能为一体，同时也是全国野生动物保护科普教育基地、江苏省野生动物救护中心，现在已成为展示江苏省、南京市生态文明的重要窗口。

Nanjing Hongshan Forest Zoo has a total area of 68 hectares. The zoo is surrounded by mountains with lush vegetation and a small lake decorating inside, enjoying a green coverage rate of 85%, displaying more than 3,000 rare animals of over 260 species from all over the world. With its unique forest landscape, abundant animal resources and colorful thematic activities, it has become one of the most distinctive zoos in China. Nanjing Hongshan Forest Zoo has a multi-function of wild animal protection, popular science education, scientific research and leisure and entertainment. Now, the zoo is a national wildlife conservation and popular science education base, Jiangsu Wild Animal Rescue Center. It is a demonstration site of ecological civilization of both Jiangsu and Nanjing.

德基广场

德基广场是一个定位于高端商业的综合购物休闲中心，总建筑面积超过30万平方米，二期主楼高337.5米。广场以综合性商业布局，囊括了奢侈品、高端家电、环球美食中心、IMAX影院和真冰溜冰场等娱乐设施在内的众多业态，其中国际六星级豪华酒店丽思卡尔顿的进驻更为德基广场增添了灿烂华美的篇章。德基美术馆打破艺术、艺术品与大众的空间界限，实现艺术与生活、艺术与商业的紧密连接。走在德基广场，人们享受着与时尚和艺术交流的感觉，拥抱浪漫，释放现代生活的激情。

Deji Plaza is a comprehensive shopping mall targeted at high-end business with a total construction area of over 300,000 square meters and the main building of Phase II is 337.5 meters in height. Deji Plaza has various business operation forms, including luxury goods, high-end household appliances, global food center, IMAX theatre, real-ice rink and other entertainment facilities. The Ritz-Carlton, an international six-star luxury hotel, has added a dash of luster and magnificence to Deji Plaza. Deji Art Museum aims to break the spatial boundaries among art, artworks and the public, establishing a close connection between art and life, art and commerce. Walking in Deji Plaza, people are enjoying the feeling of communicating with fashion and arts, embracing romance and releasing passion of modern life.

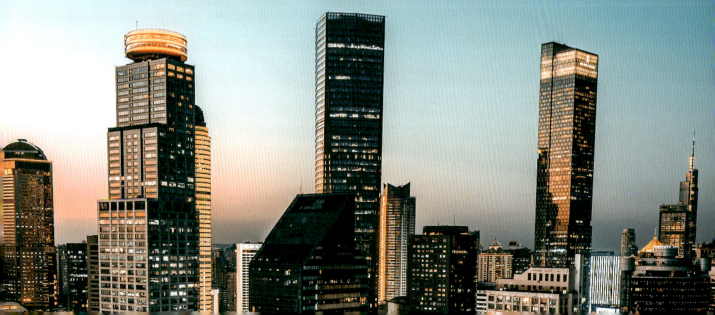

1912街区

　　南京1912街区位于玄武区,是以民国文化为建筑特点的文化商业建筑群,也是南京著名的时尚休闲中心之一。街区集餐饮、娱乐、休闲、观光、聚会等为一体,彰显城市文化、品位和活力。街区由19幢民国风格建筑及共和、博爱、新世纪、太平洋4个街心广场组成,是南京民国建筑和城市旧建筑保护与开发的成功案例,成为南京的现代城市客厅。夜晚的街区灯火阑珊、绚丽多姿,吸引众多时尚的年轻人到此享受现代生活,充分展示了都市的活力与魅力。

　　Nanjing 1912, located in Xuanwu District, is a cultural and commercial building complex characterized by the culture of the Republic of China. It is also one of the famous fashion and leisure centers in Nanjing. The block integrates catering, entertainment, leisure, sightseeing, and gatherings, highlighting urban culture, taste and vitality. There are nineteen buildings with the style of the Republic of China and four street squares, namely, the Republic, Fraternity, New Century and the Pacific. It is now a city hall of Nanjing, and also a successful case of the protection and development of buildings in the Republic of China and urban old buildings. Young people gather here and enjoy a fabulously fashionable lifestyle. The bright lights and flashing neon add a unique charm to the night life of the street, showing the vibrant local culture of Nanjing.

国展中心

南京国际展览中心（简称"国展中心"）坐落于钟灵毓秀的紫金山与风景秀丽的玄武湖之间，紧邻玄武湖隧道和地铁3号线，交通便利，是南京地标性建筑和古城的新名片。国展中心建成于2000年8月，主体造型优美，体现了现代建筑的简约流畅。国展中心占地约12.6万平方米，总建筑面积10.8万平方米，内部设施完善，各类功能齐全，具有高度自动化、智能化特征，对南京乃至江苏的经济和社会发展发挥了极大的推动作用。2020年场馆利用率排名全国第3位。现在，国展中心已经发展成为集展览、会议、商贸、信息产业、娱乐、餐饮、文化等为一体的大型多功能智能化场馆。潮SPACE活力街区、MIBO音乐空间、"ALPHAVILL阿尔法镇"等众多时尚业态的加入更是将国展中心打造成时尚的会展旅游文化综合体。

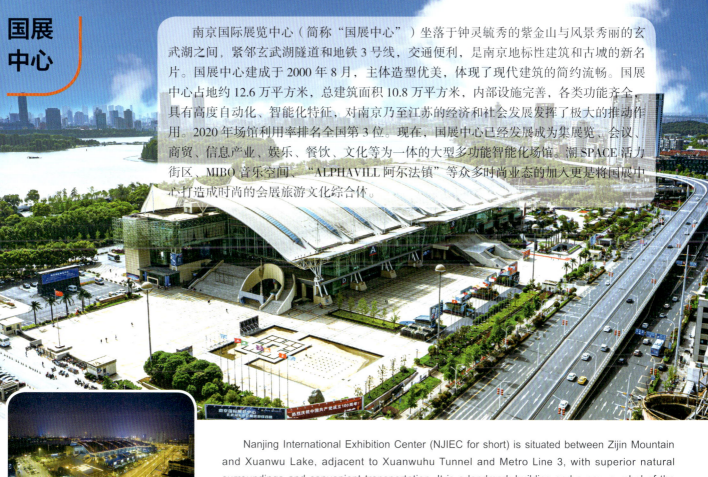

Nanjing International Exhibition Center (NJIEC for short) is situated between Zijin Mountain and Xuanwu Lake, adjacent to Xuanwuhu Tunnel and Metro Line 3, with superior natural surroundings and convenient transportation. It is a landmark building and a new symbol of the ancient city. NJIEC was completed in August 2000, with appealing design reflecting the simplicity of modern architecture. NJIEC covers an area of 126,000 square meters, including a construction area of 108,000 square meters. Due to its complete and perfect facilities, and high degree of automation and intelligence, NJIEC has played a great role in promoting the economic and social development of Nanjing City and even Jiangsu Province. In 2020, its utilization rate ranked third in China. Today, NJIEC has developed into a large multi-functional intelligent venue integrating exhibition, conference, trade and business, IT industry, entertainment, catering, culture, etc. Fashion SPACE Dynamic Block, MIBO Music Room, ALPHAVILL and many other fashion formats have promoted NJIEC into a fashionable exhibition tourism and cultural complex.

Qinhuai District

夫子庙秦淮风光带

夫子庙秦淮风光带以秦淮河和明城墙为纽带，包含了夫子庙古建筑群、内秦淮河以及大报恩寺等主要景观，有多处全国重点文物保护单位和文物古迹。秦淮河是南京文化的发祥地，风光带以儒家思想与科举文化、民俗文化等为内涵，集自然风光、山水园林、庙宇学堂、市井民居、美食购物于一体，不仅是南京历史文化荟萃之地，也是中国最大的传统古街市。古代文人雅士留下了众多关于秦淮河的诗句，其中以唐代诗人杜牧的《夜泊秦淮》最为出名。夫子庙秦淮风光带被国家旅游局列为中国旅游胜地四十佳，夫子庙小吃享誉世界。

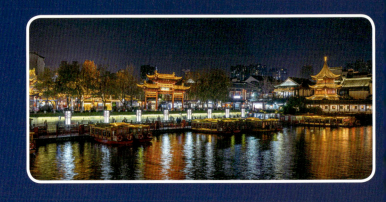

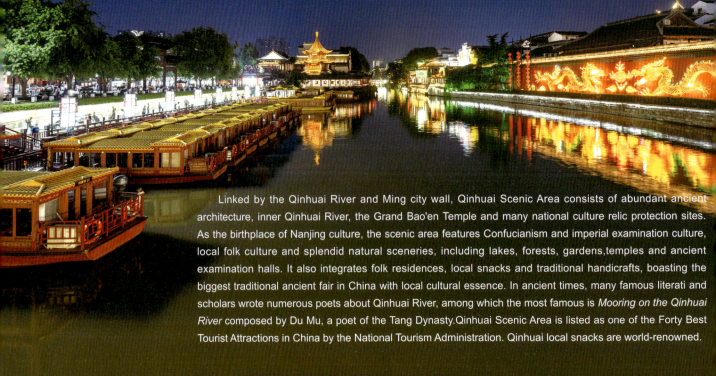

Linked by the Qinhuai River and Ming city wall, Qinhuai Scenic Area consists of abundant ancient architecture, inner Qinhuai River, the Grand Bao'en Temple and many national culture relic protection sites. As the birthplace of Nanjing culture, the scenic area features Confucianism and imperial examination culture, local folk culture and splendid natural sceneries, including lakes, forests, gardens, temples and ancient examination halls. It also integrates folk residences, local snacks and traditional handicrafts, boasting the biggest traditional ancient fair in China with local cultural essence. In ancient times, many famous literati and scholars wrote numerous poets about Qinhuai River, among which the most famous is *Mooring on the Qinhuai River* composed by Du Mu, a poet of the Tang Dynasty. Qinhuai Scenic Area is listed as one of the Forty Best Tourist Attractions in China by the National Tourism Administration. Qinhuai local snacks are world-renowned.

夫子庙

影视作品：
《远方的家》

夫子庙是中国四大文庙之一，在中国文化教育史上有着重要地位。夫子庙也是秦淮风光带的核心景点，始建于东晋咸康三年（公元337年）。夫子庙前秦淮河南岸有九龙照壁，北岸有"天下文枢"牌坊，都是著名景点。大成殿是夫子庙的主要建筑，底座1.5米，高16.22米。展厅内有孔子的铜像以及反映孔子生活的壁画、名人诗歌碑文等。此外，古代礼仪文化展、古乐表演等常年举办。每年元宵节期间的灯会、民俗庙会和纪念孔子的大型歌舞表演等吸引了许多游客。

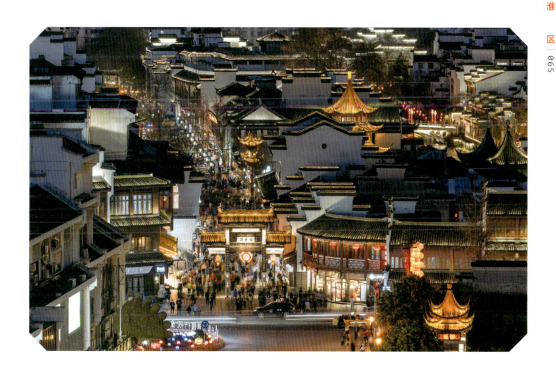

Confucius Temple is one of the four Confucian temples in China and plays an important role in the history of Chinese culture and education. Confucius Temple is also the core scenic spot of the Qinhuai Scenic Belt. It was first built in the 3rd year of Xiankang in the Eastern Jin Dynasty (337 AD). Facing Qinhuai River, with the Spirit Wall of Nine Dragons on the southern bank of the river and the Memorial Archway on the opposite, Dacheng Hall is the main part of the temple which is 16.22 meters high with a 1.5-meter-high pedestal. In the exhibition hall there is a bronze statue of Confucius and some murals and poems and inscriptions of celebrities that reflect Confucius's life. Ancient etiquette culture exhibition and music performances are performed all year round. Every year, during the Lantern Festival, temple fairs are held here with large-scale song and dance performances in memory of Confucius, attracting many tourists.

愚园

作为江南古典园林艺术宝库中的一颗明珠,愚园以水和石为特色,有"城中佳胜眼为疲,聊觉愚园水石奇"的说法。园内环境幽静,竹木秀美,江南风味浓郁。清光绪二年(公元1876年),官员胡恩燮为了侍奉母亲,辞官回家筑园并取名"愚园",以表明其不仕归隐的决心。作为当时南京最大的私家花园,愚园拥有"金陵狮子林"的美誉。铭泽堂、春晖堂等具有深厚的历史文化底蕴。园区着力打造"愚、孝、善、雅"文化,是南京老城南板块的代表性景点之一。

As a pearl in the treasure house of classical garden art in Jiangnan, Yuyuan Garden features water and stones as described in the saying, "Eyes may tire of the great scenery of the city, but will suddenly find the majestic water and stones in Yuyuan Garden enthralling." It is tranquil and delicate in style, with bamboo groves and trees charming and graceful. In the second year of the Reign of Emperor Guangxu in the Qing Dynasty(1876 AD), official Hu Enxie resigned from his position, went home to serve his mother and built a garden named Yuyuan, expressing his determination of resignation. As the largest private garden in Nanjing at that time, Yuyuan Garden enjoys the reputation of "Lion Garden of Jinling". Mingze Hall and Chunhui Hall are of great historical and cultural connotations. The garden is now one of the representative attractions in the southern section of Nanjing's old city, integrating cultural theme of great wisdom, filial piety, kindness and elegance.

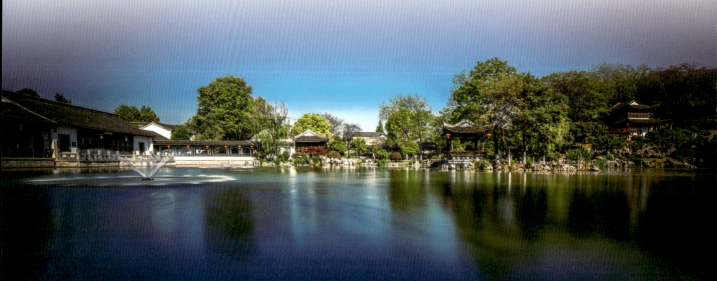

南京中国科举博物馆

南京中国科举博物馆由曾经的"江南贡院"改扩建而成，始建于南宋时期（公元1168年）。后来清朝光绪年间规模不断扩大，成为中国历史上最大的科举考试场所，同时可容纳20 644名考生。历史上的很多文化名人都曾在这里参加科考。如今，江南贡院主要收集、展示与科举考试有关的文物和史料，研究中国科举制度。作为著名旅游景点，这里除了展出文物史料以外，还定期举办一些相关的文化旅游活动，游客可以参与其中，感受古代考生赶考的氛围。

Nanjing Imperial Examination Museum of China was renovated and expanded from the former "Jiangnan Gongyuan". It was built in the Southern Song Dynasty (1168 AD). With constant expansion by Emperor Guangxu of the Qing Dynasty, it became the biggest venue for examinations in China, accommodating 20,044 examinees at the same time. Many famous people in history were directly associated with Jiangnan Gongyuan. Nowadays, Jiangnan Gongyuan mainly collects and displays cultural relics related to the imperial examination, and studies the system of the imperial examination in ancient China. As a famous tourist attraction, it offers a remarkable collection of relics and materials, not to mention daily performances for visitors to enjoy colorful activities, in which they can take part and act as ancient scholars to experience the exam atmosphere.

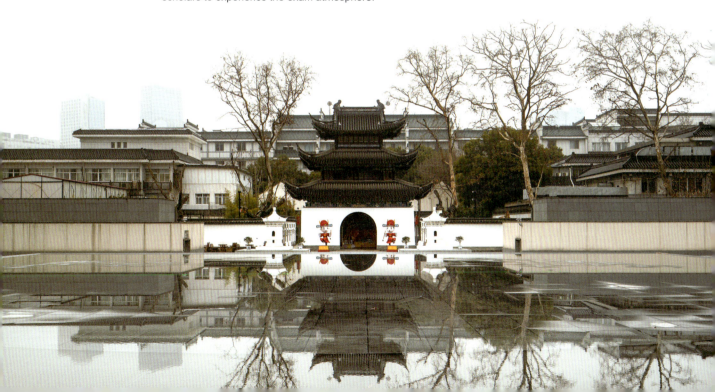

老门东

老门东是南京历史文化街区之一，因位于中华门城堡的东部，所以被称为"门东"。景区保留了大量历史建筑和遗址，也对一些老厂房加以改造，使其成为南京书画院、金陵美术馆、老城南记忆馆以及文创工作室、画廊等。区内17米高的石雕牌坊上面刻着琴棋书画、梅兰竹菊等图案，工艺精美。牌坊两旁有一副楹联，与周边的雕塑一起再现了老门东地区当时的市井生活。如今，这里已经成为集历史、文化、娱乐、观光于一体的文化区，成为南京新的网红打卡地。

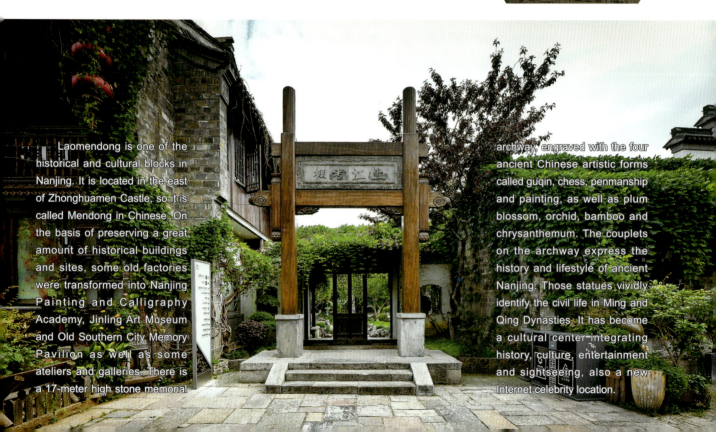

Laomendong is one of the historical and cultural blocks in Nanjing. It is located in the east of Zhonghuamen Castle, so it is called Mendong in Chinese. On the basis of preserving a great amount of historical buildings and sites, some old factories were transformed into Nanjing Painting and Calligraphy Academy, Jinling Art Museum and Old Southern City Memory Pavilion as well as some ateliers and galleries. There is a 17-meter high stone memorial archway, engraved with the four ancient Chinese artistic forms called guqin, chess, penmanship and painting, as well as plum blossom, orchid, bamboo and chrysanthemum. The couplets on the archway express the history and lifestyle of ancient Nanjing. Those statues vividly identify the civil life in Ming and Qing Dynasties. It has become a cultural center integrating history, culture, entertainment and sightseeing, also a new Internet celebrity location.

明城墙

南京明城墙始建于1366年，动用全国28余万民工，使用约3.5亿块城砖，历时28年完成。作为中国古代军事防御设施、城垣建造技术集大成者，南京明城墙具有极高的历史价值、观赏价值和考古价值。现存原京城城墙长35.3公里，是世界上现存最长的砖石构造城市城墙。台城是城墙的一部分，全长253米，站在这里可以欣赏玄武湖和紫金山的美景。优美的景色吸引了古代众多文人墨客到此浏览，也留下了许多脍炙人口的诗句，其中以唐代诗人韦庄的《台城》最为人们所知，也更为这里增添了深厚的历史文化底蕴。现在，明城墙及城门得到了很好的保护，已经成为旅游热点，每年吸引众多游客。

The Ming City Wall was firstly built in 1366. The whole project lasted for 28 years with over 280,000 civilian laborers working on it, using over 350 million city wall bricks. As a master of ancient Chinese military defense facilities, the existing city wall of the ancient capital city stretches 35.3 kilometers, known as the longest masonry city wall of the world. Taicheng is part of the city wall with a length of 253 meters, from which people can enjoy the beautiful view of Xuanwu Lake and Zijin Mountain. In history, many poets and litterateurs paid visit here and wrote many famous poets related to the city wall, among which *Taicheng*, composed by Wei Zhuang, a famous poet of the Tang Dynasty, is the most popular, enriching its historical and cultural connotations. Now, the city wall, as well as its gates is still solid and well-preserved as one of the most famous tourist resorts attracting tens of thousands of visitors every year.

乌衣巷

乌衣巷位于文德桥畔,是著名的古巷,现为以展示六朝文化艺术及王导、谢安家史为主题的纪念馆。这里曾经是东吴御林军的兵营,因为当时驻扎在这里的士兵都穿黑色衣服,所以这条巷被称为"乌衣巷"。六朝时期,这里是朝廷官员和贵族的居住区域,代表人物王导、谢安两大家族都曾住在这里。乌衣巷古色古香,以来燕堂和《竹林七贤图》壁画等为当今最著名的景点。唐代著名诗人刘禹锡曾写下《乌衣巷》,留下了千古名句"旧时王谢堂前燕,飞入寻常百姓家",抒发了自己对世事沧桑变化的感慨。

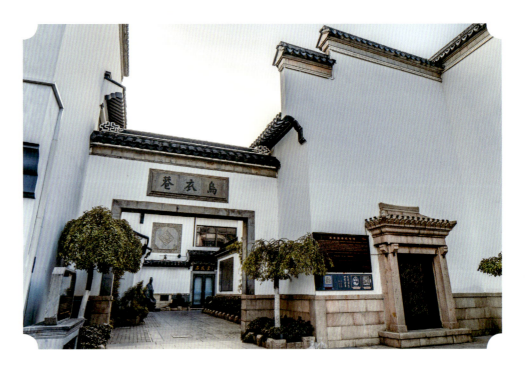

Wuyi Lane is a famous ancient lane adjacent to Wende Bridge. Now it is a memorial hall with the theme of displaying the culture and art of the Six Dynasties as well as the family stories of Wang Dao and Xie An. This venue was the barrack of imperial guards of the Eastern Wu. All the soldiers stationed here wore black uniforms at that time, so this lane was named Wuyi Lane (lane of black clothes). During the Six Dynasties, it was the residence area for court officials and nobles. Wang Dao and Xie An, representatives of two prestigious noble families in the Six Dynasties, lived here for many years and had great influences. The lane is elegant and traditional with the most famous scenic spots today, such as Laiyan Hall and the mural of *Seven Sages of the Bamboo Grove*. Liu Yuxi, a noted poet of the Tang Dynasty, composed a poem which lasts for centuries, "Swallows that nested in front of the halls of the Wangs and Xies in the past have now flown into the houses of the ordinary folks", expressing his strong feelings of vicissitudes of history.

江苏网络文学谷

江苏网络文学谷成立于2018年7月，是由江苏省委宣传部授牌，江苏省作家协会、南京市委宣传部与中国传媒大学、三江学院等多家单位联合共建的国家级文化产业试验园区的子园区。文学谷以原创网络文学精品为源头，以IP版权转化为纽带，打造了集网络文学创作、网文影视转化、游戏、动漫、出版、舞台演艺、移动阅读、有声读物、周边产品开发等文、艺、娱一体的IP全产业链园区。文学谷项目有赏心亭、孙楚酒楼、金沙井等，签约注册企业38家，引进知名作家23名，注册名人工作室7个。园区入驻企业及网文作家原创网文作品66 485部，作品多次荣获网络文学领域重要奖项，实现了高产高质量的发展。

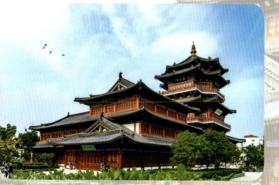

Jiangsu Network Literature Valley was founded in July 2018. As a sub-park of National Cultural Industry Experimental Park officially authorized by Jiangsu Provincial Propaganda Department, and jointly built by Jiangsu Provincial Writers' Association, Nanjing Municipal Propaganda Department, Communication University of China and Sanjiang University, the Valley is an integration of IP business, combining original online literature, IP copyright conversion, online literature creation, online film and television transformation, games, animation, publishing, performance, online reading, audio books and other cultural products as well as art and entertainment. Shangxin Pavilion, Sun Chu Restaurant and Jinshajing are popular attractions in the Valley. So far, a total of 38 enterprises, 23 famous writers and 7 studios have registered with 66,485 original works created by enterprises and writers in the Valley, which have won many important awards.

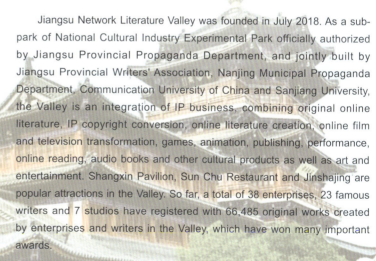

中华门

中华门原名"聚宝门",曾是南唐都城的南门,明朝洪武年间扩建,1931年改名为中华门,是中国现存规模最大的城门,也是世界上保存最完好、结构最复杂、规模最大的堡垒瓮城,享有"天下第一瓮城"的美誉。中华门东西宽118.5米,南北长128米,占地面积15 168平方米,共设3座瓮城,由4道券门贯通。首道城门高21.45米。主城门分为3层,共有27个藏兵洞,可以藏兵3 000余人。中华门具有较高的历史文化价值和建筑价值,体现了古代建筑的精湛工艺,是全国重点文物保护单位。

影视作品:
《乔家的儿女》
《消逝的皇城》

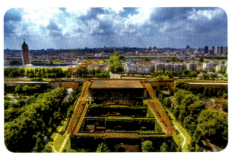

Zhonghua City-Gate, originally named "Gathering-Treasure City-Gate", was renamed in 1931. It was the southern city-gate of the capital of the Southern Tang Dynasty, and was expanded during the Ming Dynasty. It is now the largest ancient city-gate in China, as well as the best-preserved and most complex citadel of the largest scale, known as the "No.1 citadel in the world". Zhonghua City-Gate is 118.5 meters wide from east to west, stretching 128 meters from north to south, covering an area of 15,168 square meters. There are 3 citadels connected by 4 doors, with 27 caves that can hold as many as 3,000 soldiers. The first gate is 21.45 meters high. Zhonghua City-Gate is of great significance in history, culture and architecture, showing the exquisite techniques of ancient architecture, and is a national key cultural relic protection unit.

中华门火车站

中华门火车站始建于1935年,曾经是南京三大火车站之一,也是当时南京唯一的民营火车站,于2014年10月14日停止客运业务。这里曾经是"中国最繁忙的单线铁路"——宁芜铁路,每天有近百趟列车往返,是当时江苏与安徽之间重要的交通纽带。现在,中华门火车站已经成为历史,车站的遗存依然承载着当年辉煌的历史,清晰地记录着往日的繁华。

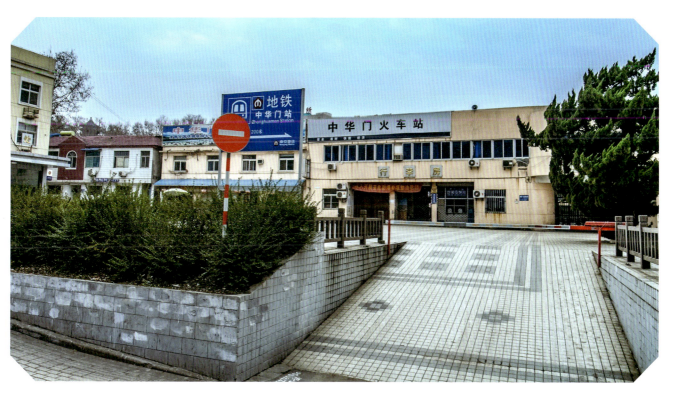

Zhonghuamen Railway Station was initiated in 1935 and went out of service on October 14, 2014. It was once one of the three major railway stations in Nanjing and the only privately-run railway. It used to be the busiest single-track railway in China, connecting Nanjing and Wuhu, with nearly 100 trains shuttling every day which made it the vital communicative line between Jiangsu and Anhui. Now, the remains still reflect the glorious history of transportation and record the prosperity of the past.

朝天宫

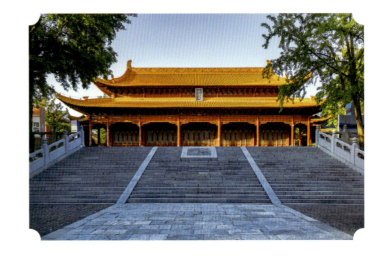

春秋时期,朝天宫就是南京最早的城邑"冶城",吴王夫差曾在这里铸剑。朝天宫也是江南地区现存建筑中等级最高、规模最大、保存最为完整的明清官式古建筑群,有"金陵第一胜迹"之美誉。明朝朱元璋把这里命名为"朝天宫"。李白等历代众多文人都曾到此游览并留下诗句。这里的建筑格局和样式、营造技术等是研究中国古代建筑尤其是明清建筑的重要实物资料,具有极高的历史、艺术和科学文化价值。朝天宫内竹林幽幽,古木参天。"万仞宫墙"、棂星门等都是游客拍照的好去处。

During the Spring and Autumn Period, the earliest city of Nanjing, Yecheng appeared in Chaotian Palace. The King of Wu Kingdom used to cast sword here. It is the largest, the highest level and the most intactly preserved Ming and Qing official style ancient buildings in Jiangnan area and is known as the "No.1 Scenic spot of Jinling". The name of the palace is an imperial grant of the first Ming Emperor Zhu Yuanzhang. Many famous litterateurs or poets such as Li Bai once visited here and composed poems. Its architectural patterns and styles, construction techniques are important for the study of ancient Chinese architecture, especially the architecture of the Ming and Qing Dynasties, and have high historical, artistic and scientific cultural value. With densely planted bamboo forests and towering ancient trees, the famous Palace Walls, Lingxing Gate are popular for tourists to take photos.

大报恩寺遗址公园

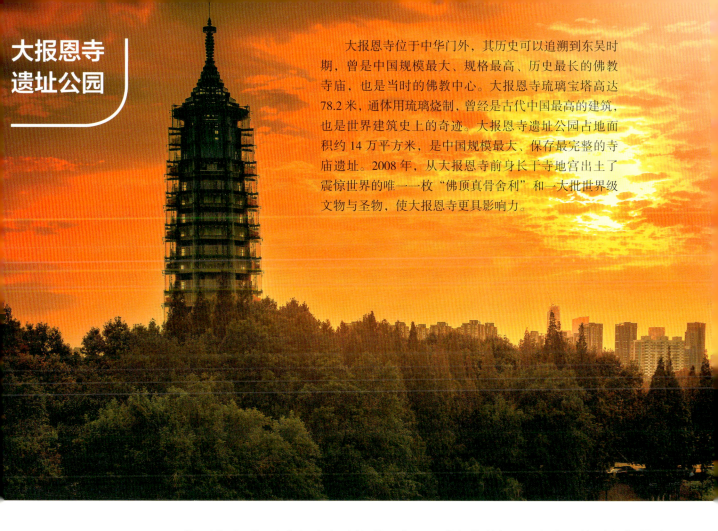

大报恩寺位于中华门外，其历史可以追溯到东吴时期，曾是中国规模最大、规格最高、历史最长的佛教寺庙，也是当时的佛教中心。大报恩寺琉璃宝塔高达78.2米，通体用琉璃烧制，曾经是古代中国最高的建筑，也是世界建筑史上的奇迹。大报恩寺遗址公园占地面积约14万平方米，是中国规模最大、保存最完整的寺庙遗址。2008年，从大报恩寺前身长干寺地宫出土了震惊世界的唯一一枚"佛顶真骨舍利"和一大批世界级文物与圣物，使大报恩寺更具影响力。

Grand Bao'en Temple is located outside Zhonghuamen Gate. Its history can be traced back to the Eastern Wu Dynasty. It was once the largest Buddhist temple in China, with the highest standard and the longest history, also the center of Buddhism. The Porcelain Tower is 78.2 meters high. It is a glazed pagoda and was once the tallest building in China and a wonder in the history of world architecture. Grand Bao'en Temple Heritage Park covers an area of 140,000 square meters and is the largest and best-preserved temple site in China. In 2008, the world's only real Buddha Usnisa and a large number of other world-class cultural and sacred relics were unearthed from the underground palace of Changgan Temple, the former site of Grand Bao'en Temple, which surprised the world, making the temple even more influential.

白鹭洲公园

白鹭洲公园是秦淮风光带上的一颗璀璨明珠,以山、湖、城、林等自然景观和独特的人文资源为特色,集观赏、娱乐、互动于一体,体现了生态、人文、历史、文化的和谐。公园以自然山水风光为主,水面上各具特色的桥形成独特风景。"春水垂杨""辛夷挺秀""红杏试雨""夭桃吐艳"被称为公园的四大春景。

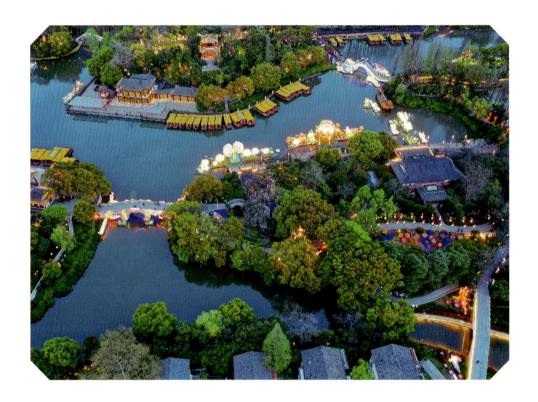

Bailuzhou Park is a bright pearl on the Qinhuai scenic belt, featuring mountains, lakes, cities, forests and other natural landscapes as well as unique cultural resources, which integrates viewing, entertainment and interaction, and embodies the harmony of ecology, humanity, history and culture. The park is famous for its natural landscape, which is also the main character with many bridges of various kinds of design. Weeping willows over the lake, charming flower-buds of lily magnolia, red apricots in rain and gorgeous peaches are known as the Four Scenic Spots of Bailuzhou Park in spring.

瞻园

瞻园始建于明朝初年,距今已有600多年的历史。清朝乾隆皇帝巡视江南地区时曾在此留宿,并御题"瞻园"匾额。景区由瞻园和太平天国历史博物馆组成。瞻园以山为主、水为辅。园内池塘迷人,来自太湖的假山是全园的主要景点,共有南、北、西三座。瞻园是"江南四大名园"之一,也是南京历史最久的一座园林。

Zhanyuan Garden was built in the early Ming Dynasty with a history of over 600 years. On his inspection tour to Jiangnan area, Emperor Qianlong of the Qing Dynasty once stayed in this garden and named it Zhanyuan Garden. It is composed of Zhanyuan Garden and the Museum on the History of the Taiping Heavenly Kingdom. Zhanyuan Garden features rockeries which are the dominant scenery with water complementary. With spacious halls and charming ponds, Zhanyuan Garden is particularly famous for its rockeries from Taihu Lake. There are three rockeries, namely Southern Rockery, Northern Rockery and Western Rockery. It is one of the "four famous gardens in Jiangnan" and also the oldest garden in Nanjing.

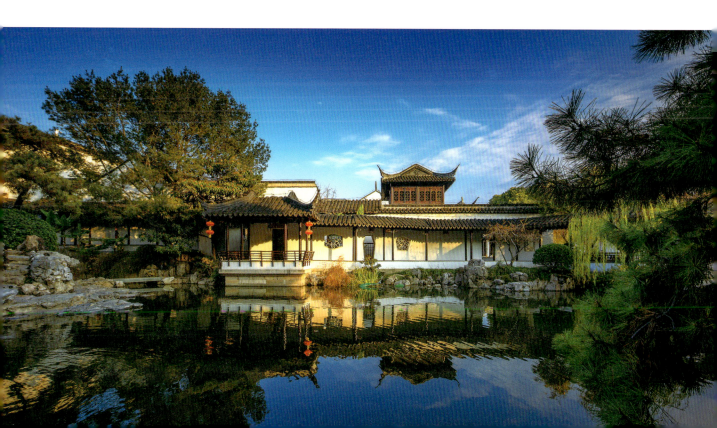

南京国家领军人才创业园

南京国家领军人才创业园位于江南铸造银元制钱总局旧址。1896年，江南铸造银元制钱总局在这里设立，开启了近代中国工业文明的道路。1959年，这里成为南京第二机床厂，是新中国工业发展的见证。2012年3月，南京国家领军人才创业园成立，以文化创意、设计服务、科技创新为基本业态。40多栋二十世纪五六十年代的老厂房被保留。随处可见的烟囱、构架、老车床等工业遗存带来清晰的历史记忆和怀旧风格，也常常能激发企业家们的创意灵感。

影视作品：
《追爱家族》

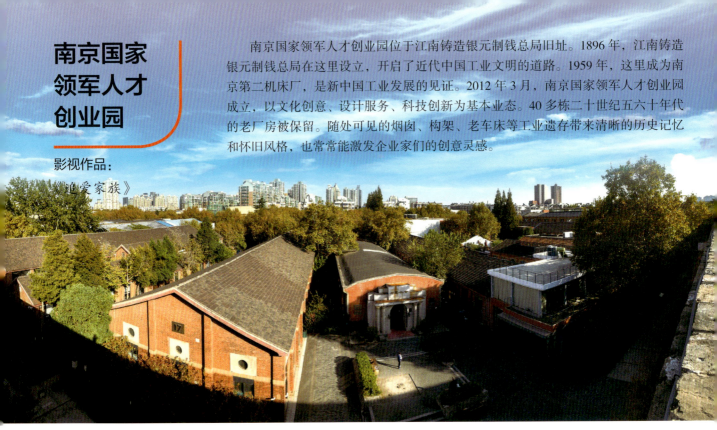

The National Innovative Park for the Entrepreneurial Leaders is located at the former site of Jiangnan Silver Dollar Making Bureau, which was established in 1896, initiating modern China's industry. In 1959, it became the Second Machine Tool Plant of Nanjing, a witness of the industrial development of new China. In March 2012, the National Innovative Park for the Entrepreneurial Leaders was established, with cultural creativity, design service and scientific and technological innovation as the basic industrial format. More than 40 old workshops from the 1950s and 1960s are all well preserved. Walking in the park, the industrial heritages are ubiquitous, such as chimneys, frames and old lathes. The clear memory of history and nostalgic style can often motivate the creative inspiration of enterpreneurs.

晨光1865科技创意产业园

 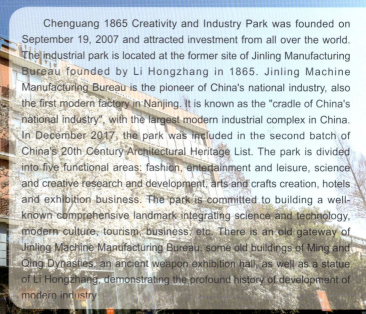

晨光1865科技创意产业园创办于2007年9月19日，吸引了来自世界各地的投资。产业园所在地为李鸿章于1865年兴建的金陵制造局旧址。这里是中国民族工业的摇篮，也是中国最大的近现代工业建筑群。2017年12月，园区被列入第二批中国20世纪建筑遗产名录。园区分为时尚生活休闲、科技创意研发、工艺美术创作、酒店商务、科技创意博览5个功能区，成为国内知名的融科技、文化、旅游、商务等为一体的综合性地标。园区现存原金陵机器制造局的大门、清代建筑、民国建筑和兵器展览馆等遗迹，还有李鸿章的雕像，展示着中国近代工业发展的历史。

Chenguang 1865 Creativity and Industry Park was founded on September 19, 2007 and attracted investment from all over the world. The industrial park is located at the former site of Jinling Manufacturing Bureau founded by Li Hongzhang in 1865. Jinling Machine Manufacturing Bureau is the pioneer of China's national industry, also the first modern factory in Nanjing. It is known as the "cradle of China's national industry", with the largest modern industrial complex in China. In December 2017, the park was included in the second batch of China's 20th Century Architectural Heritage List. The park is divided into five functional areas: fashion, entertainment and leisure, science and creative research and development, arts and crafts creation, hotels and exhibition business. The park is committed to building a well-known comprehensive landmark integrating science and technology, modern culture, tourism, business, etc. There is an old gateway of Jinling Machine Manufacturing Bureau, some old buildings of Ming and Qing Dynasties, an ancient weapon exhibition hall, as well as a statue of Li Hongzhang, demonstrating the profound history of development of modern industry.

Jianye District

侵华日军南京大屠杀遇难同胞纪念馆

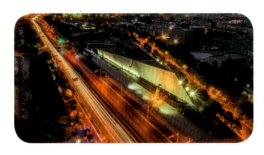
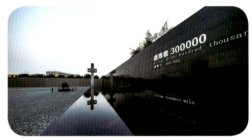

侵华日军南京大屠杀遇难同胞纪念馆位于南京大屠杀江东门集体屠杀遗址及遇难者丛葬地，是著名的爱国主义教育基地。纪念馆展陈面积达2万平方米，建有7处广场、23座单体雕塑和一座大型组合雕塑等。侵华日军南京大屠杀史实展、"三个必胜"主题展、"二战中的性奴隶——日军'慰安妇'制度及其罪行展"等三个基本陈列共展出近4 000幅照片、9 992件各类文物和262部影像资料，智慧而严肃地表达了暴行、抗争、胜利、审判、和平五大主题。从2014年12月13日起，纪念馆作为南京大屠杀死难者国家公祭仪式的固定举办地。

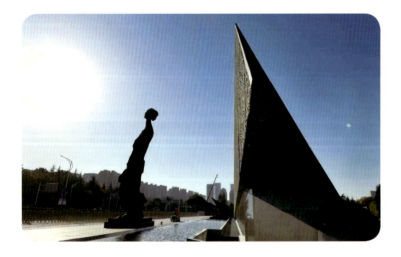

The Memorial Hall of the Victims in Nanjing Massacre by Japanese Invaders is a thematic memorial hall built on the site of Jiangdong Gate mass murder in Nanjing Massacre. It is a famous patriotic education base. The Memorial Hall has an exhibition area of 20,000 square meters, supplemented by seven public memorial squares, twenty-three single sculptures, and a large combined sculpture. There are three basic thematic exhibitions, namely the historical records of Nanjing Massacre, the theme exhibition of "three victories", and the "sex slaves in World War II—the 'Comfort Women' system in Japanese army and their crimes". A total of nearly 4,000 photographs, all kinds of 9,992 pieces of records and artifacts, along with 262 video materials are on display, expressing the five main themes of violence, resistance, victory, trial and peace in rational and serious manners. Since December 13, 2014, the Memorial Hall has also been chosen as the fixed host place for the national memorial ceremony for the victims of Nanjing Massacre.

莫愁湖公园

莫愁湖是南京主城区内的第二大湖泊,有"金陵第一名胜"的美誉,因紧邻石头城,也称为"石城湖"。"莫愁湖"的名字源自一个同名的传奇女孩。莫愁女十分美丽,当时的梁武帝欣赏她的勇气和忠贞,为她写了一首名为《河中水之歌》的诗。莫愁湖因为莫愁女的传说而被赋予了更多的文化内涵。莫愁湖公园里有莫愁女故居,还有郁金堂、胜棋楼、华严庵、粤军阵亡将士墓等主要景观。莫愁湖公园四季风景各异,冬雪夏花更是人们争相欣赏的胜景。

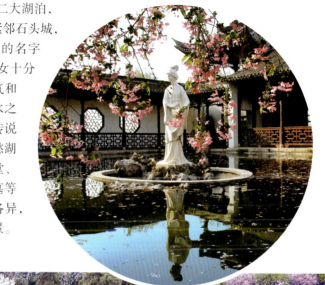

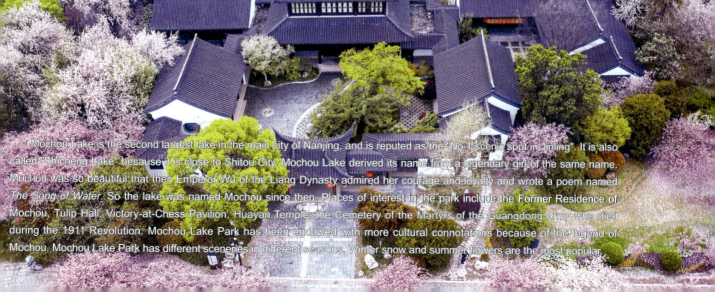

Mochou Lake is the second largest lake in the main city of Nanjing, and is reputed as the "No.1 scenic spot in Jinling". It is also called "Shicheng Lake" because it is close to Shitou City. Mochou Lake derived its name from a legendary girl of the same name. Mochou was so beautiful that then Emperor Wu of the Liang Dynasty admired her courage and loyalty and wrote a poem named *The Song of Water*. So the lake was named Mochou since then. Places of interest in the park include the Former Residence of Mochou, Tulip Hall, Victory-at-Chess Pavilion, Huayan Temple, the Cemetery of the Martyrs of the Guangdong Army who died during the 1911 Revolution. Mochou Lake Park has been endowed with more cultural connotations because of the legend of Mochou. Mochou Lake Park has different sceneries in different seasons. Winter snow and summer flowers are the most popular.

江苏大剧院

江苏大剧院紧邻长江，是一座集演出经营、艺术交流、艺术普及教育、会议功能、电影欣赏、美术展览、专业录音、艺术摄影等于一体的大型文化综合体。大剧院造型新颖别致，四颗"水滴"内蕴含着歌剧厅、音乐厅、戏剧厅、综艺厅。"荷叶水滴"的设计理念与南京"山水城林"的城市特色相吻合，从空中俯瞰，犹如漂浮在绿野上的滴滴水珠，晶莹剔透，极具想象力和创造力。夜晚的大剧院星光璀璨，绚丽多姿，宛若星空。

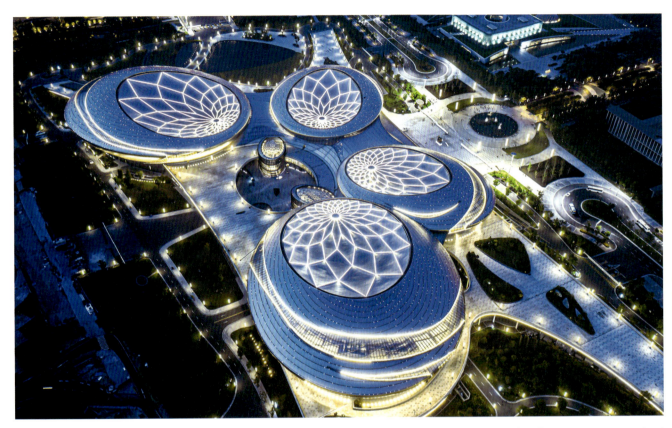

Jiangsu Centre for the Performing Arts(JCPA) is adjacent to the Yangtze River. It is a cultural complex of performance management, art exchange, art popularization and education, conferences, films, exhibitions, professional sound recording, art photography, etc. JCPA has a special design of Chinese characteristics as well as the local culture. It is composed of four architectural structures which resemble four water drops, poetically perching on lotus leaves. Lotus leaves and water drops resemble Nanjing, which is a city of mountains, rivers and forests. Seen from the sky, JCPA looks like droplets floating on a green land, full of imagination and creativity. When evening comes, JCPA is bright like a pearl in the starry sky, gorgeous and colorful.

南京奥林匹克体育中心

南京奥体中心是2005年全国十运会、2013年亚青会和2014年青奥会的主会场。中心主要建筑为"四场馆二中心",包括体育场、体育馆、游泳馆、网球馆、体育科技中心和文体创业中心。奥体中心上空的金陵红双斜拱是"世界第一双斜拱",钢拱水平跨度达360余米,斜度达45度。它们是国际体育设施历史上的第一个钢拱,也是南京城市的象征,展示了体育运动的活力与热情。现在,奥体中心已经成为集体育运动、休闲餐饮娱乐和展览、演唱会等于一体的综合城市生活设施。

影视作品:
《你好,火焰蓝》

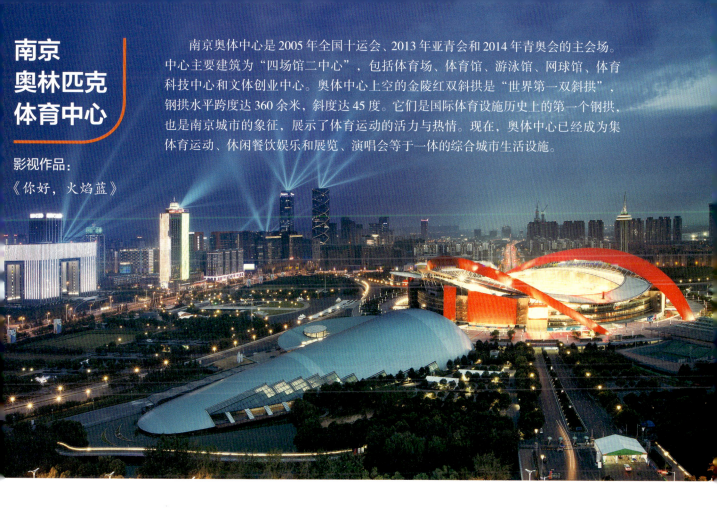

Nanjing Olympic Sports Center is the main venue of the 10th National Games in 2005, the Asian Youth Games in 2013 and the Youth Olympic Games in 2014. The main building consists of four venues and two centers, including the stadium, gymnasium, natatorium, tennis hall, sports science and technology center, and creative culture and sports business center. The double red oblique arches above the Olympic Sports Center are reputed as the "world's No.1 oblique arches", with a horizontal span of over 360 meters and a slope of 45 degrees. They are the first steel arches in the history of international sports facilities, also a symbol of Nanjing city, showing the vitality and passion of sports. Now, the Olympic Sports Center has become a comprehensive urban living facility integrating sports, leisure, catering and entertainment, exhibitions and concerts.

南京国际青年文化中心

南京国际青年文化中心由两座塔楼、一座裙楼组成，南塔楼建筑高度249.5米，北塔楼建筑高度314.5米，为南京滨江风光带上重要的标志性建筑。两座塔楼的外形呈流线型，像外太空帆船，有着光的流动感和青春的活力。双子塔是多功能建筑大厦，其中有青奥会展览中心、大剧院以及酒店公寓等。著名的南京保利大剧院为这里增添了更浓厚的文化氛围。蓝天白云映衬下的双子塔高耸入云，雄伟挺拔。夜幕下的双子塔绚丽多姿，为河西地区增添了迷人的色彩！

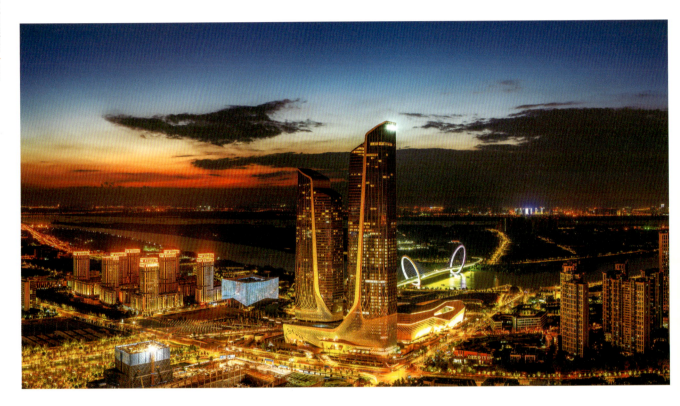

Nanjing International Youth Cultural Center is composed of two towers and one podium building. The south tower is 249.5 meters high, and the north 314.5 meters high. It is an important landmark building in the Nanjing Riverside Scenic Belt. The streamlined shape of the two towers, resembling an outer space sailboat, gives it an image of flow of light and vitality. The twin towers are multi-functional buildings, including facilities such as the Youth Olympic Exhibition Center, the grand theater and hotel apartments. The famous Nanjing Poly Grand Theater has added a strong cultural atmosphere here. The twin towers are towering and majestic. Under the curtain of night, the towers are gorgeous, adding a splash of charming color decorating the sky above Hexi area.

南京眼步行桥

南京眼步行桥是连接江心洲与河西地区的首座观光步行桥,全长827.5米,主跨240米,桥面宽10~22米,因其独特造型而闻名中外。南京眼步行桥造型别致,动感优雅,富有中国古典诗词韵味。桥的两个翅膀就像两只眼睛,让人们可以更好地了解南京。它们相对又像竖琴的琴弦和两根大拇指,在称赞河西新城建设生机勃勃和运动员无限的活力。步行桥夜晚灯光璀璨,人们观赏夜景,享受宁静夜色和江边凉风。

Nanjing Eye Footbridge is the first sightseeing pedestrian bridge with a function of transportation connecting Jiangxinzhou (an isle in the Yangtze River) and Hexi Region. Nanjing Eye Footbridge has a total length of 827.5 meters, a main span of 240 meters, and a width from 10 to 22 meters. Nanjing Eye Footbridge is unique with a dynamic and elegant shape, which contains the deep connotation of classical Chinese poetry. The two wings of the bridge are like two big eyes through which people can have a better understanding of Nanjing. They stand upward, also like the strings of a harp and two thumbs praising the vitality of the construction of Hexi New City and the athletes. With splendid landscape illumination, the footbridge attracts many people to enjoy the beautiful night scenery and the cool evening air.

影视作品:

《你好,火焰蓝》

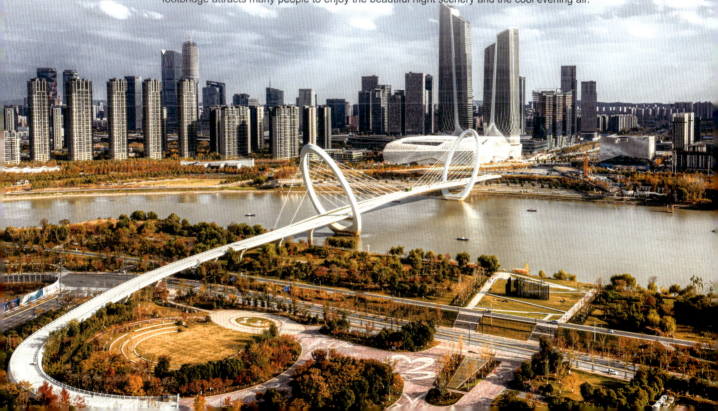

南京绿博园

南京中国绿化博览园是首届中国绿化博览会的举办地，也是中国最具特色的绿化主题公园之一和长江沿岸最大的城市公园。南京绿博园现已成为集生态园林展示、园艺技术、生态环保、科普教育、休闲娱乐等为一体的标志性生态旅游点。园内绿树成荫，空气清新，是休闲娱乐的热门去处。荷兰园中的大风车周围种着向日葵，是人们最喜爱的景点之一。徜徉在青葱翠绿的园内，欣赏着"四季花海"的美景，你可以感受到江风轻抚的惬意，也会为江岸的美景所倾倒。

The Nanjing China Green Expo Garden is the venue of the 1st China Greening Exposition. It is also one of the most distinctive green theme gardens in China and the biggest urban garden along the Yangtze River. Now it is an iconic ecotourism spot with a multifunction of ecological garden exhibition, floricultural techniques, eco-environment protection, natural science popularization and recreation. The garden is blanketed with greenery, pure and fresh air, becoming a popular resort of leisure and entertainment. The giant windmill in Dutch Garden is surrounded by a sunflower field, becoming one of the most popular spots in the garden. Strolling along the trails in greenery and admiring the marvelous floral landscape, sightseers are fascinated by the gentle breeze and the picturesque riverside scenery.

南京金融城

南京金融城占地约 15 万平方米。金融城一期工程有工商银行、邮储银行等多家金融机构入驻办公。金融城二期位于河西 CBD 轴线与青奥轴线的交汇处，是东部地区重要金融中心的标杆项目。大量现代化时尚建筑也让这里成为南京现代化、国际化的重要代表。现在，南京金融城已经成为推动南京金融服务业转型升级的重点项目，是具有国际水准、地标性的金融企业集聚区，极大地推动了南京区域金融中心城市的发展建设。

Nanjing Financial City covers an area of about 150,000 square meters. In the first phase of the project, many financial institutions such as Industrial and Commercial Bank of China and Postal Savings Bank of China have settled in and worked. The second phase, located at the juncture of Hexi CBD (Central Business District) axis and Youth Olympic Axis, is a benchmarking project of the major financial center in the eastern region. A large number of modern and fashionable buildings also make it an important representative of Nanjing's modernization and internationalization. Today, Nanjing Financial City has become a key project to promote the transformation and upgrading of Nanjing's financial service industry. It is a financial enterprises, hub with international standard and landmark, which has greatly promoted the development and construction of Nanjing regional finance center city.

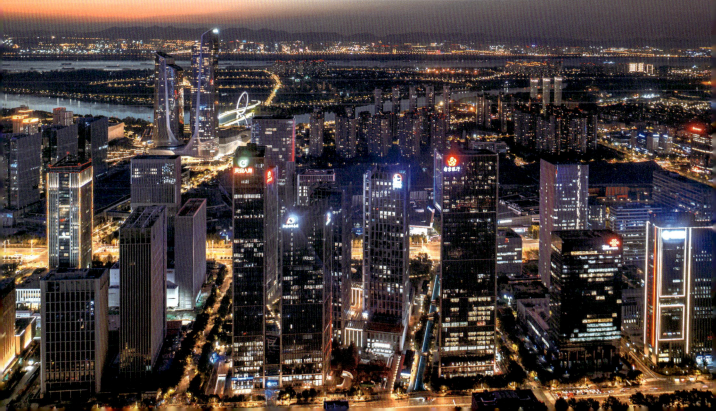

河西大街

　　河西大街西起扬子江大道，连接滨江公园和青奥公园，东至风台南路，长度约4.8千米，是建邺区主要道路之一，也是建邺区新产业发展的聚集区域。两边有河西中央公园、国际博览中心等。文化、医疗、教育、商业资源丰富，有医院、学校，以及众多的高档写字楼和银行、保险、证券、信托、基金等金融机构和大型特色商城。另外，酒店、观光旅游、餐饮娱乐业等蓬勃发展，更为这条大街注入了新的活力，使其成为集商务、新产业与生活区于一体的综合体。

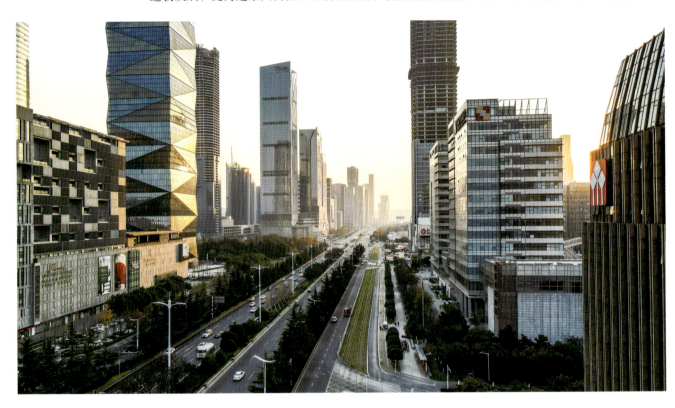

　　Hexi Avenue stretches from Yangtze River Avenue in the west, with the Riverside Park and the YOG Park, to the Fengtai South Road in the east, with a length of about 4.8 kilometers. It is one of the main roads in Jianye District and also the gathering area of new industry development. The avenue is rich in cultural, medical, educational and business resources with Hexi Central Park and the International Expo Center, hospitals and schools, as well as many high-end office buildings, financial institutions such as banks, insurance companies, trusts and securities, funds, and large characteristic shopping malls. In addition, Hexi Avenue is injected with new vitality due to the vigorous development of hotels, sightseeing tourism, catering and entertainment industry, becoming a comprehensive complex integrating business, new industry and living community.

江心洲

江心洲位于建邺区与浦口区之间，是长江南京段的一座岛屿，因形状像青梅，又称"梅子洲"。现在，江心洲已经从都市农业发展示范基地过渡成为可持续发展、生态文明和社会和谐相互交融的生态科技岛，构建最佳人居环境，并赋能城市智慧，打造智慧城市示范区。岛上的青奥森林公园植被茂盛，通过"南京眼"与奥体中心相连，内有芦苇荡、荷花池等景点，遍布杉类树木，并有木栈道穿越其间，形成湿地景观。这里也成为人们欣赏江景、观赏落日的度假休闲圣地。

Jiangxinzhou Island is situated between Jianye District and Pukou District. It is an island in the Nanjing section of the Yangtze River with the shape like a green plum, so it is also called "Plum Island". Now, Jiangxinzhou has transitioned from an urban agricultural development demonstration base to an ecological technology island that integrates sustainable development, ecological civilization and social harmony, building the best living environment, empowering urban wisdom, and creating a smart city demonstration area. The YOG Forest Park on the island is linked with Nanjing Olympic Center by Nanjing Eye. With lush vegetation, reed marshes, lotus pools and metasequoia forests, the park is a marvelous wetland scenic area where visitors can enjoy the beautiful landscape while walking on the plank path. It also becomes a perfect holiday attraction for people to enjoy the beautiful river view and sunset.

南京江心洲长江大桥

南京江心洲长江大桥也称"南京长江第五大桥",是连接浦口区与建邺区的过江通道,也是南京"高快速路系统"中绕城高速公路的重要组成部分,同时还是世界首座轻型钢混结构斜拉桥。主桥长1 796米,南北主跨长1 200米。桥面为双向六车道,设计速度最高为100千米/小时。这座大桥采用现代和最新的设计,犹如一条亮丽的彩虹横跨在江面上,成为南京又一个人文景观。

Nanjing Jiangxinzhou Yangtze River Bridge, also known as Nanjing's Fifth Yangtze River Bridge, is a river-crossing channel connecting Pukou District and Jianye District. It is an important part of the ring expressway in Nanjing's High Speed Expressway System, and is also the world's first cable-stayed bridge with light reinforced concrete structure. The bridge has a length of 1.796 kilometers, and mainly spans 1.2 kilometers from south to north, with a deck of two-way six-lane urban main road and designed the speed of 100 km/h. With the modern and latest design, the bridge is like a brilliant rainbow over the river, being another cultural landscape of Nanjing.

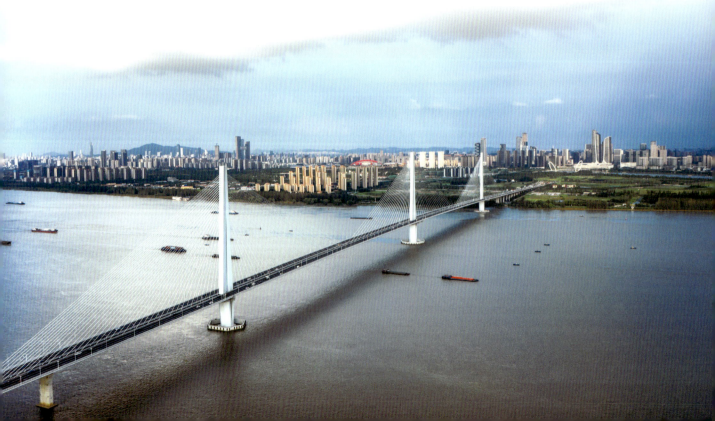

南京云锦博物馆

南京云锦博物馆是目前中国唯一的云锦专业博物馆,主要展示以南京云锦为代表的中国民族织锦艺术。云锦技术体现了中国人的智慧,也成为中华文化的瑰宝。在这里游客可以了解有着1 500多年历史的传统手工织锦技艺,欣赏明清织锦实物。南京云锦织造技艺已经入选联合国非物质遗产名录。古典名著《红楼梦》中的华丽服饰琳琅满目,是作者曹雪芹童年富贵生活的写照,其中就有云锦中最为名贵的品种。

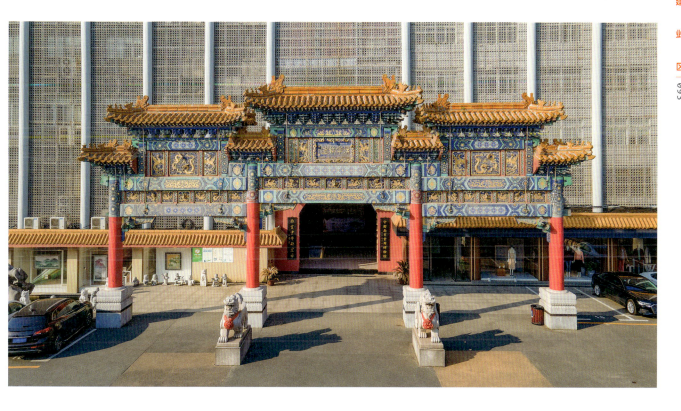

Nanjing Yunjin Brocade Museum is so far the only professional museum of Yunjin brocade in China. It mainly displays the Chinese national brocade art which is represented by Nanjing Yunjin Brocade. Visitors can learn the traditional manual brocade weaving process which has a history of over 1,500 years and watch the brocade items from the Ming and Qing Dynasties. The ancient skill of silk weaving is a typical representation of Chinese culture and wisdom, also the charm of Chinese arts. Nanjing Brocade Craftsmanship is named on the list of Intangible Cultural Heritage of Humanity of UNESCO. The gorgeous costumes in the classical masterpiece *A Dream of Red Mansions are dazzling*, which is a portrayal of the author Cao Xueqin's rich and noble life in childhood. Among them, there are the most precious varieties of Yunjin.

鼓楼区

阅江楼

阅江楼位于狮子山巅，地处扬子江畔，因明代文学家宋濂所撰《阅江楼记》而闻名，是中国十大历史文化名楼之一。阅江楼周围林木葱郁，有护城河环绕，山水秀丽。周围回廊雕有600多只神态各异的石狮。楼内以明文化为主题，分别展示了明朝16位皇帝造像、明朝版图等。主楼高52米，共7层，总建筑面积约5 000平方米，色彩典雅，绚丽多姿，为典型的明代皇家建筑风格，展示了深厚的历史内涵。站在楼上，滚滚江水和雄伟的长江大桥就在眼前，游客可以尽享美景。

影视作品：
《消逝的皇城》

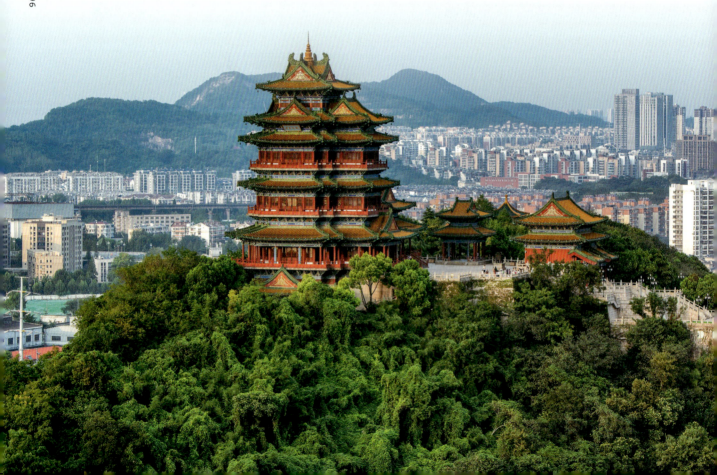

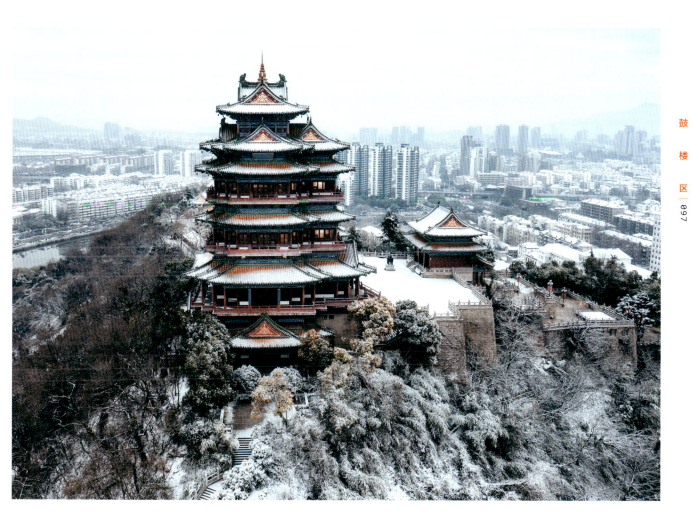

Yuejiang Tower stands on the top of Lion Mountain, adjacent to the Yangtze River. It is well known for the famous essay *Yuejiang Tower* written by Song Lian, a litterateur in the Ming Dynasty. It is one of the ten famous historical and cultural buildings in China. With dense forests and the city moat running around, the scenic area enjoys splendid landscape. There are more than 600 stone lions of different shapes in the corridors around the buildings. Inside the tower, the statues of 16 Ming Emperors and the territory map of the Ming Dynasty are displayed. The main tower is 52 meters high with seven floors, covering a total construction area of about 5,000 square meters. It is a typical royal architectural style of the Ming Dynasty, with elegant and bright colors, conveying profound historical connotations. Standing on the tower, visitors can appreciate the grand view of the Yangtze River and the Great Yangtze River Bridge.

新街口商贸区

影视作品：
《乔家的儿女》
（金陵饭店、
莱迪广场）

新街口商贸区位于南京中心区，以新街口广场（孙中山铜像）为标志，拥有百年历史，被誉为"中华第一商圈"。商贸区占地面积约5平方公里，核心商业区面积0.37平方公里，是南京国际商务商贸中心和现代金融服务中心，形成了各具特色的产业集群。这里人流量集中，高楼林立，有中央、新百、金鹰、德基等大型购物商场和苏宁、五星电器等连锁店和各类时尚商店，也有金陵饭店、丽思卡尔顿等高端酒店，餐饮娱乐业集中，是购物休闲的天堂，也是南京国际化大都市的形象标志。

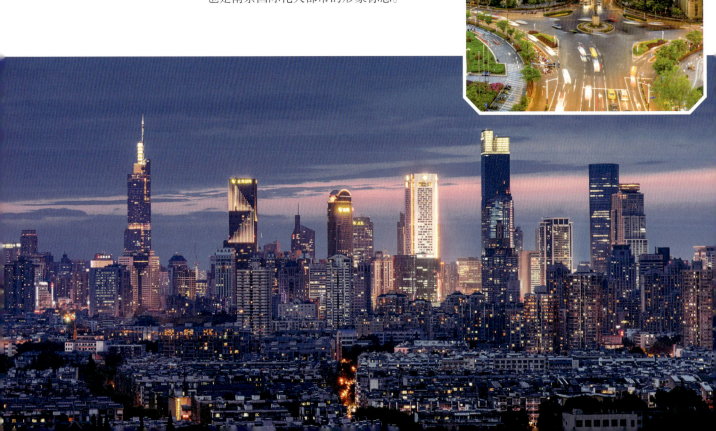

Xinjiekou Commercial District is located in the center of Nanjing city, marked by Xinjiekou Square(bronze statue of Sun Yat-sen). It is a famous commercial center in China with a hundred-year history, known as China's No.1 Commercial Circle. The commercial district covers an area of about 5 square kilometers, with a core business area of 0.37 square kilometers, making it a modern financial service center in Nanjing. As distinctive commercial clusters, there are large shopping malls such as the Central, CENBEST, Golden Eagle, Deji, and chain stores such as Suning, Five Star and various fashion shops, as well as high-end hotels such as the Jinling Hotel and the Ritz-Carlton. Xinjiekou Commercial District is a paradise for shopping and leisure, and it is also the image symbol of Nanjing as an international metropolis.

江苏广播电视塔

江苏广播电视塔位于秦淮河畔,建成于1995年,又名"紫金塔",高318.5米。高塔巍然耸立,居于空中的大、小塔楼形似飞碟,在观光层可以欣赏城市及大江风貌。塔座是由登塔大厅、科学宫、展览厅、草坪、绿化带组成和谐的建筑群,可供游人参观、游览、娱乐。位于塔座的江苏省科学技术馆集知识性、科学性、趣味性和互动性于一体,是科学与艺术的结合,也是人们高空游览、购物、娱乐、餐饮、休闲的好场所。

Jiangsu Television Tower, adjacent to the Qinhuai River, also known as "Zijin Tower", was completed in 1995 with a height of 318.5 meters. The tower stands majestically, revealing a sense of splendor with two platforms in the air like flying saucers. From the viewing platform, people can enjoy the marvelous view of the city and the Yangtze River. The tower base is a huddle of buildings composed of tower hall, science palace, exhibition hall, lawn, green belt, which provide sightseeing and entertainment. Jiangsu Science and Technology Museum is at the base of the tower, integrating knowledge, science, fun and interaction. It is a combination of science and art, and also a good place for sightseeing, shopping, entertainment, dining and leisure.

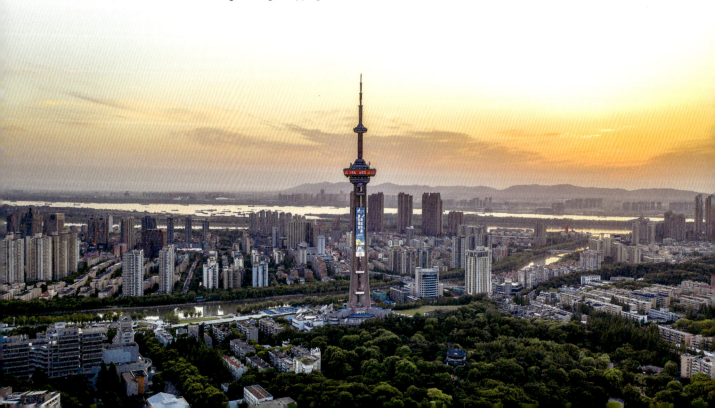

紫峰大厦

南京紫峰大厦地处鼓楼中央商务区，交通便利。主楼地上89层，高度450米，是集住宿、观光、餐饮、购物、休闲于一体的商务综合体。大厦外观设计兼顾龙文化、扬子江和园林城市三种地方元素，体现了世界当代建筑艺术与中国传统文化、南京地方史料的结合。站在第72层的观光厅可眺望远处的玄武湖、紫金山和长江壮丽景色，城市天际线尽收眼底。紫峰大厦也成为南京现代化大都市的象征。

Nanjing Zifeng Tower is located in the Central Business District with convenient transportation. The main building has 89 floors on the ground and is 450 meters high. It is a business complex comprising commercial services such as accommodation, sightseeing, catering, shopping and leisure. The design of the building takes into account three local elements of dragon culture, Yangtze River and garden city, which reflects a good combination of the world's contemporary architectural art, traditional Chinese culture and local historical materials of Nanjing. Standing on the sightseeing hall on the 72nd floor, people can admire the splendid aerial view of the city, overlooking the splendid view of Xuanwu Lake, Purple Mountain and Yangtze River. Zifeng Tower has also become a symbol of the modern metropolis of Nanjing.

鼓楼

鼓楼位于鼓楼广场边林木繁茂的鼓楼公园内,始建于明朝洪武十五年(1382年),是中国古代官式砖构建筑的代表,也是古代庆典的重要场所。明朝时期鼓楼规模宏大、规格极高,后毁于战火。鼓楼占地面积9 100平方米,分上下两层。下层建成城阙样式,高达9米,红墙环绕、气势恢宏,门上有"畅观阁"匾额。上层有中、东、西三殿,古朴典雅。鼓楼地处城市中心,闹中取静。鼓楼广场正中每年均布置变换主题的植被花坛,装点着繁忙的城市生活,让人感到轻松愉悦。

Drum Tower stands in the Drum Tower Park with lush trees surrounded, built in 1382, the 15th year in the reign of Emperor Hongwu of the Ming Dynasty. It was an important venue for ancient celebrations and a representative of ancient Chinese palace-style brick architecture. Drum Tower had a grand structure that gave it a solemn appearance during the Ming Dynasty, but was later destroyed by war. Drum Tower covers an area of 9,100 square meters and has two stories built on the base. The lower floor is built in the style of a city tower, with 9 meters high, magnificent, and there is a plague of "Changguan Pavilion" on the door. The upper floor has three halls, i.e. the middle, the east and the west, which are simple and elegant. Located in the center of the city, Drum Tower enjoys a peaceful and quiet atmosphere from hustle and bustle. In the middle of the square, the flower terrace polishes the busy city life, making people relaxed and enjoyable.

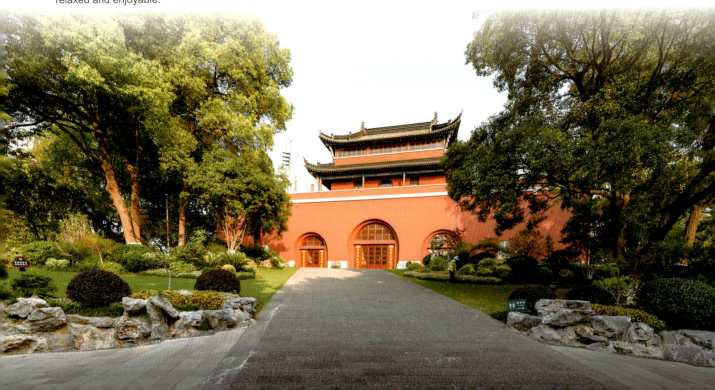

绣球公园

影视作品:
《张卫国的夏天》

绣球公园始建于 1952 年,因园内绣球山而得名。绣球山是狮子山南麓的山脉,与之形成"狮子盘绣球"之势。公园占地面积 9.56 公顷,其中水面 3.61 公顷。山、水、城、林相得益彰,景致精巧,明秀轻盈,是优雅的江南山水园林。公园内的主要景点有绣球山、马娘娘脚印、东湖、观鱼池、西园三岛等。绣球公园紧依城墙,高大的挹江门城楼巍然耸立,更赋予了公园深厚的历史文化底蕴。

Xiuqiu Park(Hydrangea Park) was built in 1952, named after the Hydrangea Mountain in the park. Hydrangea Mountain, a southward range of Lion Mountain, stands upright against its main range, thus forming the spectacle of the "lion playing with a hydrangea". The park covers an area of 9.56 hectares, with water coverage of 3.61 hectares. It is a landscape garden in the Jiangnan region featured with a compact delicate layout and beautiful scenery, including mountains, rivers, city walls and forests. As an exquisite garden, there are famous attractions like Hydrangea Mountain, Footprints of Empress Ma, East Lake, Fish Viewing Pond and Three Islands in West Garden. The park is close to the city wall, and the tall Yijiang Gate tower stands majestically, giving the park historical and cultural connotations.

乌龙潭公园

乌龙潭公园位于清凉山东麓，园内亭台楼阁错落有致，山水花木相映成趣，充满诗情画意，被誉为"西城之冠"。园内景点乌龙桥、妙香阁、颜鲁公祠、武侯祠和曹雪芹纪念馆等文化底蕴深厚。湖内曲桥小山相连，是寻凉观月佳地。庇鳞榭位于乌龙潭东面，是人们放生乌龟的地方，也是乌龙潭公园风景最优美的地方。园内曹雪芹塑像高 2.5 米，身着长袍，手持文卷，气宇轩昂，饱含文豪神韵。公园闹中取静，是人们休闲的理想之地。

Wulong Pond Park is located at the eastern foot of Qingliang Mountain. There are pavilions and terraces scattering in the park, with beautiful flowers and lush trees, full of poetic and pictorial meanings. It is known as "the crown in the west of Nanjing". The scenic spots, Wulong Bridge, Miaoxiang Pavilion, Yanlugong Memorial Hall, Wuhou Shrine and Cao Xueqin Memorial Hall all have profound cultural connotations. The lake is connected by curved bridges and hills, which is a good place to seek coolness and watch the moon. Located to the east of Wulong Pond, Bilin Pavilion is the place where people set free tortoises and it is also the most beautiful place in the park. There is a 2.5-meter-high statue of Cao Xueqin, dressed in robe, holding a scroll, with gentle and literate spirits. The park escapes from hustle and bustle, endowing an ideal place for leisure.

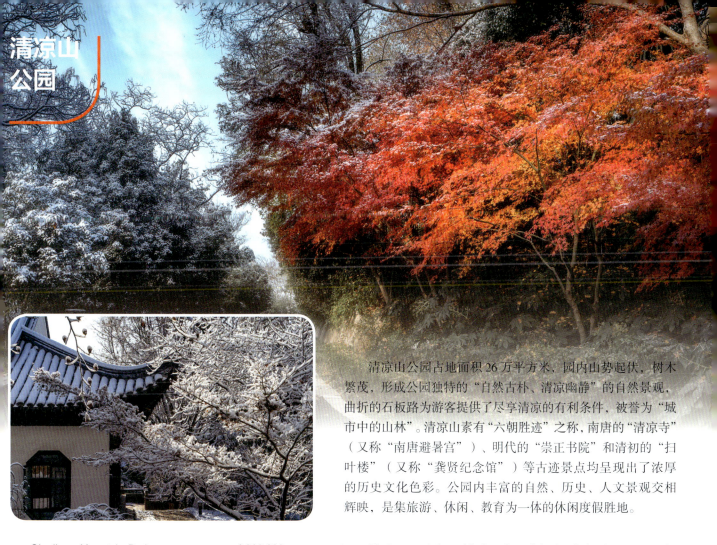

清凉山公园

清凉山公园占地面积26万平方米，园内山势起伏，树木繁茂，形成公园独特的"自然古朴、清凉幽静"的自然景观，曲折的石板路为游客提供了尽享清凉的有利条件，被誉为"城市中的山林"。清凉山素有"六朝胜迹"之称，南唐的"清凉寺"（又称"南唐避暑宫"）、明代的"崇正书院"和清初的"扫叶楼"（又称"龚贤纪念馆"）等古迹景点均呈现出了浓厚的历史文化色彩。公园内丰富的自然、历史、人文景观交相辉映，是集旅游、休闲、教育为一体的休闲度假胜地。

Qingliang Mountain Park covers an area of 260,000 square meters with the reputation of "urban forest" for its distinctive scenery. Its sunken terrains and slopes, luxuriant trees endow the park with a unique landscape of primitive simplicity and serenity. The stone slab paths are secluded and quiet. Qingliang Mountain has long been known as the "historic site of the Six Dynasties", the "Qingliang Temple"(also called "Nantang Summer Palace" in the Southern Tang Dynasty, the "Chongzheng Academy" in the Ming Dynasty and the "Sweeping-Leaves Pavilion"(also called "Gong Xian Memorial Hall") in the early Qing Dynasty and other historical and cultural attractions all present a strong historical and cultural essence. With rich natural, historical and cultural landscape adding radiance and beauty to each other, the park is an ideal leisure resort integrating tourism, leisure and education.

龙江船厂遗址

龙江船厂始建于明洪武初年,曾经是历史上最繁忙的国家级造船厂,和宝船厂一起并称为中世纪世界上最大的皇家船厂。郑和下西洋所用船只大多建造于此。遗址有7个与船坞相似的水塘,此处发现的古船构件和建造材料为研究中国造船业和造船技术发展提供了重要依据。南京郑和宝船遗址公园是为纪念郑和下西洋600周年而建造的,园区紧靠长江风光带,绿树池塘相映,风景秀丽,是融旅游、展览、休闲为一体的大型遗址性公园。公园内的宝船长148米,宽60米。

Longjiang Shipyard was built in the early years of Hongwu of the Ming Dynasty and was once the busiest state-level shipyard in history. Together with Treasure Boat Shipyard, it was called the largest royal shipyard in the world in the Middle Ages. Most of the ships used by Zheng He on his voyages were built here. There are seven ponds similar to shipyards, and the discovery of hull components and construction materials has provided important basis for the study of the development of China's shipbuilding industry and techniques. Treasure Boat Heritage Park, built to commemorate the 600th anniversary of Zhen He's voyages, is a large-scale heritage park adjacent to the Yangtze River with green lush trees and ponds, integrating tourism, exhibition and leisure. The treasure boat in the park is 148 meters long and 60 meters wide.

石头城

石头城是位于鼓楼区秦淮河畔的一段古城墙。东汉建安十六年（公元211年），孙权曾经在此建城，史称"石头城"。城墙中部有一块突出的石壁，远处看去酷似一副鬼脸，因此被称为"鬼脸城"。城墙下面有一个水塘，两者相映形成"鬼脸照镜子"的著名景点。唐代诗人刘禹锡在这里写下了《石头城》以抒发他对历史的感慨："山围故国周遭在，潮打空城寂寞回。淮水东边旧时月，夜深还过女墙来。"漫步在石头城下、秦淮河边，欣赏着城墙垂柳、碧水鲜花，人们很容易怀想历史，感叹岁月的变迁。

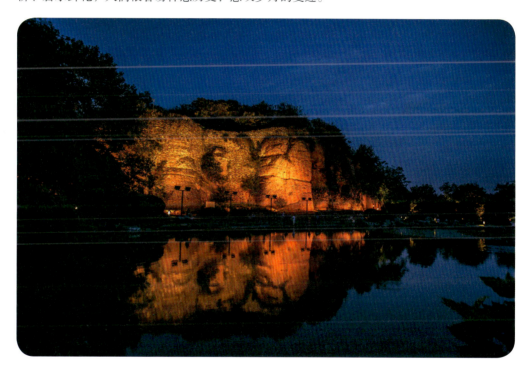

Stone City, is a segment of ancient city wall located on the bank of Qinhuai River in Gulou District. In the 16th year of Jian'an of the Eastern Han Dynasty (211AD), Sun Quan, king of the Wu Kingdom built a city here and named it "Stone City". On the western side of the hill there is a rough precipice, which juts out and looks like a wry face, so it is also called "Goblin City". Under the city wall, there is a pond, both of which form the famous spot "Grimace in Mirror". Liu Yuxi, a famous poet of the Tang Dynasty, wrote a poem with the name of *Stone City* to express his feelings about history, "The site with surrounding hills still remains, and the tides pound the hollow city and return disconsolately. The old moon is in the east of the Qinhuai River, and it is late at night to cross the parapet." Walking under the Stone City and by the Qinhuai River, people can't help recalling the history, sighing for the changes of the years and admiring the pleasant view of weeping willows, clear water and beautiful flowers.

拉贝故居

拉贝故居，又名南京大学拉贝与国际安全区纪念馆，是位于南京大学鼓楼校区内的一栋德式小洋楼。小楼外青藤围绕，静谧中透着岁月的沧桑。1937年12月13日南京城沦陷后，大量平民涌向了安全区，拉贝故居是当时的一个难民收容所，最多时收留了630多位难民。作为抗战时期原南京国际安全区主席，拉贝以日记形式真实记录了侵华日军南京大屠杀的暴行。《拉贝日记》长达2 400多页，与其他图片、文字等介绍拉贝生平的史料在纪念馆一同展出。

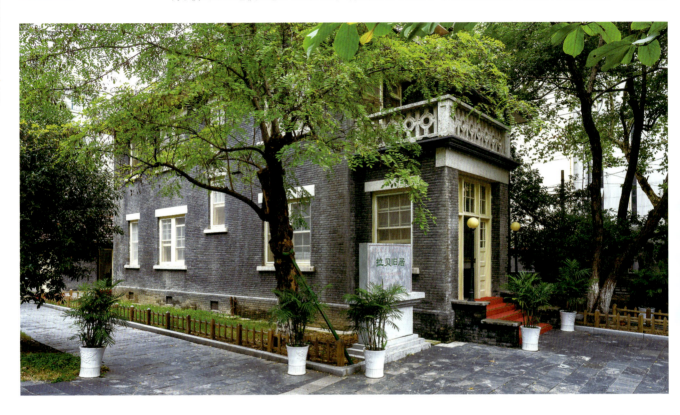

John Rabe's Former Residence, also known as John Rabe and International Safety Zone Memorial Hall of Nanjing University, is situated in Nanjing University, Gulou Campus. It is a small German-style building covered by dense ivy vines, peaceful and quiet. After the fall of Nanjing on December 13, 1937, a large number of civilians flocked to the Safety Zone. John Rabe's Former Residence was then one of the refugee shelters, housing more than 630 people at its peak. John Rabe, the former chairman of the Nanjing International Safety Zone during the Anti-Japanese War, documented the atrocities of the Nanjing Massacre by the Japanese invaders in the form of diaries. *John Rabe* is more than 2,400 pages long, and is now displayed in the memorial hall together with pictures and other forms of materials that introduce the life of Rabe.

苏宁睿城

苏宁睿城是国家级南京国际服务外包产业园综合项目的核心组成部分,是涵盖国际公寓、科技办公群、总部基地、五星级酒店、综合商业以及小学、幼儿园及高档社区服务中心等生活配套为一体的中央硅谷生活城。"苏宁银河国际社区""苏宁广场""苏宁慧谷"三大核心构成了一个集社区服务、总部经济、高端酒店、教育、科研、餐饮娱乐、休闲等于一体的大型时尚综合体。

Suning Intelligent City (SIC) is the core component of the comprehensive project of the state-level Nanjing International Service Outsourcing Industrial Park. SIC is also a central silicon valley equipped with international apartments, science and technology groups, headquarters base, five-star hotel and comprehensive business as well as supporting facilities containing primary schools, kindergartens and high-end community service centers. Composed of three core sub-projects, Suning Galaxy International Community, Suning Square and Suning Intelligent Valley, the project serves as a large fashionable complex, integrating community service, headquarters economy, high-end hotels, education, scientific research, catering, entertainment and leisure.

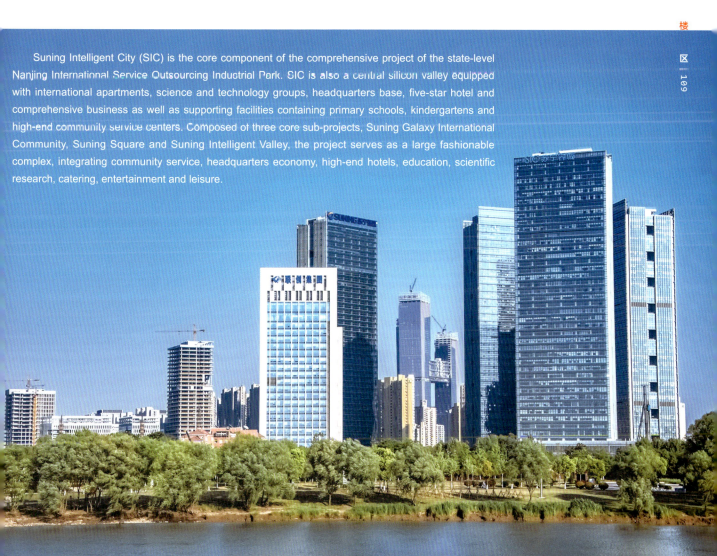

Qixia District

龙潭港

龙潭港是南京港的重要组成部分,是长江规模最大、现代化程度最高的专用集装箱港区,也是南京地区国际集装箱进出口的唯一通道和南京航运(空)与综合枢纽名城核心区。龙潭港区现已成为南京周边地区及长江中上游地区外贸物资进出口的门户口岸,年吞吐能力超亿吨。作为一个自动化程度较高的港口,龙潭港每天都呈现出繁忙的景象。白天,人们可以欣赏江上美景。夜晚灯火辉煌,营造出绚丽的夜景。龙潭港已经成为南京与世界展开友好的文化交流和贸易合作的一张名片。

As an important part of Nanjing Port, Longtan Port boasts the largest and most modernized dedicated container port area on the Yangtze River. It is also the only channel for international container import and export in Nanjing and the core area of Nanjing's shipping(air) and comprehensive hub city. Longtan Port is the gateway port for the import and export of foreign trade in the surrounding areas of Nanjing and the middle and upper reaches of the Yangtze River. It has the capacity of annual throughput of over 100 million tons. As a modern port with high degree of automation, Longtan Port is busy and prosperous. During daytime, people can enjoy the view of the Yangtze River. At night, the lights are blazing, creating a splendid night view. Now, Longtan Port has become a business card of friendly cooperation in trade and culture between Nanjing and the world.

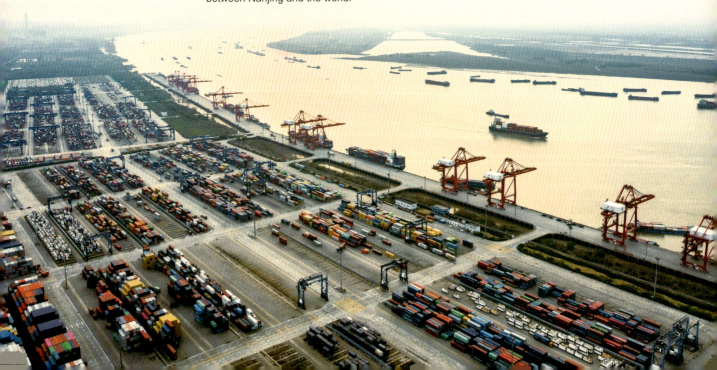

八卦洲假日山庄

八卦洲假日山庄坐落于长江第三大岛——八卦洲岛，毗邻南京长江二桥服务区，是一个交通便利、风景宜人，集餐饮、住宿、会议培训、农家生活体验于一体的度假胜地。假日山庄为绿色休闲山庄，占地面积280余亩，配套设施完善。山庄内小桥流水，湖畔垂柳依依，有别具一格的水上别墅餐厅、小木屋和旧时的画舫，是休闲度假、品尝农家土菜的好去处。人们站在酒店回廊上可远眺长江二桥与长江风貌。

Baguazhou Holiday Villa is located on the third largest island of the Yangtze River—Baguazhou Island, adjacent to the service area of the Second Nanjing Yangtze River Bridge. It is a holiday resort with convenient transportation and pleasant scenery, which contains the services of catering, accommodation, conferences and training, rural life experience. The Holiday Villa is a green leisure villa, covering an area of more than 280 mu with good supporting facilities. Inside the villa, water is flowing beneath small bridges, and willows are sweeping above the lake. There is a unique water villa restaurant, some wooden huts and an old gaily-painted pleasure-boat, making the villa a good place to taste rural local dishes and enjoy holiday. Standing on the corridor of the hotel, visitors can overlook the Second Yangtze River Bridge and the scenery of the Yangtze River.

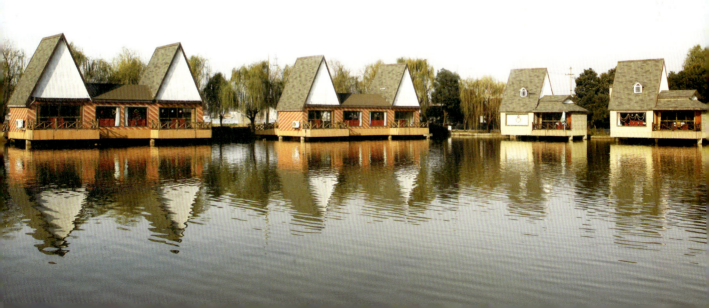

栖霞山

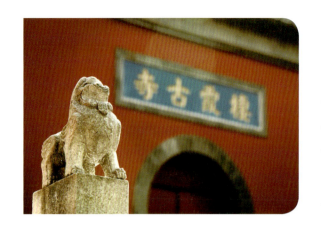

栖霞山，古称摄山，每到深秋，山中枫叶流丹，蔚为壮观，为我国四大红叶观赏风景区之一。栖霞山以红枫、怪石、密林和清泉著名，古迹遍布，历史文化底蕴深厚，素有"一座栖霞山，半部金陵史"的美誉。佛教"四大丛林"之一的栖霞古寺就坐落在栖霞山西麓，有1 500多年历史，有舍利塔、千佛岩等著名景点。舍利塔为中国最大，具有较高的历史价值。唐代诗人皮日休曾写下《游栖霞寺》，通过意境独特的画面描绘出栖霞寺的深藏幽僻。栖霞山的地学内涵也极为丰富，古生物化石众多。

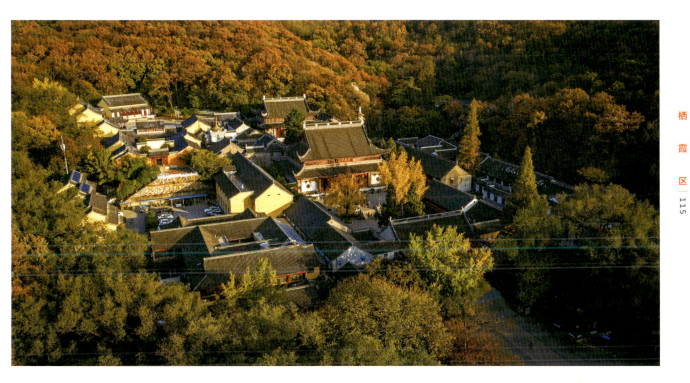

Qixia Mountain, originally known as Sheshan, is ablaze with many kinds of red leaves in late autumn. Striking yellows and reds are like a blanket of fire, making it one of the four most famous red leaves viewing resorts. Qixia Mountain is famous for its red maples, grotesque rocks, luxuriant forests and clear springs. It is full of historic sites and has profound historical and cultural heritage. It is known as "a Qixia Mountain, half of the history of Jinling". Qixia Temple is located at the western foot of Qixia Mountain, which is one of the four biggest temples of Buddhism. With a history of over 1,500 years, it has famous scenic spots such as Stupa and Qianfo Rock. The Stupa is regarded as the largest one in China and is of great historical value. Pi Rixiu, a famous poet of the Tang Dynasty, composed a poem *A Trip to Qixia Temple*, describing the tranquil and secluded temple. The mountain is also an important source of many geological names.

南京欢乐谷

南京欢乐谷位于栖霞山东侧，毗邻长江，是集科技、娱乐于一体的大型乐园。欢乐谷以"动感、时尚、激情"的品牌个性，为现代都市人提供多元化的旅游休闲方式和都市娱乐产品。同时，也致力于以新内容、新产品、新体验满足当前消费者多元化的文化休闲娱乐需求。欢乐谷拥有欢乐时光、甜品王国、遗落要塞、奇想海洋、魔眼森林和黑铁城等六大园区，还引进了亚洲首台三级弹射过山车。"蓝鲸音乐节"和"金陵宝藏"等一系列特色文化活动更为城市青年的假日休闲增添了更多的时尚元素和灵感。

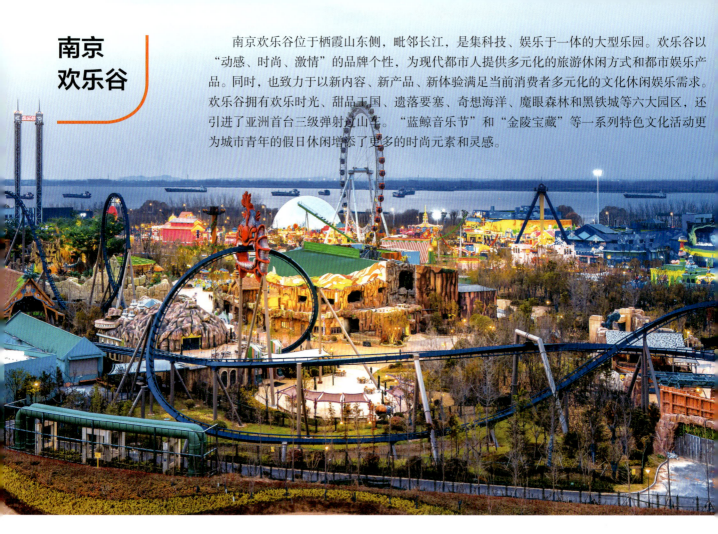

Nanjing Happy Valley Amusement Park is located on the east side of Qixia Mountain, adjacent to the Yangtze River. It is a large-scale amusement park integrating science and technology. With the brand personality of "dynamic, fashionable and passionate", the Park provides diversified travel and leisure ways and urban entertainment products for modern urbanites. Meanwhile, it is also committed to satisfying the diversified cultural leisure and entertainment needs of current consumers with new contents, new products and new experiences. With six thematic parks, including Happy Hour, Dessert Kingdom, Abandoned Fortress, Fantasy Ocean, Magic Eye Forest, and Black Iron City, the Park also introduced the first three-stage launch coaster in Asia. Blue Whale Music Festival and Nanjing Treasure together with other characteristic amusement items add more fashion elements and inspiration to the holiday of urban youth.

桃花湖

桃花湖是桃花涧中的一部分。桃花涧自明代以来就久负盛名，《栖霞山志》中对其有详细的描述。春天青葱翠绿，秋天五彩斑斓，是游览观光的绝妙之处。明末清初秦淮名妓李香君曾在此隐居，死后葬于桃花涧畔丛林。景区内有栈桥、古枫、桃林、亭榭和叠浪岩、天开岩、御花园等景点。青草绿树与湖光山色相互映照，游人漫步林间感到豁然开朗。

　　Peach Blossom Lake is a part of Peach Blossom Creek which has long enjoyed a good reputation since the Ming Dynasty. There is a detailed description of it in *Qixia Mountain Annals*. In spring, the lake is surrounded by lush vegetations. In autumn, colorful leaves create a polychromatic picture. It is a wonderful place to visit. At the end of the Ming Dynasty and the beginning of the Qing Dynasty, Li Xiangjun, a famous courtesan in ancient Jinling also lived in seclusion here and was buried in the jungle of Peach Blossom Creek after her death. There are trestle bridges, ancient maples, peach forests, pavilions, Dielangyan, Tiankaiyan, Imperial Garden and other scenic spots in the scenic area. The green grass and trees and the lakes and mountains reflect each other; visitors feel cheered up and relaxed when walking through the forest.

燕子矶

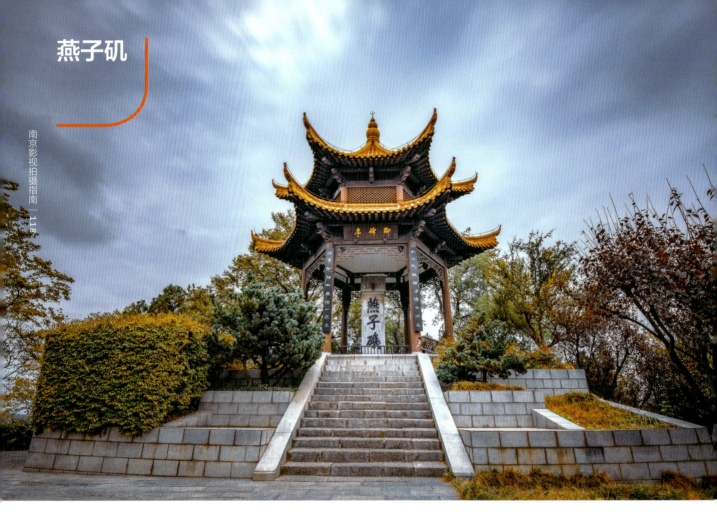

作为长江三大名矶之首,燕子矶有着"万里长江第一矶"的称号。燕子矶海拔36米,山石直立江上,三面临空,形似燕子展翅欲飞。公园绿树环绕,幽静雅致,是幕燕风光带上的主要景点。意大利旅行家马可·波罗曾在游记中提到此地。康熙、乾隆二帝下江南时均在此停留。乾隆在此书有"燕子矶"碑,还写了一首名为《燕子矶》的诗描述燕子矶的景色。燕子矶总扼大江,地势险要,矶下惊涛拍石,汹涌澎湃。黄昏时分,夕霞满天,江流滚滚,"燕矶夕照"也成为清初金陵四十八景之一。

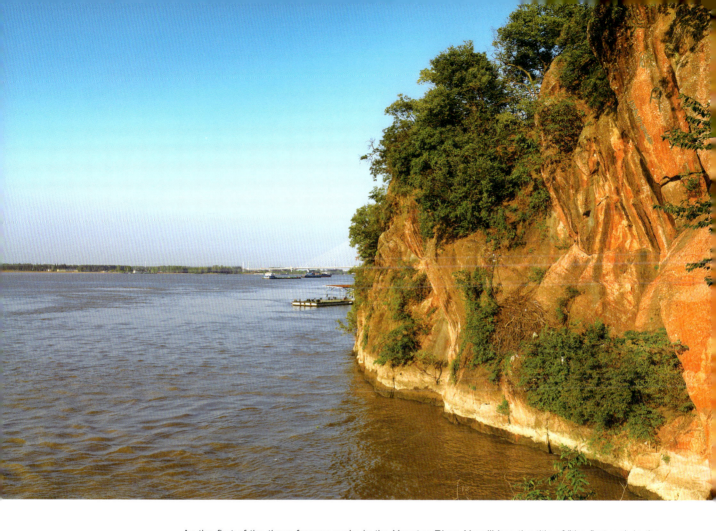

As the first of the three famous rocks in the Yangtze River, Yanziji has the title of "the first rock in the Yangtze River". It is 36 meters above sea level, with a precipitous solitary peak rising abruptly by the side of the Yangtze River, like a swallow spreading its wings to fly. Surrounded by green trees, the park is quiet and elegant, and is the main scenic spot on the Mufushan-Yanziji Scenic Belt. It was mentioned by the great Italian traveler Marco Polo in his famous travel notes. Emperor Kangxi and Emperor Qianlong stayed here in their tours to Jiangnan for inspection. From the top of the crag, people can feast their eyes with the spectacular view of the torrential eastward flow of the river plied by big ships up and down. At dusk, the evening clouds present the beautiful scenery of "Yanziji Sunset".

羊山公园

羊山公园（羊山生态森林公园）位于仙林大学城东部，占地约 134 公顷，是以羊山和人工湖为主体的原生态森林公园。公园周边有南京大学仙林校区、南京中医药大学等高校。公园内有青山、密林、草坪、湖水环抱，景色优美，人文气息浓厚。这里也是南京仙林半程马拉松的场地，里面有供游人漫步的绿道。湖畔春季杨柳依依，环湖的千株樱花竞相绽放，浪漫如画，是垂钓休闲、亲子度假的理想去处。

Yangshan Park (Yangshan Ecological Forest Park) is situated in the eastern part of Xianlin University City, covering an area of about 134 hectares. With Yangshan and an artificial lake as the main body, it is an important ecological forest park. Surrounded by universities such as Nanjing University Xianlin Campus, Nanjing University of Chinese Medicine, the park has beautiful scenery and strong humanistic atmosphere with green hills, dense forests, large lawns and clear lake around. There are jogging trails with captivating view and the famous Nanjing Xianlin Half Marathon is held here. In spring, the cherry blossoms bloom along the lakeside, with the green willows, making picturesque scenery. It is an ideal place for fishing entertainment and parent-child activities.

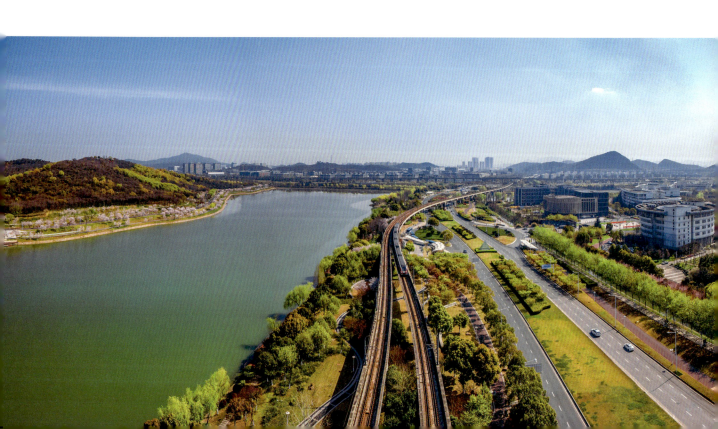

江南水泥厂

影视作品：
《大博弈》

江南水泥厂位于南京市栖霞山东麓，始建于1935年，曾是当时中国最现代化、产量最高的水泥厂。厂区旧址现被划分为抗战文化史迹区、民国建筑荟萃区和工业遗产保护区，保存有原厂房、职工宿舍和碉堡等，记载着时代的沧桑和一代人的记忆。厂区内的千年银杏树枝繁叶茂，吸引众多游客前来打卡拍照。1937年12月，侵华日军占领南京后开始疯狂屠杀平民，制造了惨绝人寰的"南京大屠杀"。德国人卡尔·京特和丹麦人辛德贝格在工厂建立难民营，救助了成千上万的难民。以这段历史为背景的文献纪录片《一座工厂的抗日传奇》曾在央视播出。现在厂址已经入选中国工业遗产保护名录第一批名单。

Located at the eastern foot of Qixia Mountain in Nanjing city, Jiangnan Cement Plant was founded in 1935 and was the most modern cement plant with the highest output in China at that time. The former site of the Plant is now divided into 3 parts, namely the Anti-Japanese War cultural and historical sites, the buildings of the Republic of China and the industrial heritage protection area. Some former buildings such as the original workshops, staff quarters and blockhouses are well preserved, conveying the vicissitudes and memories of a generation. The thousand-year-old ginkgo tree inside the Plant is still luxuriant, attracting many people to take photos. In December 1937, the Japanese invaders occupied Nanjing and began to slaughter innocent civilians. This bloody event was later known to the world as the "Nanjing Massacre". Karl Günther, a German, and Bernhard Arp Sindberg, a Dane, set up refugee camps in the factory and rescued tens of thousands of refugees. With this history as the background, a documentary has been shot and broadcast in CCTV. Now the site has been included in the first batch of Chinese industrial heritage protection list.

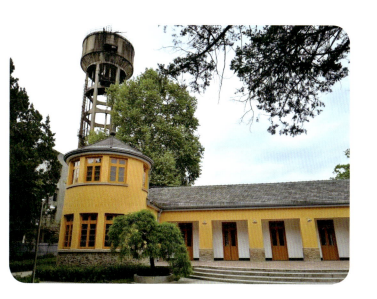

南京栖霞山长江大桥

南京栖霞山长江大桥，原称南京长江第四大桥，是国道主干线中上海—成都高速公路的枢纽工程，也是中国首座三跨吊悬索桥，在同类桥型中居当时世界第三。南京栖霞山长江大桥于2008年12月28日正式开工建设，2012年12月24日正式通车，全长28.996千米，桥面为双向六车道高速公路，设计最高速度为120千米/小时。大桥雄伟壮观，夜间灯光璀璨，像一道彩虹挂在江面上，景色壮观迷人。

Nanjing Qixiashan Yangtze River Bridge, formerly known as the Fourth Nanjing Yangtze River Bridge, is the hub project of the Shanghai-Chengdu expressway in the main national highway network. It is also the first three-span suspension bridge in China and the third of its kind in the world at that time. Nanjing Qixiashan Yangtze River Bridge officially started construction on 28 December 2008 and was officially opened to traffic on 24 December 2012. With a total length of 28.996 km, the bridge is a two-way six-lane expressway with a designed maximum speed of 120 km/h. The bridge is tall and majestic, towering above the river. At night, with glaring light, the bridge is like a rainbow hanging above the river, magnificent and charming.

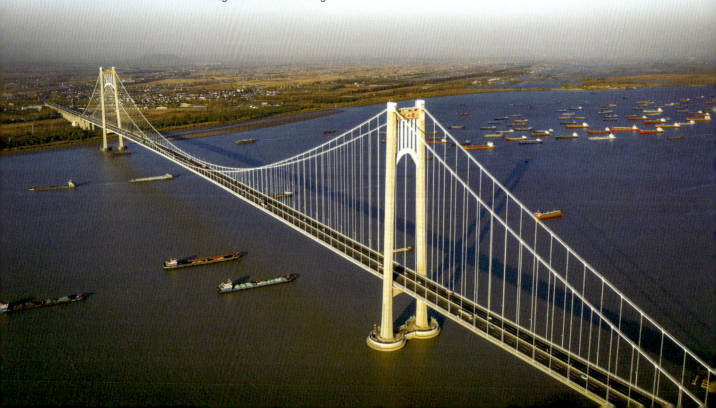

长江观音景区

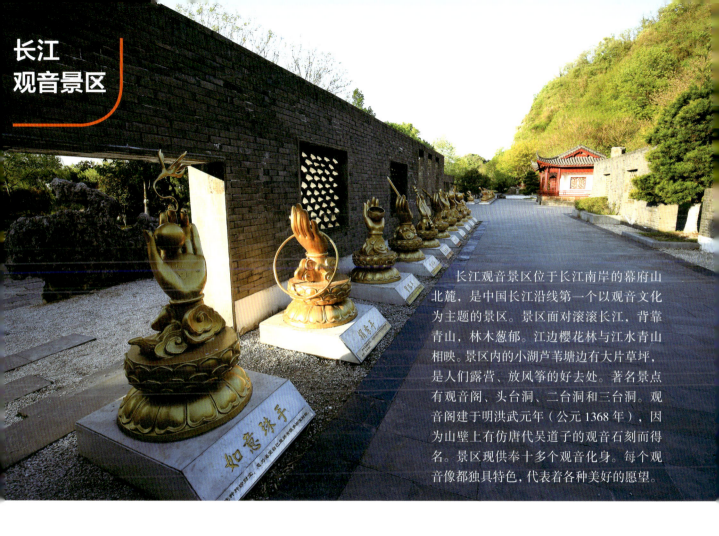

长江观音景区位于长江南岸的幕府山北麓，是中国长江沿线第一个以观音文化为主题的景区。景区面对滚滚长江，背靠青山，林木葱郁。江边樱花林与江水青山相映。景区内的小湖芦苇塘边有大片草坪，是人们露营、放风筝的好去处。著名景点有观音阁、头台洞、二台洞和三台洞。观音阁建于明洪武元年（公元1368年），因为山壁上有仿唐代吴道子的观音石刻而得名。景区现供奉十多个观音化身。每个观音像都独具特色，代表着各种美好的愿望。

Guanyin(a Buddism goddess of mercy) Scenic Area of the Yangtze River, located on the north slope of Mufu Mountain stretches along the south bank of the Yangtze River. It is the first Guanyin-themed scenic spot along the Yangtze River. The area faces the roaring Yangtze River, backed by green mountains and lush forests. The riverside cherry blossom forests and the rivers and green hills mirror each other. Beside the small ponds and weed marshes there are large patches of lawns where people can camp or fly kites. Guanyin Pavilion, Toutai Cave, Ertai Cave and Santai Cave are its famous attractions. Guanyin Pavilion was built in the first year of Hongwu of the Ming Dynasty (1368 AD). It was named because there is a stone carving of Guanyin modeled after Wu Daozi in the Tang Dynasty on the cliff. More than ten Guanyin's avatars are enshrined in the scenic spot and each one is unique and represents good wishes.

仙林金鹰湖滨天地

仙林金鹰湖滨天地是集购物、休闲、娱乐、创意文化产业、餐饮等为一体的大型开放式购物中心，毗邻仙乐湖。借助周围大学城的人文气息，这里也是集绿色健康和文化时尚娱乐于一体的城市乐园，森林公园、下沉式广场等配套齐全。风光旖旎的仙乐湖以自然水体为主，为金鹰构建了山水氤氲、绿树环抱的优美环境。商城建筑造型自然柔和，具有鲜明的节奏感。傍晚时分，在灯光的照耀下，湖面倒映着熠熠生辉的建筑，呈现出独特的迷人景色。

Nanjing Golden Eagle Xianlin Store is a large open mall adjacent to Xianle Lake, integrating shopping, leisure and entertainment, creative culture industry and catering, etc. There are sunken squares and other complete facilities. It gives full play to the advantages of natural landscape of lakes and forests parks, as well as the cultural environment around, forming a healthy and fashionable urban paradise where people can enjoy a leisure life. The design of the main buildings is gentle, soft and natural, with a distinct rhythm sensation. When the evening comes, with illumination, the lake reflects the shining bright buildings, presenting unique charming view.

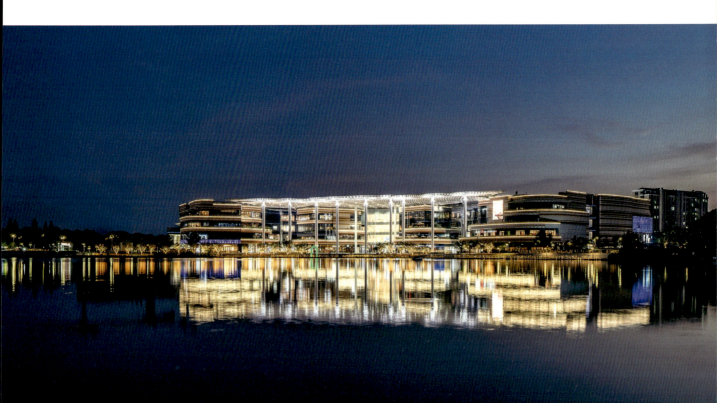

陶行知纪念馆

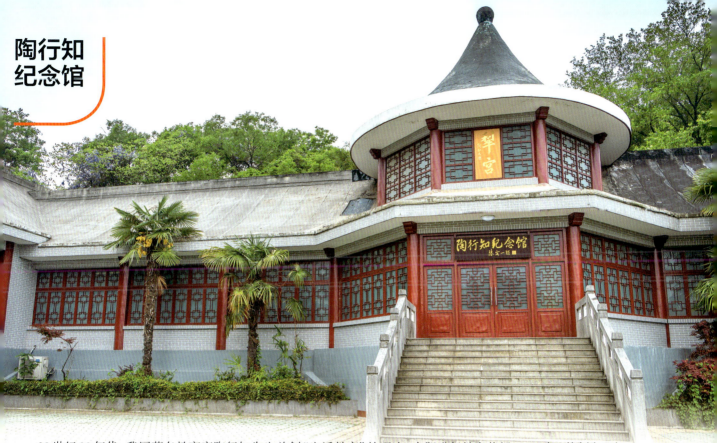

　　20世纪20年代，我国著名教育家陶行知先生首创"生活教育"的理论，大胆进行教育革新。1927年，他创办"晓庄试验乡村师范"。陶行知去世后，人们把他安葬在这里。1993年，陶行知纪念馆在原晓庄师范大礼堂旧址上建成。纪念馆门厅内有一尊陶行知全身铜像，背景是毛泽东题写的"伟大的人民教育家陶行知先生"13个金色大字。馆内设有3个展厅和宣讲厅、会客室、资料室、办公室等。每个部分都展示了大量的实物和历史图片，翔实、生动地反映了陶行知先生伟大、光辉的一生。

　　In the 1920s, Mr. Tao Xingzhi, a famous educator in China, initiated the theory of "life education" and boldly carried out educational innovation. In 1927, he founded Nanjing Rural Experimental Normal School (i.e. Xiaozhuang Normal School). After his death, people buried him here. In 1993, Tao Xingzhi Memorial Hall was built on the former site of the Normal School. There is a bronze statue of Tao Xingzhi in the hall with the background of 13 golden Chinese characters "the great people's educator Mr. Tao Xingzhi" inscribed by Mao Zedong. The memorial hall consists of 3 exhibition halls, lecture halls, reception rooms, reference rooms and offices. In each section display a large number of material objects and historical pictures which vividly reflect the great and glorious life of Mr. Tao Xingzhi.

Yuhuatai District

雨花台烈士陵园

雨花台烈士陵园是新中国成立后建立最早、规模最大的国家级烈士陵园。烈士雕像是雨花台风景区的象征，主题突出，层次独特，是 1949 年以后中国建造的最大的花岗岩雕像之一，代表了烈士在面对生命终结时的高尚革命气节。烈士纪念碑、倒影池、纪念桥、纪念馆、忠魂亭由北向南依次展开，组成中心纪念区。与中心纪念区相辅相成的，还有分布在陵园内各处的知名烈士墓、东西殉难处等纪念性建筑。雨花台烈士纪念馆展陈面积 3 091 平方米，分为上下两层，主要有七个版块展示内容，以烈士遗物、照片、史料为主体。现在，雨花台烈士陵园是全国爱国主义教育示范基地。

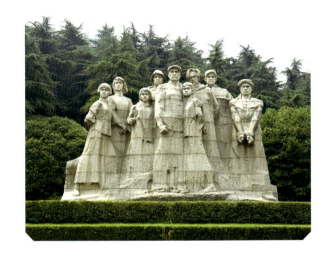

Yuhuatai Martyrs Cemetery is the earliest and largest national martyrs cemetery established after the founding of the PRC. Martyrs Group Sculptures are a symbol of Yuhuatai Scenic Area with an outstanding theme and unique gradation. It is one of the largest granite statues built in China after 1949, representing the noble revolutionary integrity of martyrs when facing the end of their lives. There are also Revolutionary Martyrs Monument, Reflecting Pool, Memorial Bridge, Memorial Hall, Loyalty Pavilion from north to south, forming the central memorial area. Complementary to the central memorial area, there are also famous martyrs' tombs, east and west martyrdom and other memorial buildings distributed throughout the cemetery. The exhibition area of Yuhuatai Martyrs Memorial Hall is 3,091 square meters, which is divided into two layers. There are mainly seven sections to display martyrs' relics, photos, historical materials. Now, the cemetery is a national patriotism education demonstration base.

南京
科技馆

南京科技馆是全国科普教育基地和江苏省科普教育基地。科技馆包含主场馆、科技影院及园区三部分。科技影院分为IMAX球幕影院、4D动漫影院、3D数字影院和5D动感影院。科技馆环境优美，有湿地公园、后山、礼仪广场等户外景点，构成科技馆的一大特色。南京科技馆是重大公益性社会文化项目，是江苏省规模最大的现代化、多功能的科普活动场馆。

Nanjing Science and Technology Museum(NSTM) is now a national and provincial science popularization base. It consists of three parts, the main hall, the science and technology cinema and the park. The science and technology cinema is divided into IMAX dome, 4D animation, 3D digital and 5D dynamic theaters. The museum features wetland park, back hill, etiquette square and other outdoor scenic spots that make it unique and picturesque. NSTM is a major public welfare social and cultural project, and it is the largest modern and multi-functional science popularization venue in Jiangsu Province.

南京南站

南京南站是国内规模最大的高铁车站之一,有"亚洲最大的火车站"的美誉。车站临近雨花台风景区,地理环境得天独厚,周边拥有浓厚的历史和人文底蕴,也位于经济高速发展的地区。车站主站房秉承"古城新站"的理念,以中国古典建筑元素为基础,将"山水城林"的和谐意境融入现代交通建筑中。柱廊、斗拱、双重屋檐,设计采用方正刚毅的直线和简约优雅的曲线,营造出传统建筑的壮美神韵和现代化铁路车站的时尚与恢宏。

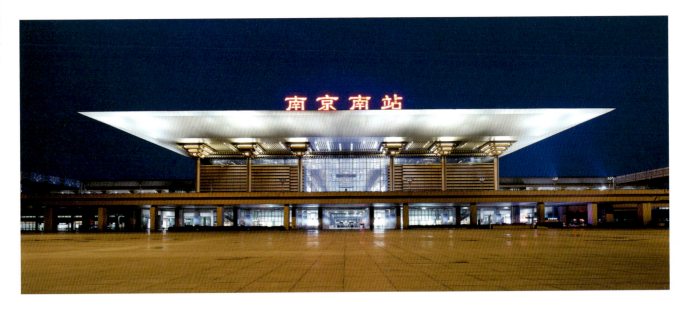

Nanjingnan Railway Station is one of the largest high-speed railway stations in China, with the reputation of "the biggest railway station in Asia". The station is close to Yuhuatai Scenic Area, with a unique geographical environment and strong historical and cultural heritage around it, and it is also located in an area with rapid economic development. The main chamber adheres to the concept of "ancient city, modern station", based on Chinese classical architectural elements, and integrates the harmonious artistic conception of "landscape, city and forest" into modern traffic buildings. Colonnades, bucket arches and double eaves are designed with square and resolute straight lines and simple and elegant curves, creating the magnificent charm of traditional buildings and the fashion and grandeur of modern railway stations.

9424 电影工园

　　"9424 电影工园"位于上海梅山宝钢基地原址,始建于 1969 年 4 月 24 日,也被称为"9424 工程"。公园包括黄村和梅山矿业两个组,有着极强的矿工业文化历史遗存特征。这里有地下 500 米深的废旧矿坑和大量老工业厂房。黄村还保留了当地浓郁的乡土气息,在留下城市记忆的同时,也为拍摄灾难、科幻以及平民生活和年代题材的影视作品提供了理想的取景地。《依依》是在 9424 电影工园拍摄的第一部电影。作为当地特色产业项目,电影工园已经成为特色鲜明、人文题材丰富、配套设施完备的一站式影视拍摄和创作基地。

　　9424 Film Park is situated in the original site of Shanghai Meishan Baosteel Base, built on April 24, 1969, also known as the "9424 Project". The park includes two parts, namely Huangcun and Meishan Mining Area, with strong characteristics of mining industry culture and historical heritage. There are abandoned mines 500 meters deep underground and a large number of old industrial buildings. Huangcun also retains its strong local flavor. While leaving city's memory, it also provides an ideal thematic shooting sites for disaster, science fiction, civilian life and historical films. *Yiyi* is the first film shot in this park. 9424 Film Park has become a one-stop film and television shooting and creation base with unique features, rich humanistic themes, and comprehensive complementary facilities.

影创基地效果图 YINGCHUANG BASE RENDERINGS

南京证大喜玛拉雅中心

影视作品：
《追爱家族》

南京证大喜玛拉雅中心位于雨花台区商业中心区，占地面积140亩，总建筑面积约63万平方米，购物中心建筑面积约10万平方米，是融合中国传统山水文化和最新商业潮流的综合性地产项目，汇集商务办公、特色酒店、综合商业、酒店公寓等多种业态。中心高山流水的建筑外形线条流畅，独具特色，外立面植被丰富，犹如绿色山岭，被誉为"南京南的艺术门面"。

Nanjing Zendai Himalayas Center is located in the business centre of Yuhuatai District, covering an area of 140 mu with a total construction area of about 630,000 square meters. The shopping center has a gross area of about 100,000 square meters. It is a comprehensive real estate project that integrates traditional Chinese landscape culture and the latest business trends. It is a collection of business office, characteristic hotel, general business, hotel apartment and other business formats. The shape of the building with high mountains and flowing water in the center is smooth and unique. There are lush greeneries outside of the buildings, creating an image of "green hills", known as the artistic facade in the south of the city.

雨花客厅

雨花客厅是雨花台区的商务中心，总面积70多万平方米，周边环境优美，交通便利，毗邻雨花台景区、菊花台公园等。地铁一号线在这里建有车站。E-PARK占地约8万平方米，是城南区域最大的商业体。雨花客厅既有高端写字楼和高档住宅区，也有时尚名品店、特色书店以及海洋世界和特色餐饮等，是以"绿色、健康、科技、生态"理念营造集商务、办公、居住、休闲娱乐、运动养生等多功能为一体的一站式都市生态综合体。

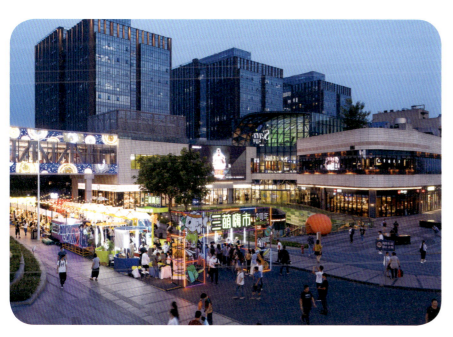

Yuhua City Hall is the business center of Yuhuatai District, covering a total area of more than 700,000 square meters, with beautiful surrounding environment and convenient transportation. It is adjacent to Yuhuatai Scenic Area and Juhuatai Park, etc. Metro Line 1 has a station here. With an area of about 80,000 square meters, E-Park is the largest commercial complex in the southern part of the city. Yuhua City Hall has not only high-end office buildings and high-end residential areas, but also fashion boutique, characteristic bookstore, marine world and special catering, etc. It is a one-stop urban ecological complex, integrating business, office, residence, leisure, entertainment, sports and healthcare with the concept of "green, health, science and technology, ecology".

莲花湖公园

　　莲花湖原名"石闸湖",水域面积400多亩,为雨花台区面积最大的湖泊,宛如城南的一颗璀璨的明珠。莲花湖公园又称南京莲花湖体育公园,室内综合运动馆和室外网球场以及篮球场、足球场等体育设施完善,还有烧烤场和垂钓园等配套休闲设施,为广大市民提供了周末休闲度假的好去处。莲花湖四季风景如画,春天杨柳依依,桃花朵朵;夏日万亩荷花盛开,人们可以走在湖中栈道上尽情欣赏;秋日一望无际的格桑花海五彩斑斓,成为拍照打卡热门景点。

　　Lianhua(Lotus) Lake, known as "Shizha Lake", covers an area of more than 400 mu. It is the largest lake in Yuhuatai District, just like a bright pearl in the south of the city. Lianhua Lake Park, also known as Nanjing Lianhua Lake Sports Park, has indoor comprehensive gyms, outdoor tennis courts, basketball courts, football fields and other sports facilities, as well as barbecue and fishing park and other supporting leisure facilities, providing a good place for the general public to relax on weekends. In spring, with green willows and pink peach flowers, the lake is full of vitality and colors. In summer, ten thousands mu of Lotus are in full bloom, and people can walk on the plank road in the lake to enjoy it. When autumn comes, people can admire the boundless sea of Galsang flowers, which is now a famous Internet celebrity resort.

三桥湿地公园

三桥湿地公园以野生物种栖息、衍生的自然环境构筑长江生态屏障,打造湿地生态特色景观。园区有林草区、密林、特色植被、湿地观赏等区域,以自然特征创造充满生态情趣的江滩湿地环境,是一个集植物观赏、生态科普、候鸟栖息、步道游览、湿地景观为主的生态景区,也是长江沿岸城市湿地可持续开发和保护的典范。每到秋天,公园内的粉黛花如烟似纱,成为著名的网红打卡地,给秋天的南京增添了更多的浪漫色彩。

Sanqiao Wetland Park is a comprehensive project of ecological protection and reservation of wetland of vibrant ecology and rich biodiversity. With its abundance natural resources such as water networks, moors, swamps, mudflats and wildlife, the park has become a natural ecological barrier for the Yangtze River system. Sanqiao Wetland Park fully embodies the natural vitality and prosperity with the multifunction of botany watching, ecological knowledge popularization, migratory birds' habitat and sightseeing. It's also a model of sustainable exploration and protection of urban wetland along the Yangtze River. Every autumn, the pink flowers in the park like smoke and gauze, making it a famous Internet celebrity check-in place, adding more romantic colors to Nanjing in autumn.

花神湖

花神湖面积约 5.6 万平方米,是南京南部地区最大的湖泊,原为丁墙水库。湖上的花神渡桥为 17 孔拱桥,桥的两侧立有掌管四季的兰花、牡丹花、海棠花和梅花四位花神雕像,桥面的栏板上刻着古人咏花的诗词名句。花神湖环境优美,水质清澈,春天杨柳依依,夏日荷花烂漫。里面建有绿色步道和大片草坪供人们健身锻炼,是一个消暑纳凉的胜地。

Huashen Lake covers an area of about 56,000 square meters. It is the largest lake in the southern part of Nanjing, formerly known as Dingqiang Reservoir. Huashen Bridge is a 17-hole arch bridge on both sides of which stand statues of the four flower gods of orchid, peony, crabapple and plum blossom in charge of the four seasons. On the railings of the bridge, there are famous poems and beautiful lines of ancient people eulogizing flowers. Huashen Lake has a beautiful environment and crystal clear water, with willows in spring and lotus flowers blooming in summer. With green jogging paths and large lawns, the park is also an ideal resort for exercise and relieving heat.

天隆寺

　　天隆寺位于雨花台区的玉环山上,被称为"中兴戒律第一祖庭",始建于明朝初年。寺庙被竹林树木环绕,石阶步道幽静,有金刚殿、天王殿、毗卢阁等历史遗址和遗迹。天隆寺塔林是天隆寺历代祖师和其他高僧的安葬地,现在是南京地区规模最大的塔林。塔林内的塔多为石刻而成,有四面或六面,由塔基、塔座、塔身、塔顶构成,装饰图案多采用精雕细刻的花卉、动物和纹饰等,雕刻手法精湛,对研究明、清时期的雕刻艺术有着重要的史料价值。

　　Tianlong Temple, situated on Yuhuan Mountain in Yuhuatai District and known as the "first ancestors' temple of Zhongxing Commandments", was built in the early Ming Dynasty. The temple is surrounded by bamboo forests and lush trees, with sequestered stone steps and paths. There are some historical relics and ruins such as Jingang Hall, Tianwang Hall and Pilu Pavilion. The pagoda forest is the burial ground of the great ancestral masters and other eminent monks and is now of the largest scale in Nanjing area. The pagodas in the pagoda forest are mostly carved from whole stones with four or six sides, composed of base, pedestal, body and top. The exquisite and elegant patterns of flowers, animals, ornamentations on the pagodas highly identify the superb carving techniques which are of great historical value to the study of the carving art in the Ming and Qing dynasties.

Jiangning District

南京禄口国际机场

南京禄口国际机场距离市中心 35.8 公里，于 1997 年 7 月 1 日正式通航。南京禄口国际机场定位为"长三角世界级机场群重要枢纽"，目前拥有 4F 级飞行区，两条平行跑道，两座航站楼，国内、国际两个货运中心，一座综合交通中心。2019 年机场旅客吞吐量突破 3 000 万人次，跻身大型机场行列。截至 2019 年底，南京禄口国际机场航线通达国内、国际（地区）143 个城市，有 68 家国内外航空公司在南京机场运营，每周约 2 260 个航班。南京禄口机场为南京的现代化发展插上了腾飞的翅膀。

Nanjing Lukou International Airport is 35.8 kilometers away from downtown. It was officially opened to navigation on July 1, 1997. Positioned as an important hub of world-class airports in Yangtze River Delta, Nanjing Lukou International Airport has a 4F-category airfield, two parallel runways, two terminals, two domestic and international cargo centers, and a comprehensive transportation center. By 2019, the passenger throughput had exceeded 30 million, making it one of the largest airports. By the end of 2019, Nanjing Lukou International Airport had served 143 domestic and international (regional) destinations, with 68 domestic and foreign airlines operating 2,260 flights per week. Nanjing Lukou International Airport adds wings to the modernization of Nanjing.

牛首山

牛首山因山顶突出的双峰对峙好像牛头双角而得名，东晋时期又称"大阙山"。牛首山自然风光秀美，尤其是春季山岚烟雨，青翠欲滴，素有"春牛首"之美誉。景区历史文化底蕴深厚，佛禅文化源远流长。山顶雄伟壮观的佛顶宫、高耸入云的佛顶塔、静谧藏幽的佛顶寺和山下的郑和公园等是主要景点。佛顶宫供奉着佛顶骨舍利。整个景区在挖掘生态资源、文化资源和旅游资源的基础上，着力打造"生态、文化、休闲"三大业态，充分体现了生态与人文的高度和谐。

Niushou Mountain, also called "Tianque Mountain" in the Eastern Jin Dynasty, is named because of the two peaks standing like two ox horns. The natural scenery of Niushou Mountain is beautiful, especially in spring, the mountains are misty and rainy, and the green is dripping. It is known as the "Spring Niushou". The scenic spot has profound historical and cultural heritage, and the Buddhist and Zen culture has a long history. The lofty and majestic Usnisa Palace where the usnisa is enshrined, the towering Usnisa Pagoda and the quiet and secluded Usnisa Temple are the main scenic spots. Zheng He Park is another attraction. On the basis of excavating ecological resources, cultural resources and tourism resources, the entire scenic spot strives to create three major formats of "ecology, culture and leisure", which fully reflects the high degree of harmony between ecology and humanity.

金陵小城

影视作品：
《极限挑战》

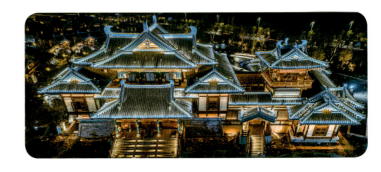

金陵小城以追忆昔日金陵古城盛景，生动再现千年金陵风华为主题，充满文旅和建筑美学智慧，是一个充满江南园林特色、蕴含金陵深厚历史文化底蕴的景区。景区内亭台楼阁错落有致，曲径通幽，竹林、假山、奇石、飞瀑和戏剧尽显江南园林的特色和深厚的文化底蕴。游客在此可以深入了解六朝文化，体验古代文人的风雅生活，领略古金陵的繁华与辉煌。主要景点有文心馆、邻曲巷、凌霄台、绿筱园等，红墙碧瓦，雕梁画栋，古色古香。夜晚的金陵小城灯火辉煌，丰富多彩的表演节目为游客提供了华丽的视觉盛宴。

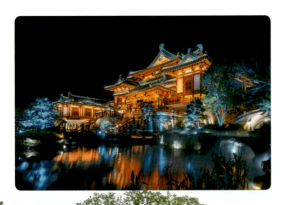

Jinling Town, with the theme of recalling the glorious scenery of ancient Jinling city in the past and vividly reproducing the elegance of Jinling for thousands of years, is full of travel and architectural aesthetic wisdom. It is a scenic spot full of Jiangnan garden features and contains the profound historical and cultural deposits of Jinling. Pavilions and terraces are exquisitely laid out in an asymmetry manner with winding paths, bamboo and pine forests, rockeries, odd-shaped rocks, waterfalls and dramas embodying the unique characteristics and the profound historical heritage of Jiangnan gardens, where visitors can deeply understand the culture of the Six Dynasties, experience the elegant life of ancient literati, appreciate the prosperity and magnificence of ancient Jinling city. The main spots are Wenxin Hall, Linqu Lane, Lingxiao Terrace and Lüxiao Garden, with red walls, green tiles, carved beams and painted buildings of the ancient styles. At night, the town is brilliantly illuminated, ablaze and magnificent. A variety of performances and shows attract visitors with gorgeous visual feast.

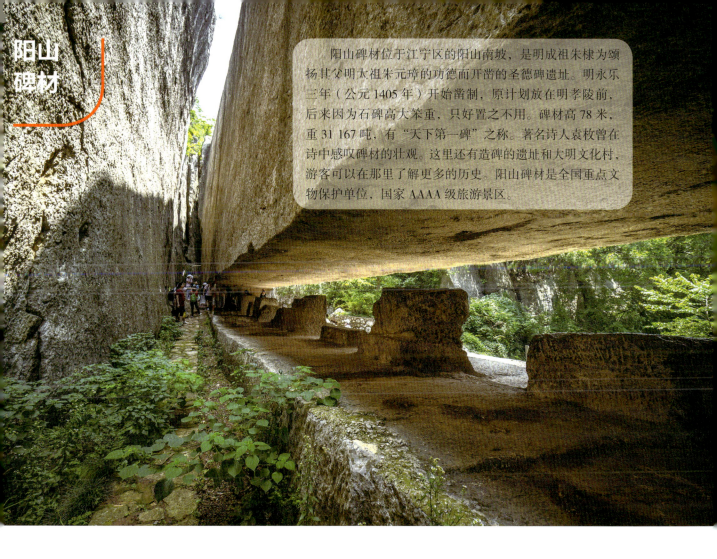

阳山碑材

阳山碑材位于江宁区的阳山南坡,是明成祖朱棣为颂扬其父明太祖朱元璋的功德而开凿的圣德碑遗址。明永乐三年(公元1405年)开始凿制,原计划放在明孝陵前,后来因为石碑高大笨重,只好置之不用。碑材高78米,重31 167吨,有"天下第一碑"之称。著名诗人袁枚曾在诗中感叹碑材的壮观。这里还有造碑的遗址和大明文化村,游客可以在那里了解更多的历史。阳山碑材是全国重点文物保护单位、国家AAAA级旅游景区。

Yangshan Stele stands on the southern slope of Yangshan Mountain in Jiangning District. It is the ruin of the stele made by Emperor Zhu Di of the Ming Dynasty, for praising the great merits and virtues of his father, Zhu Yuanzhang, the Founding Emperor. The work was started in 1405 AD with the purpose of putting it in front of the Ming Tomb, but was abandoned because the stele was too big and heavy. The stele is 78 meters high and weighs 31,167 tons, known as the "No.1 stele on earth". The famous poet Yuan Mei once eulogized the grandeur of the stele in his poem. There are also some ruins of the working sites and the Ming Dynasty Culture Village where visitors can learn more about the history. The stele is now a national key cultural relic protection unit and a national 4A level tourist attraction.

汤山矿坑公园

汤山矿坑公园是由汤山最大的废弃矿坑改造而成的。通过对湿地、草甸、湖泊等进行整治改造，公园现已成为全国矿坑修复的示范性案例。公园以矿坑为主题，有滨水景观、户外剧场、帐篷露营区和儿童游乐等设施，是集休闲、体验、餐饮和环境教育于一体的著名景点。天空走廊、大草坪、三叠湖和人工瀑布等点缀其间，吸引了大量游客。

Tangshan Quarry Park is transformed from Tangshan's largest abandoned quarry. By renovating and transforming wetland, meadow, lake, etc., the park has become a demonstration case of quarry restoration in China. The park is themed with mines and has waterfront landscapes, outdoor theaters, tent camping areas and children's amusement facilities. It is a famous scenic spot integrating leisure, experience, catering and environmental education. Sky corridors, large lawns, three-tiered lakes and artificial waterfalls are dotted among them, attracting a large number of tourists.

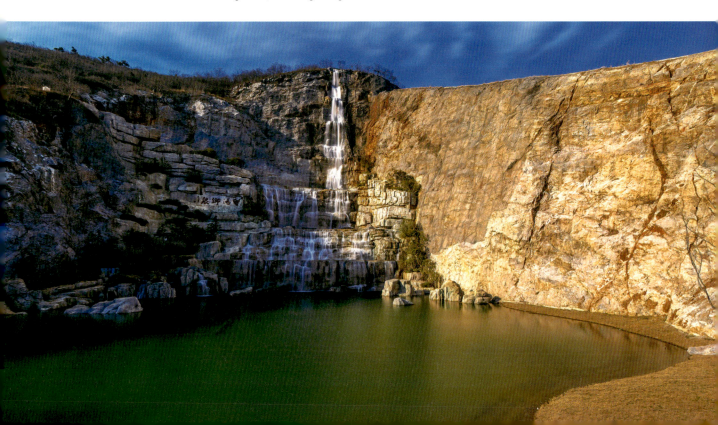

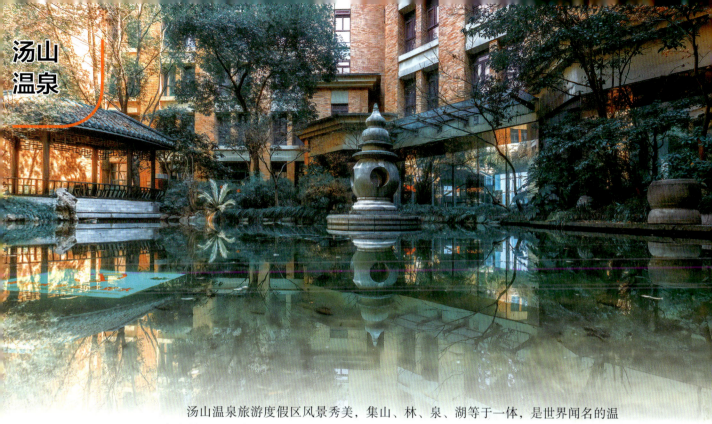

汤山温泉

　　汤山温泉旅游度假区风景秀美，集山、林、泉、湖等于一体，是世界闻名的温泉疗养区。温泉水温常年保持在60到65摄氏度左右，富含多种对人体有益的矿物质和微量元素，自南朝以来就被人们开发利用，至今已有1 500多年历史。汤山温泉被授予"世界著名温泉小镇"和"中国最佳休闲度假旅游目的地"等多项称号。金乌温泉公园以温泉文化为主题，以亲水平台、栈桥、仿古石桥和环湖景观跑道等景观为特色，为游客提供了一个享受温泉美景的理想休闲胜地。

　　Tangshan Hot Spring Tourist Resorts boast beautiful scenery, integrating mountains, forests, springs and lakes. It is a world-famous hot spring resort. The water temperature of the hot springs maintains at about 60 to 65 degrees Celsius all year round and is rich in various minerals and trace elements beneficial to human body. The history of the utilization of hot springs here can be traced back to the Southern Dynasty and has a history of more than 1,500 years. The resorts have been awarded many titles such as "World Famous Hot Spring Town" and "China's Best Leisure Tourist Destination". With the theme of hot spring culture, Jinwu Hot Spring Park is very beautiful with waterfront platforms, trestle bridges, antique stone bridges and loop jogging way around the lake, providing visitors an ideal leisure resort to enjoy the hot spring and the impressive scenery.

江苏园博园

江苏园博园紧邻汤山国家旅游度假区，位于紫金山、栖霞山、宝华山、汤山四个风景区之间，有着优秀的自然禀赋和深厚的文化底蕴。紫东阁为标志性建筑，登上阁楼可北观长江与栖霞，东眺宝华山，西南瞰阳山，景观令人叹为观止。江苏省十三个地级市的园林精美绝伦，各具匠心，点缀景区。观光小火车和缆车为园区提供了便捷的交通。时光艺谷、光智工程、精品花园让园区更具魅力。

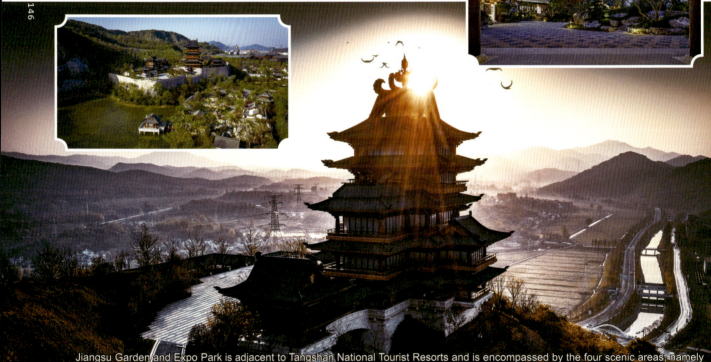

Jiangsu Garden and Expo Park is adjacent to Tangshan National Tourist Resorts and is encompassed by the four scenic areas, namely Purple Mountain, Qixia Mountain, Baohua Mountain and Tangshan Mountain. It has excellent natural endowment and profound cultural heritage. Zidong Pavilion is a landmark in the garden on which you can view the Yangtze River and Qixia Mountain in the north, Baohua Mountain in the east and Yangshan Mountain in the southwest. The landscape is breathtaking. The gardens from the 13 prefecture-level cities of Jiangsu are exquisite and each with its own originality embellishing the scenic area. The scenic train and cable car provide the park with convenient transportation. Time Artistic Valley, optical and intelligent projects and exquisite gardens make the park more attractive.

百家湖

影视作品：
《你好，火焰蓝》

百家湖位于江宁区，有600多年的历史，是江宁第一大湖。因历史上约有一百户人家居住于此，故名"百家"。湖水面积约为2500亩，两岸绿树成荫。湖上有四座桥，其中白龙桥横跨湖心，长度约1000米。百家湖风景秀美，夜晚灯光璀璨，妩媚动人。巨大的摩天轮矗立在湖边，灯火通明。春天，杨柳随风飘扬，人们在河边漫步赏月。现在，百家湖附近已经形成江宁区最大的商贸圈，拥有游乐园、广场等配套设施，是休闲娱乐的新景点。

Baijia Lake, located in Jiangning District, has a long history of over 600 years. It is the largest lake in Jiangning. It was named Baijia because there were about 100 families living nearby in history. The lake covers an area of about 2,500 mu, with green trees lining its bank. Four bridges span over the lake, among which the White Dragon Bridge is the longest with a length of about 1,000 meters. Baijia Lake has a captivating landscape with bright lights at night, charming and alluring. The great ferris wheel stands by the side of the lake, ablaze with lights. In spring, with graceful willows flying in the breeze, people stroll by the riverside enjoying the full moon. Now, Baijia Lake has formed the largest business circle in Jiangning District, with facilities like amusement park and square, making it a new scenic spot for leisure and entertainment.

景枫中心

景枫中心位于江宁区百家湖畔,是百家湖商圈的地标建筑,也是集甲级办公楼、商业配套和高端住宅于一体的商业综合体,交通便利。景枫中心以满足消费人群的不同需求进行业态布局,追求国际化、时尚感,兼具家庭式购物体验,餐饮休闲娱乐等功能。四楼的美食广场创意独特,围绕多彩的海底世界这一主题,强调创意性、互动性,为顾客提供了新奇的美食体验。

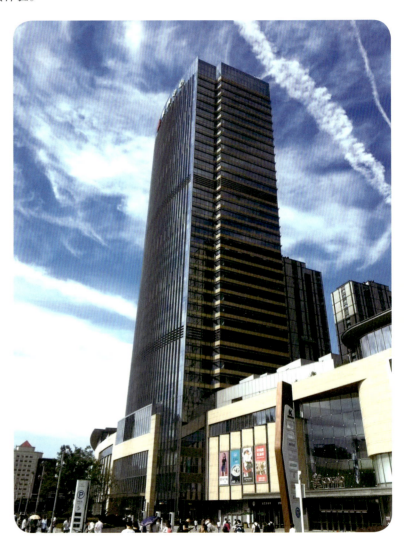

Kingmo is located on the bank of Baijia Lake in Jiangning District. It is the landmark of Baijia Lake commercial area, also a commercial complex featuring Grade A office buildings, commercial facilities and high-class residential communities with convenient transportation. Kingmo meets the different needs of consumer groups, and pursues internationalization and fashion, integrating family-style shopping experience, catering, leisure and entertainment. The food court on the 4th floor is creative and unique, focusing on the theme of the colorful underwater world, emphasizing creativity and interaction, and providing customers with a novel food experience.

凤凰广场

凤凰广场位于百家湖畔，有雕塑群、滨水休闲区、绿地、公共活动区等。时光隧道雕塑造型魔幻，颇具特色。广场整体景观以红色为主基调，绿色植被构成底色，景观现代简约，色彩丰富。主体雕塑"凤凰"立于三层高台之上，造型优雅，寓意美好。夜晚市民们聚集在这里跳广场舞，享受生活的美好。这里是江宁变化发展的见证，也是江宁的新地标之一。

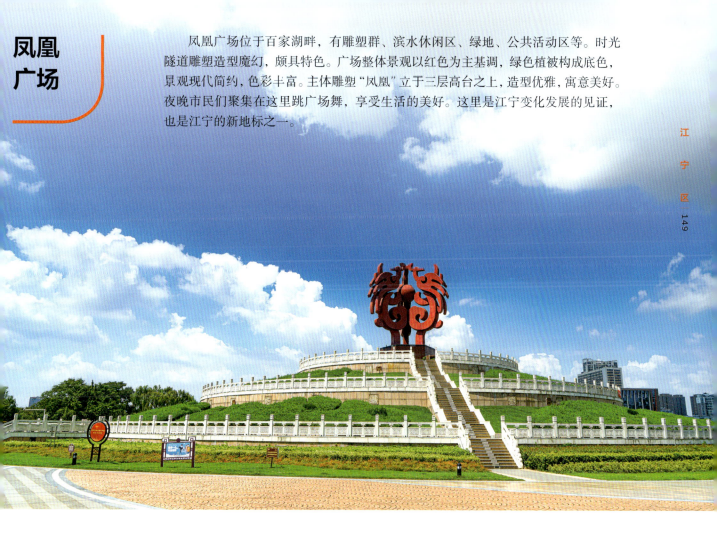

Phoenix Square is located on the bank of Baijia Lake, composed of sculpture groups, waterfront leisure platform, greenbelt and public square, etc. The sculpture of Time Tunnel is magical and distinctive. The overall landscape of the square is dominated by red, with green plants as the background color, modern and simple with rich colors. The main sculpture "Phoenix" stands on the three-layered terrace, elegant in shape and conveys good will. At night, local residents gather here to dance in the square and enjoy good times. It is the witness of Jiangning's profound changes and development, also one of the new landmarks of Jiangning.

银杏湖

银杏湖生态旅游度假区依山傍水、森林环抱，里面有大型游乐场、园林和生态休闲区等，集餐饮、观光、休闲、娱乐于一体。从40米高的摩天轮上，游客可欣赏公园的奇妙全景。建在峡谷上的"城堡"内设410米长的水道，蜿蜒曲折，游客可以体验神秘惊险的"奇幻漂流"。小型湖泊错落有致地点缀在山林之间，有绿道、廊桥相连。游客可以在千年银杏林、天鹅湖、四季花海、双桥湖心岛、音乐喷泉等景观之中畅游。长220米的吊桥横跨在两座小山之间，被称为"圆梦之桥"，为游客提供了体验惊险刺激的高空之旅的好机会。

Ginkgo Lake Ecotourism Resort is surrounded by mountains, rivers and forests. There are large amusement parks, gardens and ecological leisure areas, etc., integrating catering, sightseeing, leisure and entertainment. From the 40-meter-high ferris wheel, visitors can enjoy the marvelous panorama of the park. The castle has a 410-meter-long water way which winds its way down, allowing visitors to experience mysterious and thrilling "fantasy drifting". Small lakes scatter in the forests, connected with bridges and corridors. Visitors can walk among the landscape composed of Millennium Ginkgo Forest, Swan Lake, Four Seasons Flower Sea, Shuangqiao Lake Island and Music Fountain. The 220-meter-long suspension bridge, known as "Dream Bridge", spans astride two hills and provides visitors with a good opportunity to experience thrilling high-altitude trip.

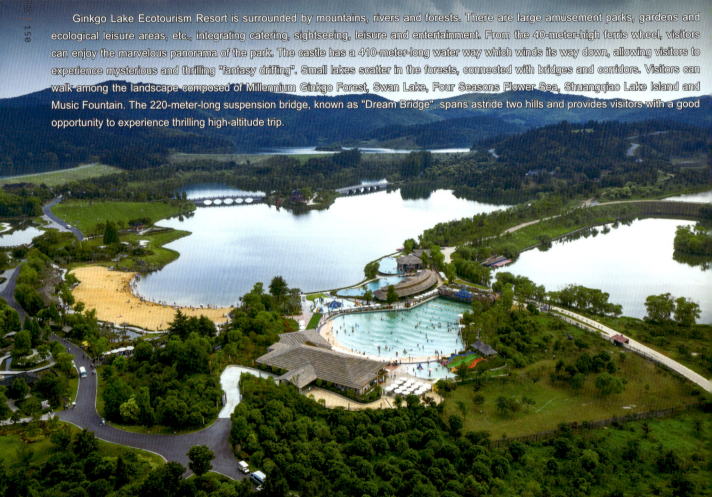

谷里薰衣草庄园

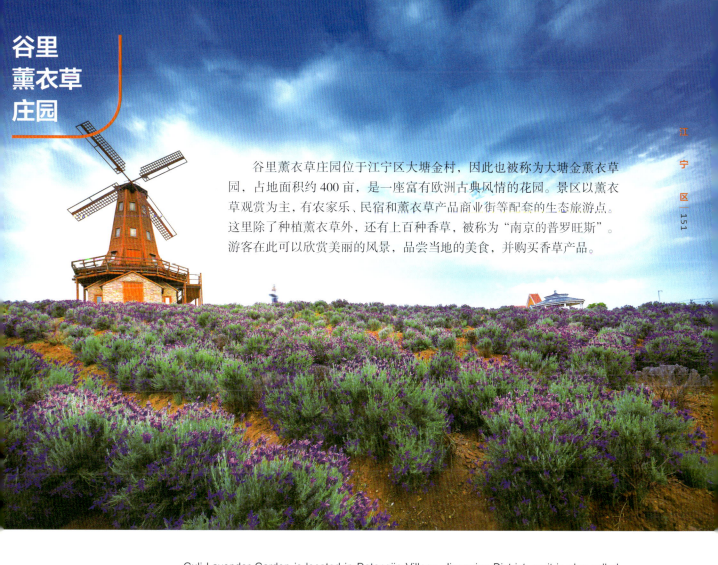

谷里薰衣草庄园位于江宁区大塘金村，因此也被称为大塘金薰衣草园，占地面积约400亩，是一座富有欧洲古典风情的花园。景区以薰衣草观赏为主，有农家乐、民宿和薰衣草产品商业街等配套的生态旅游点。这里除了种植薰衣草外，还有上百种香草，被称为"南京的普罗旺斯"。游客在此可以欣赏美丽的风景，品尝当地的美食，并购买香草产品。

Guli Lavender Garden is located in Datangjin Village, Jiangning District, so it is also called Datangjin Lavender Garden. Covering an area of about 400 mu, it is a garden with rich classical European flavor. Lavender Garden focuses on lavender sightseeing, and there are supporting eco-tourism spots such as farmhouse, homestay business and lavender products commercial street. Besides lavender, there are hundreds of other vanillas and herbs here, so it is known as "Provence of Nanjing". Visitors can enjoy beautiful scenery and local food and buy vanilla products.

黄龙岘

黄龙岘被称为"金陵茶文化休闲旅游第一村",入选首批全国乡村旅游重点村名单。黄龙岘山清水秀,竹林茶园特色鲜明。建筑以徽派为主,突出"小桥流水,春潭柳绿,竹林黛瓦"的江南气息。原汁原味的农家特色菜和绿色食品为游客带来难忘的体验。黄龙大茶馆是游客品茗、赏景、休憩的绝佳去处。黄龙潭四周青翠环绕,是山水合一的雅境。云龙亭、荷塘湿地等魅力无穷。这里是新农村振兴的典范,也是乡村休闲度假的好去处。

影视作品:
《曾少年》

Huanglongxian is known as the "first village of tea culture leisure tourism in Jinling", and was selected into the list of the first batch of national key villages for rural tourism. The picturesque landscape features bamboo forests and tea gardens. The architecture is mainly characterized by Huizhou Style, highlighting the Jiangnan flavor of "small bridges and flowing water, spring pools with green willows, bamboo forests and black tiles". The authentic local specialties and green food provide visitors with unforgettable experience. Huanglong Tea House is a perfect place where visitors can enjoy tea, admire the marvelous scenery, and have a rest. Huanglong Pond is surrounded by bamboo forests and green trees, forming an elegant picture of hill and crystal clear water. Yunlong Pavilion and Lotus Pond Wetland are charming and attractive. It is now a model of new rural revitalization, and also an ideal destination for rural leisure and vacation.

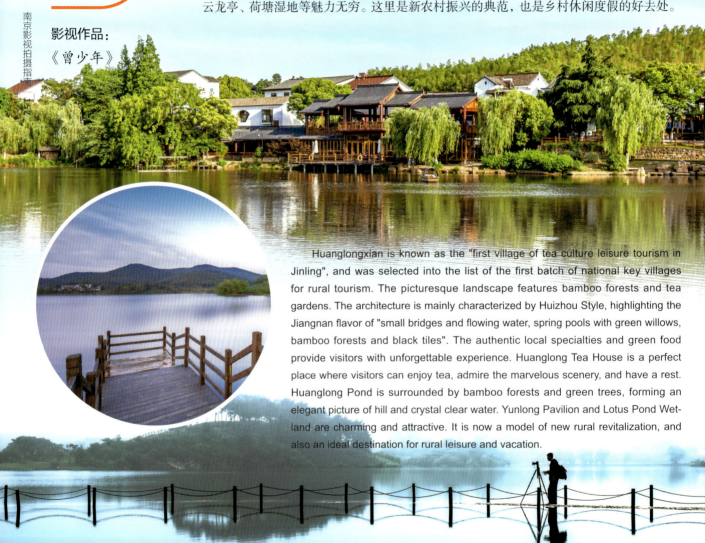

七仙大福村

七仙大福村位于江宁区横溪，占地3 500亩。村子布局以汉唐风格为主，围绕农耕文化和七仙女与董永的爱情传说两大主题，充分挖掘当地历史文化资源，彰显古镇的地方情怀，展现当地人诗意的生活方式。主要景点大门牌坊是徽派建筑风格，古典的设计元素，木质结构，大气恢宏，展现出大福村的热情。七仙大舞台集戏剧观赏、休闲、观光等功能于一体，周围有七仙爱情主题的雕塑，村民们经常聚集在这里休闲娱乐。观音寺和莲花大道等也是著名景点。

Qixian Dafu Village is located in Hengxi, Jiangning District measuring 3,500 mu in size. The design features the styles of Han and Tang Dynasties, focusing on the two themes of the farming culture and the love legend of the Seventh Fairy and Dong Yong. It fully excavates the local historical and cultural resources and highlights the local feelings of the ancient town, showing the poetic lifestyle of local people. The wooden Gate Archway is one of the main scenic spots with Huizhou-style, classical and magnificent, showing the enthusiasm of the village. The Qixian Grand Stage integrates the functions of drama viewing, leisure, and sightseeing, surrounded by seven immortals love-themed sculptures where villagers often gather to enjoy leisure and entertainment. Guanyin Temple and Lotus Avenue are also famous attractions.

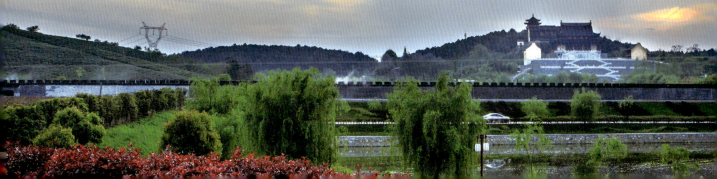

佘村

影视作品：

《王牌部队之英雄岁月》

《你好，火焰蓝》

佘村坐落于大连山与青龙山之间，被誉为"金陵古风第一村"。充满神秘气息的龙都采石场因常年被雨水冲刷，颜色各异，被网友称为"丹霞地貌"和"魔鬼城"。横山水库和佘村水库如两颗明珠点缀着这个古老的村落。村子周围青山环绕，风景秀丽，生活静谧纯朴，宛如世外桃源。

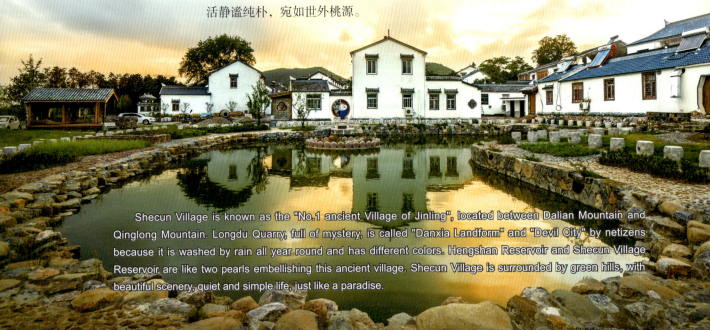

Shecun Village is known as the "No.1 ancient Village of Jinling", located between Dalian Mountain and Qinglong Mountain. Longdu Quarry, full of mystery, is called "Danxia Landform" and "Devil City" by netizens because it is washed by rain all year round and has different colors. Hengshan Reservoir and Shecun Village Reservoir are like two pearls embellishing this ancient village. Shecun Village is surrounded by green hills, with beautiful scenery, quiet and simple life, just like a paradise.

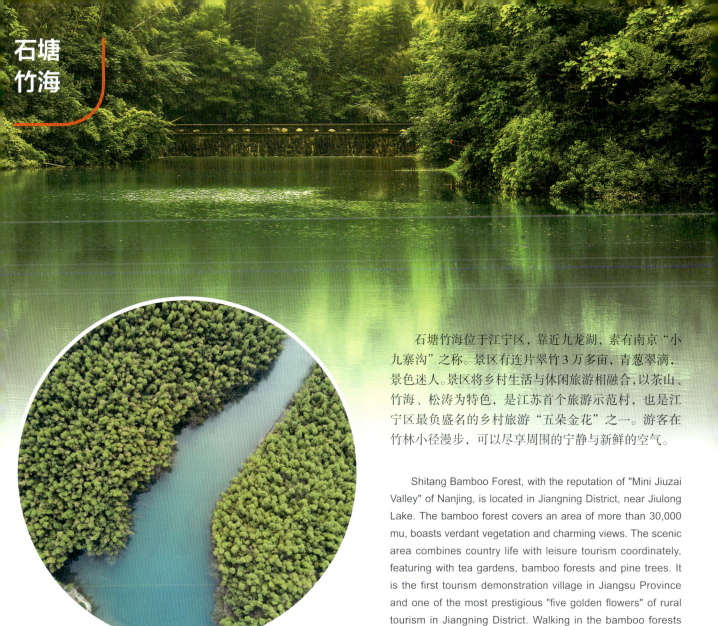

石塘竹海

石塘竹海位于江宁区，靠近九龙湖，素有南京"小九寨沟"之称。景区有连片翠竹3万多亩，青葱翠滴，景色迷人。景区将乡村生活与休闲旅游相融合，以茶山、竹海、松涛为特色，是江苏首个旅游示范村，也是江宁区最负盛名的乡村旅游"五朵金花"之一。游客在竹林小径漫步，可以尽享周围的宁静与新鲜的空气。

Shitang Bamboo Forest, with the reputation of "Mini Jiuzai Valley" of Nanjing, is located in Jiangning District, near Jiulong Lake. The bamboo forest covers an area of more than 30,000 mu, boasts verdant vegetation and charming views. The scenic area combines country life with leisure tourism coordinately, featuring with tea gardens, bamboo forests and pine trees. It is the first tourism demonstration village in Jiangsu Province and one of the most prestigious "five golden flowers" of rural tourism in Jiangning District. Walking in the bamboo forests along the trails, people can appreciate the fresh air and tranquility of nature.

将军山

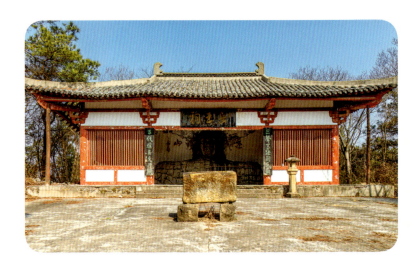

将军山历史底蕴深厚,南宋时期岳飞曾在这里大败金军,连绵数里的军事工事见证了当年的历史,将军山也因此而得名。将军山四周绿树成荫,水清澈见底。森林自然景观优美,空气清新,是著名的天然氧吧,被人们誉为"南京九寨沟"。景区内有利用山体巨石雕刻而成的观音像和为了纪念岳飞而建的将军塔。山间林木苍翠、山花烂漫,茶园、幽静的池林栈道和长长的竹廊情趣盎然。人们可以在此尽享大自然的恩赐,体现了人与自然的高度和谐。

Jiangjun Mountain has a rich history. Yue Fei, a famous general of the Southern Song Dynasty once defeated the Jin army here. Miles of military fortifications witnessed the history of that year, and Jiangjun Mountain was named after it. Jiangjun Mountain is surrounded by lush green forests and crystal clear water. With beautiful natural landscape of forests and fresh air, it is a famous natural oxygen bar, known as "Nanjing's Jiuzhai Valley". There are stone carvings of Guanyin Statue and Jiangjun Tower in memory of Yue Fei. The mountains are lush with green trees and blooming flowers, tea gardens, quiet ponds and forest plank roads and long bamboo corridors are full of interest. People can fully enjoy the gifts of nature here, which demonstrates a harmonious coexistence between humans and nature.

方山风景区

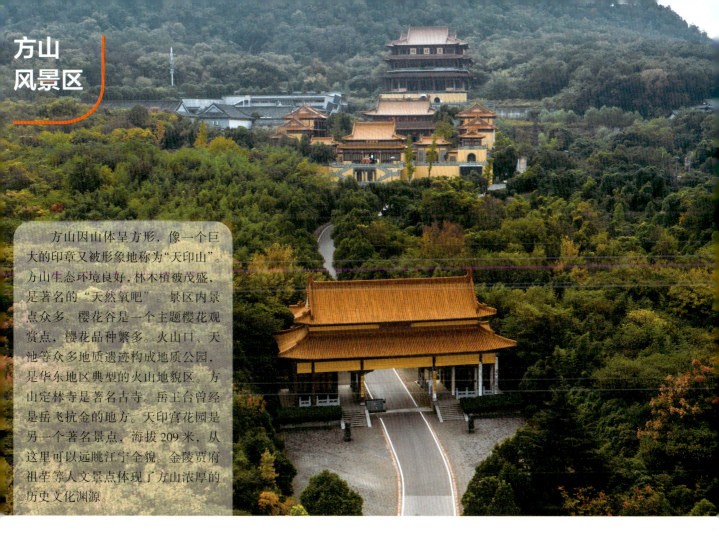

方山因山体呈方形，像一个巨大的印章又被形象地称为"天印山"。方山生态环境良好，林木植被茂盛，是著名的"天然氧吧"。景区内景点众多。樱花谷是一个主题樱花观赏点，樱花品种繁多。火山口、天池等众多地质遗迹构成地质公园，是华东地区典型的火山地貌区。方山定林寺是著名古寺。岳王台曾经是岳飞抗金的地方。天印宫花园是另一个著名景点，海拔209米，从这里可以远眺江宁全貌。金陵贾府祖茔等人文景点体现了方山浓厚的历史文化渊源。

Because of its square shape, Mount Fang looks like a seal and is vividly called "Tianyin Mountain", enjoys a splendid ecological environment with lush trees, known as a "natural oxygen bar". There are many scenic spots in the Fang Mountain Scenic Area. Cherry Valley is a thematic cherry blossoms appreciation spot with varieties of species of cherry blossoms. Many geological relics, such as the Geopark with Volcano Mouth (crater) and Heavenly Pond inside, make it a typical volcanic landform in East China. Dinglin Temple has been famous since ancient times. Yuewangtai is a place where Yue Fei once resisted the Jin invaders. Tianyin Palace Garden is another famous scenic spot. It is 209 meters tall and offers a panoramic view of Jiangning. The ancestral tombs of Jia's Family of ancient Jinling and other cultural attractions reflect the profound historical and cultural origins of Fang Mountain.

定林寺

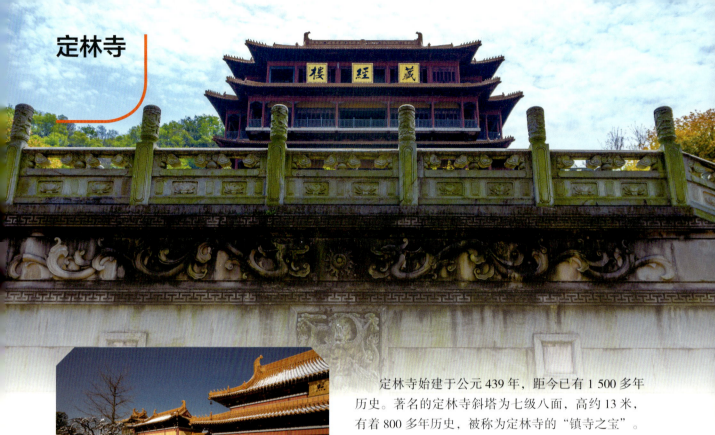

定林寺始建于公元439年，距今已有1 500多年历史。著名的定林寺斜塔为七级八面，高约13米，有着800多年历史，被称为定林寺的"镇寺之宝"。南朝梁武帝时期，菩提达摩曾到此地参禅并留下"达摩崖"等遗迹。大雄宝殿是定林寺的主体建筑，里面供奉着"药师佛"，另外还有天王殿和钟、鼓楼等。位于定林寺西侧山腰的八卦泉不仅是寺内著名景点，而且还富含对人体有益的微量元素的矿泉水而著名。

Dinglin Temple was built in 439 A.D. with a history of more than 1,500 years. The famous Oblique Pagoda is considered as the "heirloom of the temple", with a history of more than 800 years. It is an octahedral pavilion-like pagoda with seven storeys, with a height of about 13 meters. During the reign of Emperor Wu of Liang in the Southern Dynasty, Bodhidharma visited the temple for meditation and left relics such as "Dharma Cliff". The Great Hall is the main building of the temple, which enshrines "Medicine Buddha". There are the Hall of the Heavenly King, the Bell Tower and Drum Tower and other buildings. Located on the hillside of the west side of Dinglin Temple, the Eight Diagrams Spring is not only a famous scenic spot, but also rich in beneficial trace elements.

龙湖南京龙湾天街

龙湖南京龙湾天街位于江宁区市民公园东侧，紧邻小龙湾，地理位置优越。天街设计时尚，流线型内部环境宛若银河在天上流淌，是集购物、餐饮、休闲、娱乐等多业态于一体的一站式商业服务综合体。天街不仅满足顾客的日常生活购物所需，更带来新鲜的感受、惊喜和灵感，点亮每一个平凡的日子，传递家人的美好回忆。天街建筑独特而时尚的现代流线型设计，使其成为当地的地标性建筑，五彩缤纷的灯光和霓虹灯牌耀眼夺目，绚丽迷人。

Nanjing Longwan Paradise Walk is located on the east side of Civic Park in Jiangning District, near Xiaolong Wan, with a superior geographical location. Paradise walk has a fashionable design and a streamlined internal environment like the Milky Way flowing in the sky. It is a one-stop commercial complex integrating shopping, catering, leisure, entertainment and other business formats. Jiangning Paradise Walk not only meets the daily needs of customers, but also brings fresh feelings, surprises and inspiration, lights up every ordinary day and conveys the good memories of the family. The unique and fashionable modern streamlined design of the buildings in Paradise Walk makes it a local landmark, dazzling with colorful lights and neon signs, splendid and charming.

文鼎广场

文鼎广场位于江宁大学城,占地70亩,总建筑面积6.5万平方米,因其繁华热闹,被称为"大学城的新街口"。广场是一个开放式的商业综合体,拥有99商业街区和其他一些商业区,包括购物、餐饮、娱乐、高档写字楼等。水街内集中了全国各地的美食,是吃货们的天堂。广场周边环境良好,水街后面的公园内有小桥流水和儿童乐园。临水店铺更别有风味。夜幕降临时,街道上灯火辉煌,游客熙熙攘攘。

Wending Plaza is located in Jiangning University Town, covering an area of 70 mu, with a total construction area of 65,000 square meters. It is busy and prosperous and is known as the "Xinjiekou of the university town". The plaza is an open commercial complex with the 99 Block and some other business areas which include shopping, catering, entertainment, high-end office buildings and so on. Water Street gathers delicacies from all over the country and is a paradise for foodies. The environment is perfect. Behind Water Street there is a park with a small bridge over running water and an amusement park. Those waterfront shops are of special styles. When evening comes, the street is ablaze with lights and bustling with visitors.

小龙湾桥

小龙湾桥横跨秦淮河,位于杨家圩湿地公园,全长1 064米,是江宁第一座悬索桥。夜幕降临后,在灯光勾勒下,一桥飞渡,身姿优雅。桥上飞下的彩色瀑布、幻彩灯光带以及四个桥墩上的LED像素屏不停变换的图案使小龙湾桥迅速成为网红景点。现在,它是江宁的独特地标。

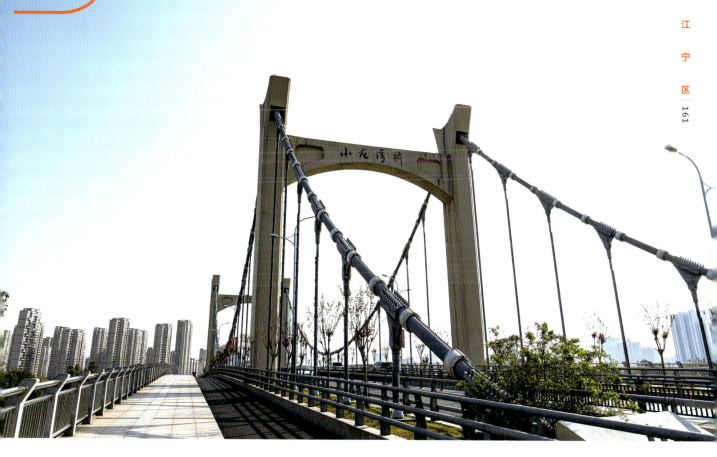

Xiaolongwan Bridge is situated in Yangjiawei Wetland Park, spanning astride Qinhuai River. It is the first suspension bridge in Jiangning District with a length of 1,064 meters. When evening comes, the bridge shines with dazzling brilliance, elegant and charming. The colorful waterfalls flying off the bridge, the fantastic light strips and the constantly changing images of the LED pixel screen on the four piers make Xiaolongwan Bridge quickly become a cyber celebrity attraction. Now, it is a unique landmark of Jiangning.

华谊兄弟（南京）电影小镇

华谊兄弟（南京）电影小镇位于上秦淮湿地公园内，占地2 500亩。小镇以电影文化为主题，结合丰富多彩的南京本土文化和国际多元文化和时尚元素，既是古代都市繁华的缩影，也体现了多元文化的魅力。小镇以身临其境的户外表演，致力于发展集影视艺术、观光、娱乐、餐饮、体验为一体的新型旅游业态。小镇以民国风格建筑为主，也有意大利风格的建筑以及明清建筑等。

Huayi Brothers (Nanjing) Film Town is located in the Upper Qinhuai River Wetland Park, covering an area of 2,500 mu. With film culture as the theme, the town combines the rich and colorful local culture of Nanjing and international multicultural and fashion elements, which not only is the epitome of the prosperity of ancient cities, but also reflects the charm of diversified cultures. With immersive outdoor performance, it is dedicated to develop a new type of tourist business of film art, sightseeing, entertainment, catering and experience. The town is mainly built in the style of the Republic of China, and there are also Italian style buildings and Ming and Qing architectures.

Lishui District

石湫影视基地

石湫影视基地总面积近 3 万亩，是江苏的影视文化名片，被称为"东方环球影视城"。基地重现经典的民国建筑群，成为以民国拍摄背景为主题的综合性大型影视城，为电影人提供全方位的服务。基地根据自然生态环境布局，河湖树木与特色建筑构建富有文化气息的人居环境，同时打造特色影视文化体验场所。民国街、大教堂、大花园等景点深受游客喜爱。《金陵十三钗》《推拿》《一站到底》等电影或综艺节目都曾在这里拍摄。

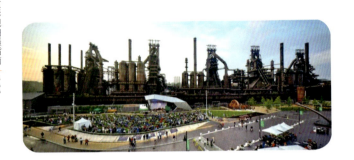

Shiqiu Film and TV Base has a total area of nearly 30,000 mu, is the name card of TV and film culture in Jiangsu Province, known as the "Universal Studio in the East". The base recreates the classic architecture complex of the Republic of China and becomes a comprehensive large-scale film and television city in China with the theme of shooting scenic sites of the Republic of China, offering a comprehensive service for film makers. According to the natural ecological environment, the base builds a living environment rich in cultural atmosphere with lakes, rivers and forests, creating a site for characteristic film and television culture experience. The Street of Republic of China, the Cathedral and the Grand Garden are all popular spots. Some famous films or TV shows such as *The Flowers of War*, *Blind Massage*, and *Who's Still Standing* have been shot here.

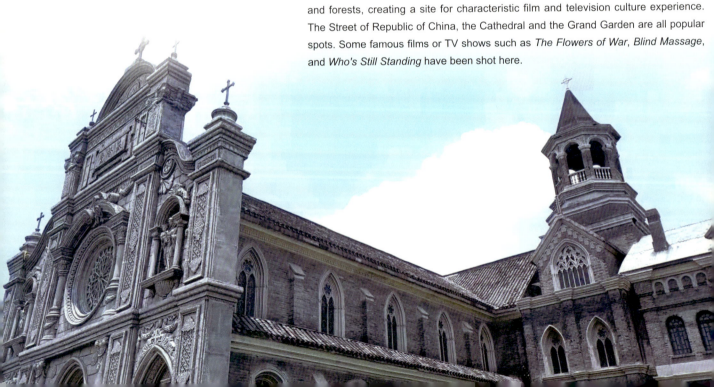

无想寺

无想寺位于溧水无想山国家森林公园内,始建于六朝中期,历史上颇负盛名。无想山景区依山傍水,绿树成荫,竹林环绕。景区内无想山、平安山等青葱翠绿,点缀着碧波荡漾的天池、水库等,风景如画。松林、竹林掩映着亭台古迹,构成集"山水""人文""竹海"于一体的寻古探幽绝美之景,被称为"溧水第一胜境"。自古以来,无数文人雅士到此游览并留下千古佳句,最著名的是北宋周邦彦任职溧水期间写下的《满庭芳·夏日溧水无想山作》。

Wuxiang Temple is located in the Wuxiang Mountain National Forest Park. Built in the middle of the Six Dynasties, it was very famous in history. Wuxiang Mountain Scenic Area is surrounded by mountains, lakes, lush trees and bamboos. Wuxiang Mountain, Ping'an Mountain and some others dot among the rippling Tianchi and some other lakes or reservoirs, presenting a fantastic landscape. Ancient sites and pavilions are under the exuberant foliage of pine trees and bamboos, forming a tranquil and marvelous scenic spot which embodies the complex meaning of "landscape", "humanities" and "bamboo forests". It is known as the "best scenic spot in Lishui". Since ancient times, countless literati and elegant scholars have visited this place and left long-lasting quotes, the most famous of which is *Mantingfang, Written for Lishui Wuxiang Mountain in Summer*, written by Zhou Bangyan, a poet of the Northern Song Dynasty during his tenure in Lishui.

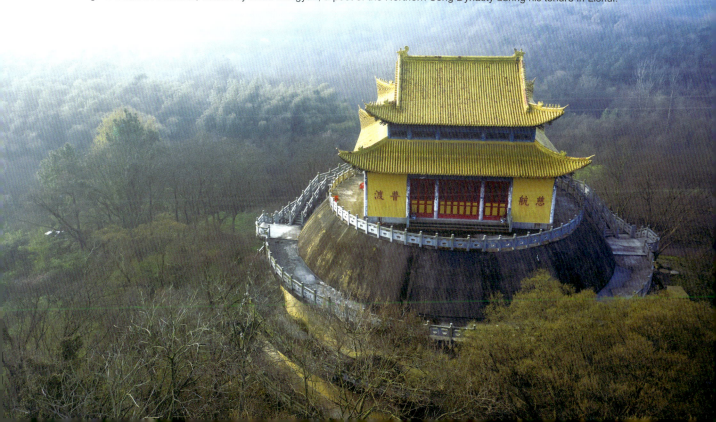

石臼湖

石臼湖，又名"北湖"，面积207.65平方公里。石臼湖生态环境保护良好，从空中看去宛如一面镜子映照着蓝天白云。石臼湖大桥似一道彩虹横跨在平静的湖面上。乘坐地铁S9号线，可以欣赏到如画般的湖光山色，领略飞翔在仙境的感觉。湖边的湿地公园是候鸟的天堂，湖水清澈见底，藻类色彩斑斓。每到周末或者节假日，大批游客慕名而来，欣赏湖面美景，品尝湖内特产。

Shijiu Lake, also known as "North Lake", covers an area of 207.65 square kilometers. The lake is well protected in terms of the ecological environment. Looking from the sky, the lake is like a mirror reflecting the blue sky and white clouds, with the long Shijiu Lake Bridge winding its way across the lake like a rainbow. Taking Metro Line S9, people can admire the picturesque view of the vast lake, appreciating the feeling of flying in a fairyland. With crystal clear water and colorful algae, the wetland by the lake is a paradise of migrating birds. At weekends and on holidays, large numbers of visitors come to enjoy the beauty of the lake and its specialties.

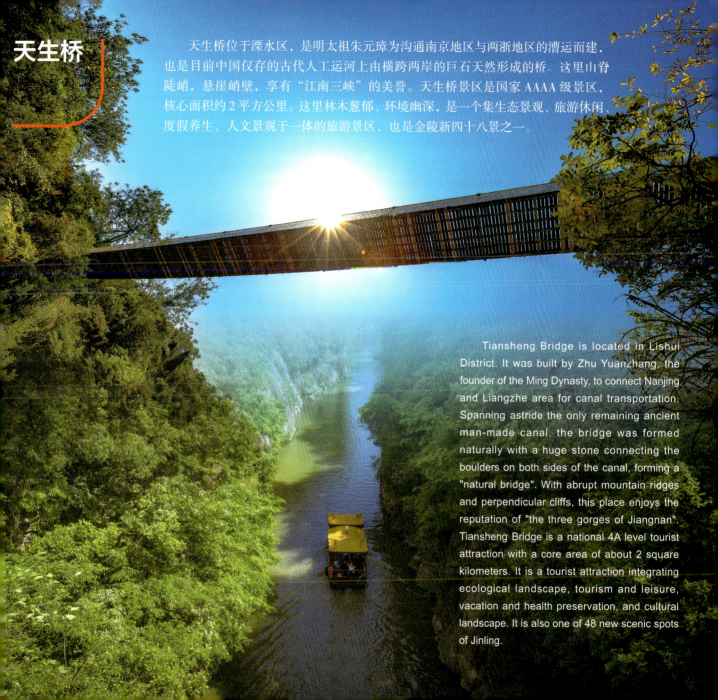

天生桥

天生桥位于溧水区，是明太祖朱元璋为沟通南京地区与两浙地区的漕运而建，也是目前中国仅存的古代人工运河上由横跨两岸的巨石天然形成的桥。这里山脊陡峭、悬崖峭壁，享有"江南三峡"的美誉。天生桥景区是国家AAAA级景区，核心面积约2平方公里。这里林木葱郁、环境幽深，是一个集生态景观、旅游休闲、度假养生、人文景观于一体的旅游景区，也是金陵新四十八景之一。

Tiansheng Bridge is located in Lishui District. It was built by Zhu Yuanzhang, the founder of the Ming Dynasty, to connect Nanjing and Liangzhe area for canal transportation. Spanning astride the only remaining ancient man-made canal, the bridge was formed naturally with a huge stone connecting the boulders on both sides of the canal, forming a "natural bridge". With abrupt mountain ridges and perpendicular cliffs, this place enjoys the reputation of "the three gorges of Jiangnan". Tiansheng Bridge is a national 4A level tourist attraction with a core area of about 2 square kilometers. It is a tourist attraction integrating ecological landscape, tourism and leisure, vacation and health preservation, and cultural landscape. It is also one of 48 new scenic spots of Jinling.

大金山风景区

大金山风景区紧邻东屏湖,旅游资源丰富,既有绚丽多彩的自然风景,又有威武庄严的军事景观,是集生态自然景观、休闲旅游、会议商住、人文景观和国防教育于一体的综合旅游景区。凌霄阁位于大金山之巅,俯瞰东屏湖,远眺东庐山,人们在此可以领略特有的风光秀色。国防教育展览馆以图片、雕塑及实物等展示了战争年代的烽火硝烟。现在,景区已经成为宁杭生态旅游带上的一颗明珠。

Dajin Mountain Scenic Area is adjacent to Dongping Lake, with both gorgeous and colorful natural scenery and majestic solemn military landscape, forming a comprehensive tourism area, integrating natural landscape, tourism and leisure, conference and business accommodation, human landscape and national defense education. Lingxiao Pavilion stands on the top of Dajin Mountain, from which people can enjoy the gorgeous view of Dongping Lake and Donglu Mountain in a far distance. In the national defense education hall, there are pictures, sculptures and real materials that demonstrate the scenarios of war. Now, it is a pearl in the eco-tourism belt of Nanjing-Hangzhou.

东庐山观音寺景区

东庐山观音寺景区以其壮丽的自然风光和众多的历史遗迹而闻名于世，享有"东庐叠巘"之美誉。景区总面积12平方公里，主峰海拔289米。观音寺始建于元代，背倚东庐山，面临中山湖，历史悠久，香火旺盛。重建的寺院规模宏大，有天王殿、钟楼、鼓楼和大佛像等，是溧水重要的佛教圣地。东庐山也是百里秦淮河的源头之一，景区内有狮子山、白虎山、庐峰等十余座山峰，长约7.5公里，遍布竹林亭台、山泉溪流等，幽静秀美，宛若人间仙境。

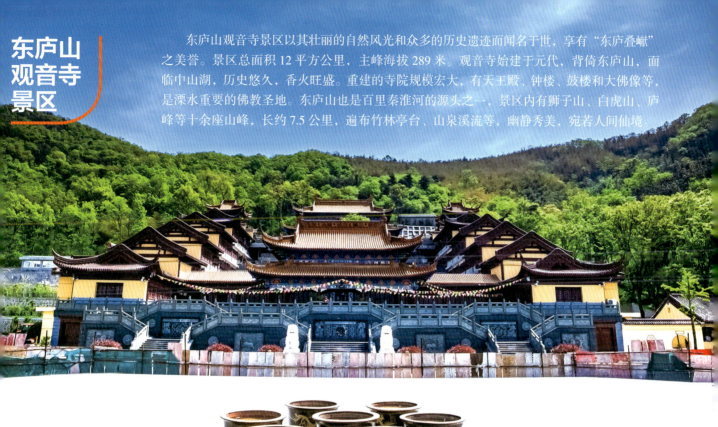

　　Donglu Mountain Guanyin Temple Scenic Area is famous for its splendid natural scenery and numerous historical remains, enjoying the reputation of "Donglu Dieyan (the stacked peaks)". It covers a total area of 12 square kilometers with the main peak of 289 meters above sea level. Guanyin Temple was built in the Yuan Dynasty, back against Donglu Mountain and facing Zhongshan Lake. It has a long history and striving incense. There are many ancient buildings like Tianwang Grand Hall, bell tower, drum tower and the large Buddhist statue, making the temple an important center of Buddhism in Lishui. Donglu Mountain is also one of the headwaters of the Qinhuai River, comprises many notable spots, including more than 10 peaks, such as Lion Mountain, White Tiger Mountain and Lufeng, which stretch about 7.5 kilometers and dotted with bamboo forests, pavilions, springs and creeks. It is tranquil and beautiful, just like a wonderland on earth.

状元坊文化公园

状元坊文化公园有着深厚的历史人文底蕴,旁边的小河是南京秦淮河的源头。北宋崇宁四年(公元1105年)俞栗成为溧水历史上第一位状元。他为官清正廉明,后来遵循朝廷惯例建造状元坊。状元坊有前厅和后院,为中式古典建筑风格,有照壁和古色古香的圆门等。园中的荷花湖中有一个帆船造型的喷泉,景色优美。园里有大量的诗歌对联,激励年轻人发奋读书。

Zhuangyuanfang Cultural Park has profound historical and cultural connotations. Next to the park lies a small river which is the source of Qinhuai River. In the fourth year of Chongning (1105 A.D.) of the Northern Song Dynasty, Yu Li, who was honest and upright, became the No.1 Scholar in Lishui. Later, following the practice of the imperial court, he built Zhuangyuanfang(The No. 1 Scholar's Residence). Zhuangyuanfang has a front hall and a backyard, as well as a screen wall facing the gate of a house with antique round doors. All the architecture is of ancient Chinese style. The park has beautiful scenery with a lotus lake, among which there is a fountain shaped like a sailboat. A large number of poems and couplets here inspire young people to study hard.

周园

周园占地面积100多亩，由周园、文化艺术展示中心及徽文化精品体验中心三部分组成，是中国最大的私人收藏馆，享有"北有故宫，南有周园"的美誉。主要景观有周家大院、石雕群、周氏祠堂、根雕馆等。周家大院占地面积6 000多平方米，老宅整体从安徽搬迁而来，雕龙画凤，极尽奢华。园内还有玉雕、古床、古董家具、佛像、壁画等珍贵的文化艺术品。这些奇珍异宝让游客们眼界大开，叹为观止。

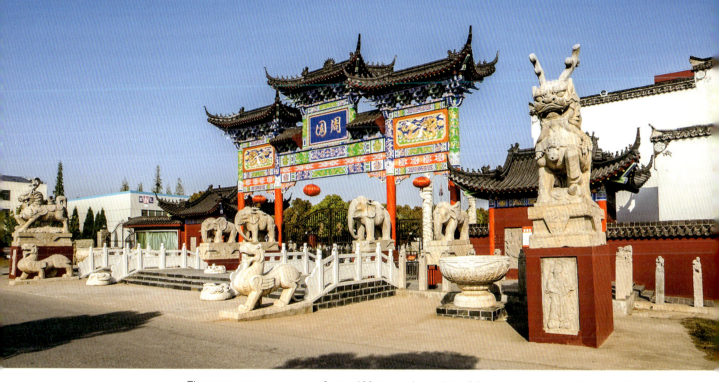

Zhouyuan covers an area of over 100 mu and consists of three parts, namely Zhouyuan Garden, the Culture and Artistic Exhibition Centre and the Hui Culture Experience Centre. It is the largest private collection in China, with the reputation of "the counterpart of the Palace Museum in the south". There are many resorts like Zhou's courtyard, stone carving group, Zhou's ancestral hall and root carving museum. Zhou's courtyard covers an area of more than 6,000 square meters with extravagant architectures carved with patterns of dragons and phoenixes. The whole structure was moved here from Anhui integrally. Zhouyuan also brings together a comprehensive collection of other ancient cultural works of art, including jade carvings, ancient beds, antique furniture, Buddhist statues and murals. These rare treasures are eye-opening and breathtaking.

溧水城隍庙文化街区

溧水城隍庙文化街区以舒适雅致的园林小品和体现唐代风情的商业街为游客带来观光、购物、娱乐、住宿一站式文旅新体验。街区各点以水系相连，街巷的石板路、小桥流水等都具有江南特色。花间堂、保利大剧院等知名品牌落户于此，形成民宿、商业、餐饮等休闲娱乐综合体。街区内历史文化资源丰富，有文昌阁、崔致远纪念馆等景点。水幕灯光秀、夜间演艺、当地美食等系列活动把街区打造成了热门的文化旅游休闲胜地。

With elegant gardens and commercial streets reflecting the style of the Tang Dynasty, Chenghuang Temple Cultural Block provides visitors with a fresh one-stop cultural and tourism experience of sightseeing, shopping, entertainment and accommodation. All sites in the street are linked by a water system, with stone paths and small bridges, all of which have the characteristics of Jiangnan. Famous brands such as Blossom House and Poly Grand Theatre have settled here, forming leisure and entertainment complex such as B&B, business and catering. The street is rich in historical and cultural attractions, including Wenchang Pavilion, Cui Zhiyuan Memorial Hall and so on. A series of activities, such as water screen hologram projection, night shows and local delicacies have made the street a popular cultural tourist and leisure destination.

江苏万驰国际赛车场

江苏万驰国际体育公园位于溧水区,距离南京城区30分钟车程,占地面积3 000亩,是江苏省首家以汽车运动为主题的3A级景区,有符合国际汽联标准的专业赛车场和卡丁车、越野车运动场地,设施齐全、先进。园区举办国际、国内汽车运动多项赛事,涵盖旅游交通、旅游游览设施、旅游安全、环境卫生、娱乐及餐饮保障、资源和环境保护等多种业态,成为南京时尚体育运动的重要标志性场所。

Jiangsu Wantrack International Sports Park is located in Lishui District, 30 minutes' drive from the downtown of Nanjing, covering a total area of 3,000 mu. It is the first professional race circuit meeting FIA standard in Jiangsu, also a thematic park of motor sports. It is now a 3A scenic spot. Many important international and domestic car sport events are held here every year. With convenient transportation and high-qualified tourism facilities, such as the go-carting and cross country areas, the park has become a complex of transportation, tourism safety, sanitation, environmental protection, entertainment and catering, boasting the symbol of fashionable sports in Nanjing.

Gaochun District

高淳
国际慢城

高淳国际慢城位于桠溪街道,面积80平方公里,生态景观廊道全长48公里。2010年11月,桠溪"生态之旅"被正式授予"国际慢城"称号,成为中国慢城概念的引领者。桠溪生态旅游是以慢生活、慢休闲、慢运动为主题,集生态观光、农业体验、休闲度假于一体,整合山地生态资源,将秀丽的自然景观与古吴、楚文化相结合,赋予生态之旅文化内涵。游子山、高淳老街、固城湖等都是著名景点。景区优美的自然环境与独具风情的特色村让游客尽情享受诗情画意的田园生活。

Gaochun International Cittaslow lies in Yaxi, covering an area of 80 square kilometers, with a total length of 48 kilometers of ecological landscape corridor. In November 2010, Yaxi Ecological Tour was awarded the title of "International Cittaslow" and became the pioneer of the Cittaslow concept in China. Yaxi Ecological Tour is a slow life leisure vacation destination with the theme of slow life, slow leisure and slow sports, integrating ecological sightseeing, agricultural experience and leisure vacation with the integration of hilly ecological resources, connecting the beautiful natural landscape with the ancient Wu and Chu culture, endowing the ecological journey with cultural connotations. Youzi Mountain, Gaochun Old Street and Gucheng Lake are all famous tourist spots. Not only can visitors enjoy the gifts of nature, but also experience the poetic and idyllic country life.

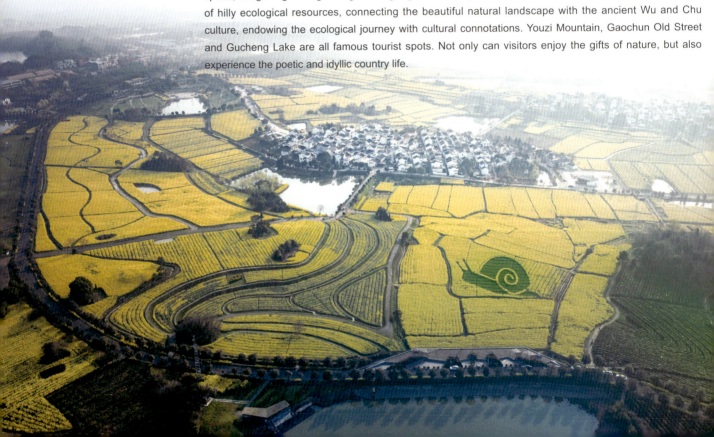

固城湖国家城市湿地公园

固城湖国家城市湿地公园位于固城湖西北岸，核心面积约 13 平方公里，是江苏省面积最大的湿地公园。公园内湖光山色，杨柳依依，景色秀美。荷花园、芦苇荡、湿地和杉树林等与湖水相互映衬。广场、花海等文化主题公园和各种形状的廊桥、栈道等更丰富了旅游资源。一望无际的花海内有不同品种的菊花和马鞭草等，色彩艳丽，美不胜收。公园内有大片的草坪、步道和餐厅等，游客既可以欣赏美景，锻炼身体，又可以品尝当地美味。

Located on the northwest bank of Gucheng Lake, Guchenghu National Urban Wetland Park covers a core area of about 13 square kilometers, making it the largest wetland park in Jiangsu Province. The park endows a splendid landscape of mountains, lake with tender willows. Lotus gardens, reed marshes, wetlands and cedar forests coordinately dot among the park, bringing out the best to each other. Squares and gardens, together with corridors and trestle paths of various shapes enrich the tourism resources. The boundless sea of flowers is dotted with different species of chrysanthemum and verbenas, etc., creating a colorful blanket. There are large patches of lawns, trails and restaurants in the park, where visitors can enjoy the beautiful scenery, exercise and enjoy local delicacies.

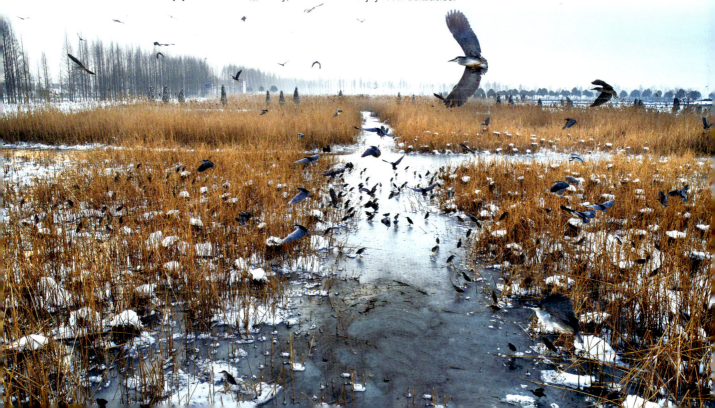

高淳老街

高淳老街初建于宋代，是江苏省目前保存最为完好的明清古街之一，2012年成功入选"全国十大历史文化名街"。老街以白墙青瓦、雕梁画栋，展现了宏伟的古代建筑艺术和深厚的民俗文化，被誉为"东方文明之缩影""古建筑的艺术宝库"。老街景点众多，有非遗展示馆、雕刻展示馆、关王庙、民俗表演馆等，充分展示了当地的风土人情。抗日战争时期，新四军司令部就设在老街的吴氏宗祠内。老街集餐饮、客栈、酒吧、文创精品等为一体。走在老街上，人们能感受传统建筑的智慧与优雅，远离喧闹，心旷神怡。

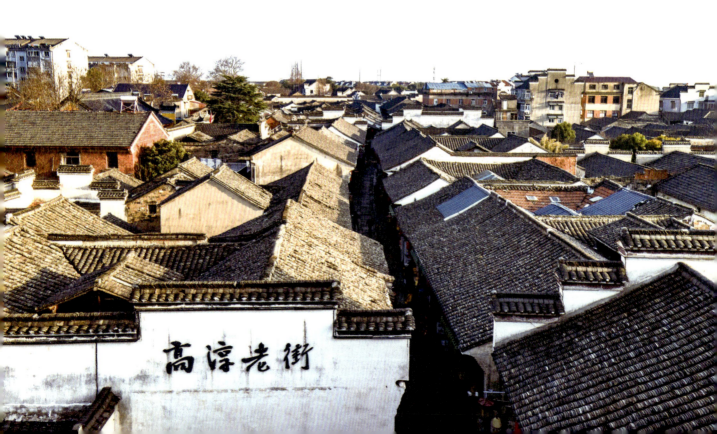

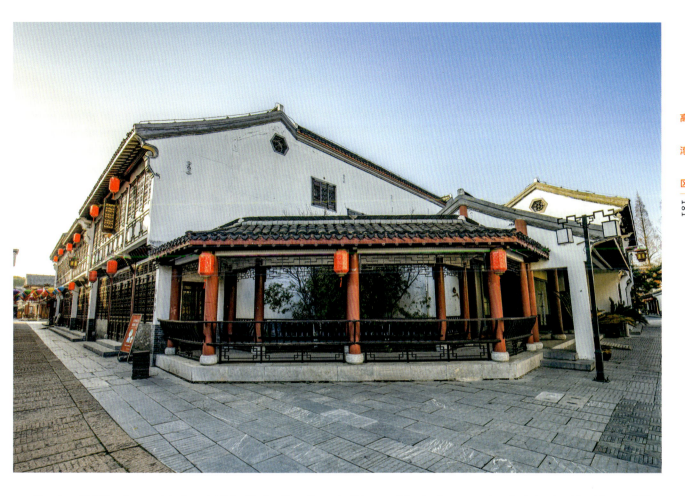

 Gaochun Old Street was originally established in the Song Dynasty. It is one of the best-preserved ancient streets of the Ming and Qing Dynasties in Jiangsu Province, It was selected as one of the "top 10 famous streets of history and culture in China" in 2012. The old street shows the magnificent ancient architectural art and profound folk culture with white walls lined with black tiles, carved beams and painted buildings, and it is honored as "the epitome of oriental civilization" "the artistic treasure house of ancient architecture". Main attractions such as Gaochun intangible cultural heritage exhibition hall, sculpture exhibition hall, Guan Wang Temple, folk performance hall, offer a glimpse of the local culture and folk customs. During the Anti-Japanese war, the former site of the headquarters of the first branch of the New Fourth Army was in the ancestral hall of the Wu clan. The street integrates catering, inns, bars, cultural and creative products, etc. Entering the time-honored street, visitors can admire the wisdom and elegance of ancient tradition, stay away from bustle and hustle and embrace tranquility.

固城湖

固城湖生态系统完好,面积24.3平方公里,地理位置得天独厚,交通便利。固城湖水慢城是一个著名旅游区,面积约8 000亩。固城湖依托优越的生态环境和自然人文景观,集生态养殖、生态旅游、科普教育、水上娱乐、餐饮、运动于一体,具有典型的地方特色。水杉大道、千亩荷园、湿地动物园和滨湖花海等成为热门景点,吸引了众多游客。固城湖大闸蟹是当地特产,已被列入农产品地理标志。

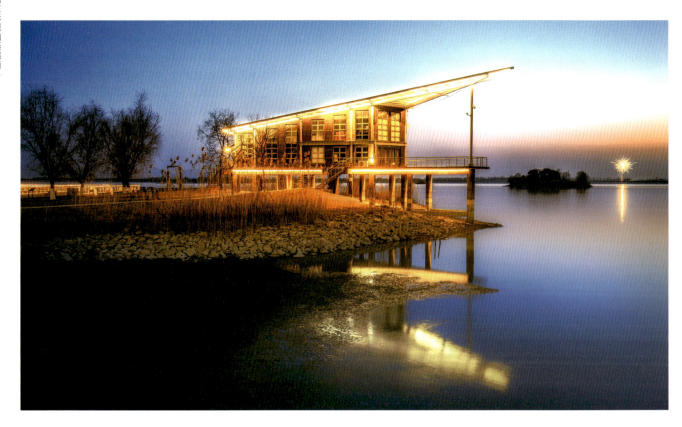

Boasting its intact ecosystem, Gucheng Lake covers an area of 24.3 square kilometers with advantageous geographical location and convenient transportation. Gucheng Lake Water Cittaslow is a famous tourism resort, with an area of over 8,000 mu. Relying on its well-integrated ecosystem and rich cultural landscape, the scenic area is a collection of ecological breeding, ecological tourism, science education, water entertainment, catering, sports with typical local characteristics. Popular tourist attractions such as Metasequoia Avenue, lotus garden, wetland zoo and the lakeside flower sea attract tens of thousands of visitors. Gucheng Lake crabs are the local specialties and have been enlisted the Agro-product Geographical Indications.

关王庙

位于高淳老街的关王庙是江南地区唯一现存的供奉三国名将关羽的庙宇，始建于明弘治四年（公元1491年）。寺庙占地3 800多平方米，建筑宏伟，布局严谨。庙内有九龙照壁、左右钟鼓亭等，威风凛凛的关羽塑像栩栩如生，庄严肃穆。传说农历五月十三是关羽生日，民间做"关王会"以纪念这位有传奇色彩的武将。庙里的一副对联高度赞扬了关羽忠勇的品格和高尚的道德情操。

Guan Wang Temple, located in Gaochun Old Street, is the only existing temple commemorating Guan Yu, the famous warrior during the Three Kingdoms. The temple was originally built in the fourth year of Hongzhi of the Ming Dynasty (1491 A.D.), covering an area of more than 3,800 square meters. It is a magnificent building with a delicate layout and a Nine-Dragon Wall, bell and drum pavilions on both sides. The grand statue of Guan Yu is vivid and solemn. According to the local legend, Guan Yu's birthday fell on the 13th day of the 5th lunar month. The folks once held "Guan Wang Fair" to commemorate this legendary general. A pair of couplets in the temple highly complimented Guan Yu's loyalty, bravery and morality.

学校类

南京大学

影视作品：
《曾少年》

南京大学历史悠久，环境优雅。赛珍珠故居和校史馆等建筑古朴典雅，有着深厚的历史底蕴。建于1917年的北大楼原为金陵大学的钟楼，糅合了西方的建筑风格，盘绕其上的爬山虎让整幢建筑显得格外宁静、优雅而富有历史气息，已经成为南大的标志性建筑。著名诗人余光中先生在他的《钟声说》一诗中就提到北大楼，表达出对母校和祖国的深情。

南大校园还是《致我们终将逝去的青春》《建国大业》等许多电影和电视剧的取景地。

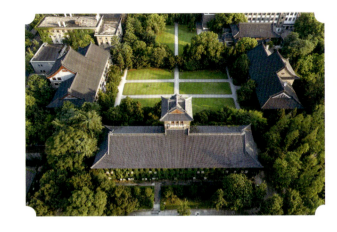

Nanjing University(NJU) has a long history and an elegant environment. Pearl S. Buck's Former Residence and the History Museum and other buildings are simple and elegant, with profound historical deposits. The North Building, formerly the Bell Tower of Jinling University, built in 1917 is now a symbol of NJU. It combines the Western architectural style, with ivy twinning round, quiet and tranquil, elegant with rich history. It has become the landmark building of NJU. Yu Guangzhong, a famous poet, mentioned the North Building in his poem *The Bell Tells*, expressing his strong feeling to the university and the love to his motherland. NJU Gulou Campus is also the shooting sites of many films and TV series, such as *So Young* and *The Founding of a Republic*.

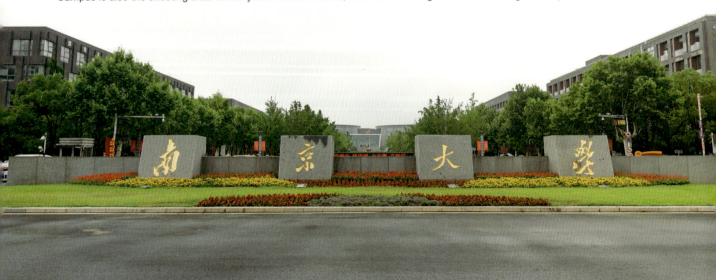

南京理工大学

南京理工大学创建于1953年,是国家首批"211工程"重点建设高校,也是"985工程优势学科创新平台"和"双一流"建设高校。学校建有南京校区、江阴校区。南京校区坐落在风景秀丽的钟山风景名胜区,校园景色优美。紫霞湖、三迎桥、时间广场和水榭红亭等都是校园景点。校园内的二月兰红遍网络,已成为南京著名景点。夏日鲜艳的荷花、秋天深红的杉树林和金黄的梧桐叶把校园装扮成了多彩世界,分外迷人。

魏鑫悦 / 摄影

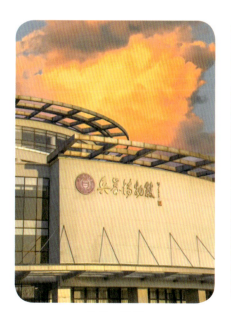

孙磊 / 摄影

孙磊 / 摄影

Founded in 1953, Nanjing University of Science and Technology (NJUST) is one of the key universities involved in "211 Project" and the "985 Innovative Platforms for Key Disciplines Project", also selected into the "Double First-Class" construction universities. NJUST boasts 2 gorgeous scenic campuses, namely Nanjing campus, Jiangyin campus. Nanjing campus is situated in the famous Zhongshan Scenic Area and enjoys excellent natural and historical environment. Zixia Lake, Sanying Bridge, Time Square, Waterside Pavilion and Red Pavilion are all scenic spots on campus. The blooming *Orychophragmus violaceus* on the campus is popular all over the Internet and has become a famous scenic spot in Nanjing. Summer lotus, ablaze firry leaves and golden leaves of plane trees make the campus a a colorful world, which is especially charming.

南京师范大学

南京师范大学是一所文化底蕴深厚的百年名校,其历史可追溯到1902年创办的三江师范学堂和1888年创办的汇文书院。学校现为国家"双一流"建设高校和江苏高水平大学建设高校以及国家"211工程"高校,对江苏的教育发展发挥了巨大作用。学校现有仙林、随园和紫金三个校区。随园校区被誉为"东方最美丽的校园",位于鼓楼区,设计精巧,布局优雅。漫步在校园里,古典建筑随处可见,雕梁画栋、曲桥连廊,展示着校园优雅的气质。大片的草坪和高大的古树相得益彰,体现了校园深厚的历史底蕴和活力。

Nanjing Normal University (NNU) is a century-old famous university with profound cultural heritage. Its origin can be traced back to 1902 with the establishment of Sanjiang Normal College and Huiwen Academy, founded in 1888. NNU is one of the key universities of Jiangsu Province and a member of "Project 211", and also selected into the "Double First-Class" construction universities, which has played a great role in the development of education in Jiangsu Province. NNU has three campuses, namely Xianlin campus, Suiyuan campus, and Zijin campus. Renowned as "the most beautiful campus of the Orient", Suiyuan campus is situated in Gulou District with an exquisite and elegant layout. Walking on the campus, classical buildings can be seen everywhere, with carved beams and painted pillars, curved bridges and corridors, convey the elegance of the campus. Countless old trees and large patches of lawns embody the profound history and vigorous campus life.

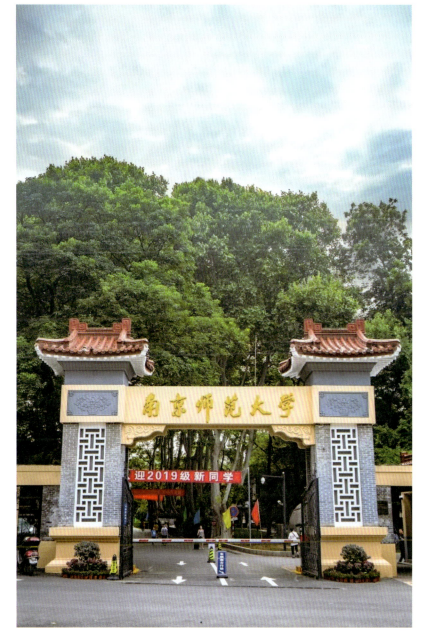

南京航空航天大学

南京航空航天大学创建于1952年10月，是新中国自己创办的第一批航空高等院校之一，以航空航天技术为特色专业，也是国家"211工程"和"985工程优势学科创新平台"重点建设高校，并进入国家"双一流"建设序列。学校现有明故宫、将军路、天目湖三个校区，占地面积3 046亩。明故宫校区位于明故宫遗址，校园内有高大的梧桐树、水杉和红柱翠瓦的古亭，环境优美。日晷、航空航天博物馆内展示的各式飞机等彰显了学校特色。明代太庙水井井栏蕴含着浓厚的历史韵味。将军路校区的砚湖绿树环绕，是著名的网红景点。

Nanjing University of Aeronautics and Astronautics (NUAA) was founded in October 1952. As one of the first batch of aeronautical institutions founded by the People's Republic of China, NUAA is one of the key universities involved in "211 Project" and the "985 Innovative Platforms for Key Disciplines Project", also one of the first universities selected into the "Double First-Class" National Initiative. The university now consists of three campuses, namely Minggugong campus, Jiangjunlu campus and Tianmuhu campus, covering a total area of 3,046 mu. Minggugong campus is situated in the ruins of the Ming Imperial Palace. With tall plane trees and metasequoia trees and ancient pavilions with red pillars and green tiles, the campus endows excellent environment. The sundial and various aircrafts displayed in the Air and Space Museum highlight the school's characteristics. The well curb of the Tai Temple of the Ming Dynasty conveys a profound history. The Yan Lake, lying on Jiangjunlu campus, surrounded by green trees, is a hot online attraction.

南京艺术学院

南京艺术学院是中国最早的综合性艺术学院，前身是1912年刘海粟先生创办的上海图画美术院，1959年更名为南京艺术学院。学校紧邻风景秀美的古林公园和秦淮河，景色优美，历史悠久。图书馆和原上海美专旧门都承载着厚重的历史。校园内随处可见的各类雕塑展现了南艺独有的艺术氛围和较高的艺术品位。南艺校园也是众多热门影视剧的取景地之一。南艺后街是一个集书画艺术、文创产业、休闲娱乐、观光旅游于一体的文化街区。每年6月举办的毕业嘉年华已经成为国内知名的艺术盛会，吸引了数以万计的观众。

Nanjing University of the Arts (NUA) is the earliest comprehensive art institute in China, tracing back to the year of 1912 when Mr. Liu Haisu first set up Shanghai Academy of Fine Arts. In 1959, it was named Nanjing Arts Institute. The campus is close to Gulin Park and adjacent to Qinhuai River with marvelous scenery and historical background. The library and the old gate of former Shanghai Academy of Fine Arts both bear profound history. Sculptures of different styles are ubiquitous, showing the unique artistic atmosphere and high artistic taste of NUA. The campus of NUA is also the shooting location of many popular films or TV series. NUA Back Street is a cultural and tourist block integrating arts, cultural and creative industries, leisure and entertainment and sightseeing. Held every June, the graduation gala is an annual show with high reputation across China, attracting tens of thousands of fans.

影视作品：
《曾少年》
《追爱家族》

南京传媒学院

南京传媒学院原名中国传媒大学南广学院,是江苏省唯一一所传媒艺术类应用型大学。学校创办于2004年9月,占地面积1 058亩。学校紧邻方山国家地质公园和秦淮湿地生态公园,素有"江苏最美校园"之美誉。学校建筑风格现代,拥有2万多平方米的观光草坪和4万多平方米的图书馆、气势宏大的教学楼群、露天剧场与学生活动中心,是集求学研习、艺术展演、传媒实践为一体的园林式校园。

Communication University of China, Nanjing, formerly known as Nanguang College of Communication University of China, is the only application-oriented university of media arts in Jiangsu Province. The school was founded in September 2004, covering an area of 1,058 mu. The campus is close to National Geopark of Mount Fang and Qinhuai Wetland Ecological Park, and is known as "the most beautiful campus in Jiangsu Province". The school has modern architecture, a lawn of more than 20,000 square meters, a library of more than 40,000 square meters and magnificent teaching buildings as well as an outdoor theater and a student's theater. It is a garden-style campus integrating study, art performance and media practice.

后 记

本书通过对南京的著名景点进行中英双语介绍，为影视拍摄提供了一份直观形象、生动具体的高品质实用指南。同时，走进本书，也可以更深入地了解南京这座城市的发展变迁，感受时代的进步。而南京城的美又不止于此，在本书之外，还有六朝古都深厚的历史文化积淀、自然界巧夺天工的奇山胜景……这座古城让人流连忘返的还有很多很多。遗憾的是，因篇幅所限，无法将这些散落在城市各个角落的璀璨明珠一一呈现。

本书在编写和翻译过程中遇到过很多困难，所幸得到相关景点、部门的大力协助，在此谨向对本书编写不吝赐教并提供无私帮助的各界朋友表示衷心的感谢，特别感谢参与本书翻译和校对工作的南京师范大学外国语学院的王永祥、钟敏、张彤。由于编者水平有限，书中所述和翻译可能存在不当之处，敬请读者和相关单位谅解、批评及指正。

编 者

2021 年 12 月